Visual Futures

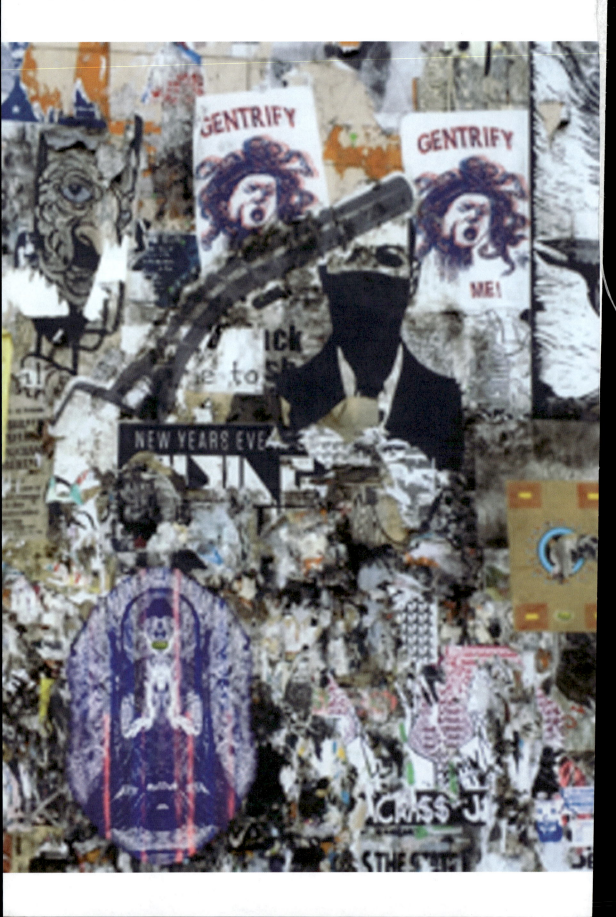

Visual Futures

Exploring the Past, Present, and Divergent Possibilities of Visual Practice

Edited by

Tracey Bowen and Brett R. Caraway

Bristol, UK / Chicago, USA

First published in the UK in 2021 by
Intellect, The Mill, Parnall Road, Fishponds, Bristol, BS16 3JG, UK

First published in the USA in 2021 by
Intellect, The University of Chicago Press, 1427 E. 60th Street,
Chicago, IL 60637, USA

Copyright © 2021 Intellect Ltd

All rights reserved. No part of this publication may be reproduced, stored in a retrieval system, or transmitted, in any form or by any means, electronic, mechanical, photocopying, recording, or otherwise, without written permission.

A catalogue record for this book is available from the British Library.

Cover designer: Aleksandra Szumlas
Frontispiece: Valencia Street, San Francisco.
Copy editor: Newgen KnowledgeWorks
Production manager: Jessica Lovett
Typesetting: Newgen KnowledgeWorks

Print ISBN 978-1-78938-446-8
ePDF ISBN 978-1-78938-447-5
ePub ISBN 978-1-78938-448-2

Printed and bound by Page Brothers.

To find out about all our publications, please visit
www.intellectbooks.com
There you can subscribe to our e-newsletter,
browse or download our current catalogue,
and buy any titles that are in print.

This is a peer-reviewed publication.

Contents

List of Figures — vii

1. See and See Again: Mapping the Fractures in Visual Culture — 1
 Brett R. Caraway and Penny Kinnear
2. In Between Whiteness: Pierre Bourdieu and Rudolph Valentino, An Unlikely Pairing — 11
 Elizabeth Peden
3. Ink to Inkling: Artful Messages in the Visuals of Biology — 31
 Charudatta Navare
4. Visualizing Gentrification: Resistance and Reclamation Through the Writing on the Walls — 53
 Tracey Bowen
5. Intentional Viewing: Decoding, Learning, and Creating Culturally Relevant Architecture — 73
 Matthew Dudzik and Marilyn Corson Whitney
6. Visualizing Art-Science Entanglements for More Habitable Futures — 91
 Kylie Caraway
7. Seeing, Sensing, and Surrendering the Inside: Expressions of the Adolescent Self in a "Structured Illustrative Disclosure" — 113
 Edie Lanphar and Phil Fitzsimmons
8. Picturing the State of Visual Literacy Initiatives Today — 125
 Dana Statton Thompson

Afterword: To Visualize the Future Is Political Work — 158
 Danielle Taschereau Mamers

Notes on Contributors — 169

Figures

2.1	Rudolph Valentino, *The Bronze Collar*, Exhibitor's Trade Review, Mar-May 1925, Media History Digital Library.	12
2.2	Rudolph Valentino and Agnes Ayers in a scene from *The Sheik* (1921), Core Collection. Production files, Margaret Herrick Library, Academy of Motion Picture Arts and Sciences.	22
2.3	Evelyn Keyes in an advertisement for Lux Soap, *Photoplay,* November 1947, v.3, no. 6, p. 32. Media History Digital Library.	25
3.1	One of Paul Ehrlich's drawings, depicting his theory of antibody formation. Proceedings of the Royal Society of London. Credit: Wellcome Collection. Reproduced under creative commons license Attribution 4.0 International: CC BY 4.0.	34
3.2	RGB color model represented as a cube (on the left), and Hue, Saturation, and Value represented as a cylinder (on the right). Images from Wikimedia Commons, represented here in grayscale. Credits: SharkD. Reproduced under Creative Commons Attribution-Share Alike 3.0 Unported license.	40
3.3	An example image showing the interaction between normal prion protein, shown using green circles, and infectious prion protein, depicted using red spiked circles. Image from Wikimedia Commons. Credits: Tecywiz121. Image under the public domain, represented here in grayscale.	43
3.4	A typical diagram of fertilization. Figure under the public domain, adapted from Wikimedia Commons. Reproduced here in grayscale. Credits: LadyofHats.	44
3.5	Analysis of shapes of the components. "Pattern" refers to antibodies, sperm, or infectious prion being depicted using more pointed shapes than antigen, egg, or normal prion protein.	46
3.6	Analysis of hue of the components.	48
4.1	Clarion Alley, San Francisco, California.	63
4.2	This city is not for sale, Ivy Jeanne McClellend, 2014.	64
4.3	Everything must go, Daniel Doherty, 2015.	65
4.4	Valencia Street, San Francisco.	66

4.5	On the ground, sidewalk stencils, Valencia Street.	67
4.6	Chicano Park, San Diego.	68
4.7	Mural and graffiti bordering Chicano Park.	68
5.1	Hsu-Jen Huang. Travel Sketches. 2019. Watercolor sketches. Courtesy of Artist.	78
5.2	Matthew Dudzik. Shifting Perspectives: Mexican Identity. 2017. Photomontage. Courtesy of Artist.	79
5.3	Matthew Dudzik. Alternative Realities. 2010. Photomontage. Courtesy of Artist.	80
5.4	Felipe Palacio Trujillo. Polyphony. 2018. Unreal Engine video stills. Courtesy of Artist.	83
6.1	Grant Grove in Kings Canyon National Park.	96
6.2	Krista Matias speaking about Sequoia National Park.	97
6.3	Douglas squirrel barking at visitors in Sequoia National Park.	98
6.4	Sequoia tree in General Grant Grove.	99
6.5	Setting up the 360° camera in Sequoia National Park.	102
6.6	Digital ecosystem.	104
6.7	Various perspectives in the ecosystem. From left corner, clockwise human digital perspective, squirrel perspective, mushroom perspective, tree perspective, ecology perspective.	105
7.1	A middle school student's schematic representation of self.	118
8.1	Basic dimensions of visual literacy (left) and differentiation of sub-competencies (right) of the CEFR–VL competency model.	134
8.2	Jacob Burns Film Center Learning Framework.	135
8.3	The Art of Seeing Art™.	136

1

See and See Again:
Mapping the Fractures in Visual Culture

Brett R. Caraway, University of Toronto Mississauga
and Penny Kinnear, University of Toronto

Visual studies has weathered questions for some time now regarding its status as an academic discipline, a subset discipline, an interdisciplinary field, or a loose intellectual movement. Its object of study, its approach, and its associated methodologies continue to inspire weighty debates. These discussions are especially germane today given the ascendance of a post-truth political culture in which emotional appeals and repeated soundbites often garner more influence than factual rebuttals and policy discussions. These developments draw attention to the rhetorical aspects of communication practices and technologies. Contemporary media systems are characterized by a variety of modes including video, images, narration, dialogue, score, text, animation, virtual and augmented realities, broadcasting, and interactivity. In each of these, visuality and visual practice play an important role. This is not to suggest that ours is the first age in which visuality has served as an effective conduit for persuasion or the exercise of power. Yet the way in which today's assemblage of media generates representations, independent of referents—what Metz (1982) refers to as *scopic regime*—is both historically unique and dynamic. The scopic regime compels us to observe and resist the limits to its own horizon of imagination. Its particularities necessitate an approach to visuality and visual practice that is stubbornly recursive in its investigation of *the social conditioning of the visual* and *the visual conditioning of the social*. While the predominance of the visual and ways of seeing in contemporary media are up for debate, ignoring them is not.

In this book, we confront the visual as an instrument of ideology, conditioning our understanding of the world. So conceived, the visual constitutes not just an object to be seen, but a lens through which we perceive and understand the world around us. Ideologies are constituted through these systems of representation. Through them we live out our imaginary relations to the conditions of our

existence (Althusser, 2006; Hall, 1985). They are the semiotic systems by which "we represent the world to ourselves and one another" (Hall, 1985, p. 102). Visuality, understood as a means of seeing and being seen, influences culture by fabricating worlds bearing some resemblance to our own. Through them, we are invited to attach meaning (signified) to the sights and sounds (signifiers) we encounter there. Thus, ideology functions to the extent that the link between signified and signifier is successfully managed, allowing a desired range of meanings to be transmitted and reproduced.

According to Althusser (1971), ideology represents the "imaginary relationship of individuals to their real conditions of existence," creating a dichotomy between the abstract and concrete aspects of social relations (p. 162). This dichotomy can be understood partly in terms of structure wherein individual consciousness is, to some degree, conditioned by the social relations in which it finds itself. But the contingent nature of this conditioning speaks to the other side of the dichotomy between abstract and concrete realties. Just as the visual may serve as a conduit of domination, it may also serve as a means of resistance and negotiation. Hall (1999) famously characterized this contingent process of meaning-making as encoding and decoding. Hence, Hall (1985) understood ideology as "indeterminate, open-ended, and contingent" (p. 95). That is to say, there is no necessary correspondence between ideology on the one hand and individual consciousness or social relations on the other. It is our position that visuality exists in the liminal space between encoding and decoding, between structure and agency. Or as Mitchell (2002) argues, images are best understood as both tools for manipulation and autonomous sources of meaning: "This approach would treat visual culture and visual images as go-betweens in social transactions, as a repertoire of screen images or templates that structure our encounters with other human beings" (p. 175). Such an approach deftly avoids reductive and deterministic understandings of visual practice as a raw exercise of domination by envisioning it instead as an open-ended and forward-looking inquiry into the power relations undergirding visual culture.

The attempt to manage visuality and visual practice so as to arrive at a desired range of meanings is what gives structure to the scopic regime. The relative degrees of autonomy between structure and agency register the intensity of the unavoidable contradiction embedded in any ideology. Ideology may alternately withstand a hairline fracture or it may crumble from a comminuted fracture. In either case, it is our task to map these fractures—the points at which the correspondence between encoding and decoding break down. Perhaps the scopic regime loses shape as attempts are made to accommodate a diverse range of perspectives. Or perhaps it finds a way to repeatedly overcome and adapt to its own contradictions. As Fleckenstein (2007) reminds us, multiple scopic regimes may exist

simultaneously as "competing ways of seeing clash and contend for organizational power within a culture" (p. 14). Exploring the nonalignment of perspectives provides us with opportunities for both ideological critique and creative response. As Hageman (2013) contends, "contradictions are spaces within ideology where new subjectivities might be produced: new constructions of and relationships between individual subjects and the social totality" (p. 65).

It is in this spirit that the current volume explores visuality and visual practice. The title *Visual Futures* speaks to this agenda of forward-looking and open-ended investigation of visuality and visual practice. By *visuality and visual practice* we do not assert a primacy of the visual in contemporary culture. In keeping with Bal (2003), we are concerned instead with particular ways of seeing, the visual quality of objects, and how each of these confront a variety of social constituencies. Our investigations consider the processes by which objects are visually assembled, transmitted, and ultimately reassembled. Yet this collection is also about more than criticism. In critiquing the ways in which visuality and visual practice are put to use, there is an implicit recognition that these processes are implicated in shaping the future. What is happening in the present gives rise to a future—hence the *Futures* in the title. Here we take inspiration from the field of *futures studies*, which leaves both terms in the plural, signaling a democratic and inclusive sensibility. Futures studies is a transdisciplinary field with roots in philosophy, sociology, history, psychology, economics, and pedagogy that contemplates not just one kind of future but many (Gidley, 2017). It "makes value judgements about impending futures" and considers how to forestall undesirable outcomes (p. 64); it cultivates "creativity and engagement with multiple perspectives" (p. 69); and it "facilitates empowerment and transformation through engagement and participation" (p. 70). Accordingly, we start with a set of guiding principles regarding the relationship of visuality and visual practice to the future: (1) we believe it is necessary to orientate people in the present so they can start to think about the future; (2) some futures are probable, some are desirable, and some are less desirable; and (3) visions of the future condition both present and future action (Bell, 2017). In this way, the current collection uses critique as a means to orientate readers in the present moment while the open-endedness of the investigations invites normative prescriptions on the best ways forward.

The origins of this book extend back more than a decade. The work contained within is the product of a diverse group of artists, educators, and scholars whose primary objective has been to develop a multidisciplinary research agenda focusing on visuality and visual practice. From 2007 to 2016, this group came together each year at Oxford University in a small gathering where the emphasis was on facilitating intense discussions among individuals from a broad range of academic disciplines and artistic backgrounds. The first gathering was called the

Global Conference on Visual Literacies: Exploring Critical Issues. It was limited to only 30 participants, all of whom had answered a call for "Perspectives [...] from those engaged in the fields of education, visual arts, fine arts, literature, philosophy, psychology, critical theory and theology [...] from any area, profession and vocation in which visual literacy plays a part." That original call delivered a fortuitous gathering of academics and creators. The most recent gathering was recommenced in 2018, this time as the Visual Futures Through International Perspectives: A Dialogic Compendium on Visuality and Visual Practice symposium, giving rise to this collected volume. The newly inaugurated gathering took place at the University of Toronto's McLuhan Coach House. Established in 1963, the McLuhan Coach House has a long history of facilitating debate and dialogue about contemporary issues and the impact of technology on culture. Fittingly, participants were asked to focus on one of the following three questions:

1. How are visuality and the visual provoking a new kind of economy or cultural exchange?
2. What are the relationships, intersections, and collisions between visuality and/or visual practices and one (or a combination) of the following: embodiment, spatial literacy, emerging languages, historical reflection, educative practices, civic development, social development, human geographies, indoctrination, spirituality, ecology, wellness, building and construction, migration, and unplugging?
3. How do you visualize the future? This section requires a 'social imaginary' reflection concerning possible implications for the future in regard to (but not limited to): education, sociology, psychology, literature, technology, architecture, and philosophy.

A number of interweaving threads emerged from the two days of presentations. The threads came in the form of questions about "seeing." Who sees? Who can see? What can be seen? What is unseen? What are the images we produce? How do we produce them? What is brought closer and what is obfuscated or erased in those images? What is visual practice? What are the ethics of visual practices? Sometimes these questions confronted the collisions of culture(s), identities, and power. They all challenged our assumptions and definitions of what seeing entails and how it is accomplished. One certainty did emerge—visual practices are more than visual culture or visual literacy. Before we can consider the implications of visual culture or literacy, we must understand how we practice and engage with all of our ways of seeing.

This book attempts to capture some of the spirit of those presentations and dialogues. Fundamentally, it is composed of seven chapters derived from the work of

a group of participants in the Visual Futures symposium. But it is also much more than that. We have attempted to replicate the role of "discussant" by including an afterword by Danielle Taschereau Mamers, one of our participants at the gathering. As of this writing, Taschereau Mamers is an Andrew W. Mellon Postdoctoral Fellow in the Humanities at the University of Toronto's Jackman Humanities Institute. Much like the Visual Futures group itself, the Jackman Humanities Institute emphasizes interdisciplinary approaches to understand human experience by generating new networks for research and study. Similarly, this book encapsulates a diverse collection of scholarship, reflecting the content and style of the conference. Moreover, our discussant responds to the synergies created among the chapters and the authors' perspectives, drawing out questions—questions that we hope will provide momentum to propel us into subsequent Visual Futures symposia.

As a collection, the following chapters are also reflective of some of the larger trends in approaches to information and media literacy. Over the last decade or so, there has been a noticeable rhetorical shift in the discourse surrounding visual literacy. Not too long ago, media literacy programs and initiatives were chiefly concerned with media access as a function of physical infrastructure, technical proficiency, and critical awareness of embedded meanings. Since the advent of the internet, digital content, online social media, and user-generated content, a growing emphasis has been placed on people as active producers of media content. This broadening of our understanding of media literacy is likewise reflected in this book. The important work of decoding the underlying meanings that are part and parcel of visual culture is still front and center. Yet these chapters also move fluidly into analyses of the creative process itself, confronting it both as a domain of struggle against dominant ideology and the scopic regime, and as a domain of contemplation, self-awareness, and empathy.

Elizabeth Peden kicks things off with an examination of the visual construction of race. In her chapter, "In between whiteness: Pierre Bourdieu and Rudolph Valentino, an unlikely pairing," Peden asks how individuals seen as racially ambiguous navigate these social constructions to achieve recognition and success. In doing so, she illuminates the means by which ideology becomes naturalized and unseen, making it all the more potent. Peden employs Bourdieu's work on systems of classification to show how individuals and groups have navigated and struggled over racial divisions, vying for social recognition. She focuses on the large population of Southern Italians who immigrated to the United States during the early twentieth century. There was considerable apprehension about race and immigration during this period, and Southern Italians were often perceived as racially ambiguous. The boundaries of whiteness were—and perhaps still are—dynamic and an object of struggle. It was not immediately clear whether Southern Italian immigrants should be considered white or nonwhite. Peden shows how the inconsistency in social

categorization implied by racial ambiguity is evidence of the contingent nature of systems of social control. Peden notes the important role of Hollywood silent film in the early twentieth century and reveals how it served as an arena of racial domination and contestation. Using Southern Italian immigrant and Hollywood star Rudolph Valentino as a case study, Peden shows how the famous actor was able to cut across racial lines while navigating his own racial ambiguity. She argues that silent film mediated between individual agency and social constraint for people seen as racially ambiguous. Peden illuminates the political and social mores of the time, while giving us much to consider about the visual representation of race in contemporary contexts.

Charudatta Navare usefully draws our attention to the ways in which meaning has been embedded in visual content at the intersection of art and science in his chapter "Ink to inkling: Artful messages in the visuals of biology." Using discourse analysis, Navare inquires into the latent meanings of biology illustrations. He uses common coding theory and research on color psychology to analyze 55 images drawn from biology textbooks. In doing so, he shows how rhetorical communication functions subtly yet effectively in biology discourse. As far back as the fifteenth century, illustrations have been critical to the advancement of scientific knowledge. Because science often relies on representation to give shape to unseen phenomena, Navare argues that we must give careful consideration to the role of visualizations and diagrams in scientific discourse. He demonstrates how pointed and curbed shapes are used to depict implicit or explicit motion, denoting an underlying dichotomy of agency and passivity. He also shows how warm and cooler colors are used to the same effect. His examples speak to the importance of investigating the pedagogical and social implications of the visual rhetoric of biology and science more broadly.

In her chapter, "Visualizing gentrification: Resistance and reclamation through the writing on the walls," Tracey Bowen discusses the visual activism of graffiti and mural artists in the Mission District of San Francisco and Chicano Park in San Diego. Bowen delves into how these artists carve out space for alternative voices and histories in the peripheries of economic development. As cities like San Francisco and San Diego are reformed to appeal more broadly to middle-class tastes, an inevitable tension arises within the communities being displaced by gentrification. Bowen's contribution provides us with a compelling account of the efforts of artists to elevate the visibility of cultural histories and injustices and to reclaim the public spaces and collective imagination of their communities. As municipal governments increasingly affiliate themselves with the global movement of *creative cities*, they promote forms of creativity that are amenable to investment and business interests. Thus, creative economies and their attendant infrastructures are built on foundations of displacement, alienation, exploitation, and precarity. Nowhere are these tensions more evident than in the official legitimization/delegitimization

of urban art. Bowen shows how graffiti abatement programs often pit mural artists against graffiti artists. These programs promise to deliver social stability and innovation to investors, businesses, and citizens without substantial engagement with the underlying issues of race and wealth disparity. Through open defiance of imposed renovations of the urban visual landscape, unsanctioned murals and graffiti visually transform neighborhoods while reasserting aesthetic control. In this way, cultural spaces emerge as terrains of resistance and pedagogical incubators for struggle. Bowen's depiction of San Francisco's Clarion Park and San Diego's Chicano Park provides us with confirmation of the power of collective action to illuminate cultural histories and lived experiences, even under the threat of immanent erasure.

In their chapter "Intentional viewing: Decoding, learning, and creating culturally relevant architecture," Matthew Dudzik and Marilyn Corson Whitney explore how visual literacy skills can aid architects and designers. They explore how the cultural relevancy of design projects is related to three aspects of creativity: mind's eye envisioning, digital technology, and cultural understandings of the visual. The authors make the case that cultural data derived from investigation, contemplation, and iterative inquiry can be used to develop a shared vocabulary of the visual. Dudzik and Whitney affirm the need for the continued development of visual literacy skills. They do this in spite of the ascendance of the so-called digital native—those individuals born during the age of computers, digital content, networks, and mobile technologies. The authors caution against assuming that younger generations possess an innate capacity to decode cultural meanings embedded within visual content. By taking the time to cultivate the skill sets necessary to interpret, negotiate, and produce meaning from visual imagery, Dudzik and Whitney assert that professionals can create more culturally sensitive designs. The authors assert that greater attention to visual analysis allows designers and architects the opportunity to recognize and act on previously obscured connections. They point to mind's eye envisioning as an example of a design process that would encourage more culturally empathetic architecture and less alienating spaces. They allude to the ways that technology can be used to augment the human capacity for three-dimensional (3-D) cognition which allows designers to form spaces, and to reconstitute components internally—in the mind's eye. More specifically, Dudzik and Whitney discuss how game design and immersive environments can be used as educational tools to foster creativity and strategic thinking among design professionals. They ask us to consider how these technologies might flatten out social hierarchies in the design process by making representations of cultural spaces more accessible to the public.

In her chapter, "Visualizing art-science entanglements for more habitable futures," Kylie Caraway draws attention to the way rhetorical communication functions at the intersection of science and art—but she does so by describing her own artistic practice. While earning her Master of Fine Arts degree from OCAD University in Toronto, Caraway used virtual reality technology to create an immersive environment called *Mother of the Forest*. In it, she combines 360-degree video, 3D modeling and animation, voice-over narrative, and field recordings to bring users into a representation of a sequoia forest ecosystem. Weaving together a number of theories on symbiosis, becoming-with, and speculative design, Caraway merges scientific information and artistic practice to raise awareness about issues of biodiversity decline and climate change. Rather than allowing users to adopt the familiar human perspective, Caraway uses virtual reality technology to place users into a variety of different species' perspectives, compelling users to look at an ecosystem from a distinctly nonhuman point of view. In doing so, users are able to experience for themselves different perceptions of time, space, and scale. Her art and her writing ask us to consider a radically different form of embodiment, and a new, more fruitful relationship between science and the arts. Her work takes on even greater significance—even urgency—when we recognize the immense threats to these intertwined ecosystems.

In their chapter, "Seeing, sensing, and surrendering the inside: Expressions of the adolescent self in a 'structured illustrative disclosure,'" Edie Lanphar and Phil Fitzsimmons speak to the capacity of visual literacy to aid in emotional awareness and self-identity. Drawing on a case study of twenty Hispanic middle-school students in a Catholic school in southern California, Fitzsimmons and Lanphar discuss the findings of their qualitative investigation and its significance for visual literacy in education. Their chapter focuses on a single student from the study, providing us with rich details of how the visual is implicated in explorations of the self. The authors make use of a pedagogical method known as 'heart mapping' that allows students to use drawing as a means to explore their writing process. Heart mapping asks students to recognize and organize the people, places, things, and ideas that are most important to them. Fitzsimmons and Lanphar seek to fill a gap in the visual literacy literature exploring the psycho-dynamics underlying the creative processes of children. In their own work, Fitzsimmons and Lanphar combine interviews and visual analysis to show how the heart map data reveal that these students were actively seeking to achieve identity balance, agency, and meta-awareness. By foregrounding the emotional presence of the students, the authors show how visuality can be integrated within traditional reading and writing assignments to enhance the empathetic appreciation and meaning-making processes of students. Thus, Fitzsimmons and Lanphar demonstrate how visual

literacy can be used to aid students as they begin to encode their own meanings into visual artifacts.

With an eye to the future, Dana Statton Thompson provides us with a comprehensive assessment of media literacy initiatives worldwide. Her chapter, "Picturing the state of visual literacy initiatives today," outlines visual literacy initiatives and related visual arts initiatives across a variety of education contexts. Thompson begins by arguing that media scholars and educators have not achieved consensus around the meaning of visual literacy, nor have they systematically integrated media literacy into education systems. Where these efforts do exist, Thompson not only takes stock of their status, she also provides a convincing case for the further integration of visual literacy curriculum into all levels of education, from elementary to graduate school. This may be the only compendium of contemporary media literacy resources, organizations, and programs in existence. Spanning efforts in North America, Europe, and Oceania, Thompson asserts that visual literacy is a vital component of the education experience—especially given the proliferation of visual content through digital media and the internet. She concludes with a series of practical recommendations on how to better integrate visual literacy into educational systems for both current and future students.

Closing things out, in Afterword: To visualize the future is political work, Taschereau Mamers directs our attention back to the always political character of visualizing futures. In doing so, she reminds us that "the stakes of visuality are high." As visual practices and ways of seeing reach ever deeper into the fabric of our social, cultural, and economic relations, it remains the case that we have an inadequate understanding of what, exactly, is going on. Consequently, Taschereau Mamers advocates for a political approach to the analysis of the relationship between visualities and futures. Such an approach would illuminate the means through which visual orders are reproduced and maintained, and how they might be disrupted. Looking forward, Taschereau Mamers closes with four questions, intended as a jumping off point for future research into the domain of visualizing futures.

This collection accomplishes a number of important tasks. It acknowledges the continued importance of unpacking the embedded meanings, ideologies, and biases within the visual. Peden and Navare provide compelling accounts of the rhetorical function of visual communication in both popular media and in scientific discourse. Yet these accounts also begin to move us beyond mere critique by demonstrating how the very process of encoding meaning is contingent and contested. Peden's analysis of silent film and racial categories show how the visual functions both as a constraint and as a resource for agency. Bowen's analysis of graffiti and mural artists also provides us with an explicit account of contestation and resistance. These chapters speak to the increasing significance of media literate

individuals, not as mere consumers of information and culture, but as producers. This shift in analysis allows us to start asking questions about how the visual can be used to bring about a better world. Dudzik and Whitney consider how technological innovations can extend the capacity of the mind's eye to bring about more culturally aware design. Fitzsimmons and Lanphar describe how visual practice can be used to reinforce writing and reading exercises by cultivating greater emotional engagement with class materials. Caraway provides us with a powerful example of how art can be used for (dis)embodiment, allowing us to decenter human concerns and to see the world through other species' eyes. All of which brings us back to those initial questions about seeing. Who sees? Who can see? What can be seen? What is unseen? How do we see? How do they see? It is our hope that this collection prompts as many questions as it does answers. More questions will bring us closer to that much coveted goal of sustaining a multidisciplinary research agenda focusing on visuality and visual practice.

REFERENCES

Althusser, L. (1971). Ideology and ideological state apparatuses. In L. Althusser (Ed.), *Lenin and philosophy and other essays* (pp. 127–86). New York, NY: Monthly Review Press.

Althusser, L. (2006). *For Marx*. New York, NY: Verso.

Bal, M. (2003). Visual essentialism and the object of visual culture. *Journal of Visual Culture*, 2(1), 5–32.

Bell, W. (2017). What do we mean by futures studies? In R. A. Slaughter (Ed.), *New thinking for a new millennium: The knowledge base of futures studies* (pp. 3–25). New York, NY: Routledge.

Fleckenstein, K. S. (2007). Testifying: Seeing and saying in world making. In K. S. Fleckenstein, S. Hum, & L. T. Calendrillo (Eds.), *Ways of seeing, ways of speaking: The integration of rhetoric and vision in constructing the real* (pp. 3–30). West Lafayette, IN: Parlor Press.

Gidley, J. M. (2017). *The future: A very short introduction*. Oxford, UK: Oxford University Press.

Hageman, A. (2013). Ecocinema and ideology: Do ecocritics dream of a clockwork green? In S. Rust, S. Monani, & S. Cubitt (Eds.), *Ecocinema theory and practice* (pp. 63–86). New York, NY: Routledge.

Hall, S. (1985). Signification, representation, ideology: Althusser and the post-structuralist debates. *Critical Studies in Media Communication*, 2(2), 91–114.

Hall, S. (1999). Encoding, decoding. In S. During (Ed.), *The cultural studies reader* (pp. 90–103). New York, NY: Routledge.

Metz, C. (1982). *The imaginary signifier: Psychoanalysis and the cinema*. Bloomington, IN: Indiana University Press.

Mitchell, W. J. T. (2002). Showing seeing: A critique of visual culture. *Journal of Visual Culture*, 1(2), 165–181.

2

In Between Whiteness: Pierre Bourdieu and Rudolph Valentino, An Unlikely Pairing

Elizabeth Peden, University of Toronto

In 2015, when the Academy Award nominees were announced, a protest erupted via social media over the underrepresentation of people of color. As part of this protest, the problematic representation of ethnic minorities also emerged over concerns of how racial ambiguity was embodied in film. These problematic representations are not new, however, and can be found in films from 100 years ago. More specifically, what occurred when a large influx of Southern Italian immigrants seen as racially ambiguous and thus uncategorizable arrived in America, and how did film become a locus for the contentious ideologies surrounding these immigrants? Moreover, how can studying the case of Hollywood film star Rudolph Valentino, himself a racially ambiguous Southern Italian immigrant in this period, provide us with a lens through which to both reflect and view racial ambiguity in early twentieth-century America?

This chapter will consider these issues by examining the very notion of racial categories in relation to racial ambiguity. The focus of this chapter will be situated in film, as film is an important tool that can both reflect and reproduce the social and political ideologies of the period in which they are made. Relying on Bourdieu's concepts of symbolic violence, habitus, and cultural capital, this chapter will examine Southern Italian immigrants who came to America during this time, who were seen as racially ambiguous, and the role film may have played in all of this.

With respect to categories, Bourdieu and Wacquant (1992) argue that society is not composed of "autonomous spheres" that can be easily grouped (p. 17). Still, Bourdieu (1984) argues, all societies fabricate social hierarchies by establishing categories thereby rendering natural differences that are socially produced. What is at stake in these struggles are classifying systems between groups who battle over the categories. A group's presence or absence in the official classification depends on its capacity to be recognized and admitted in the existing social order.

VISUAL FUTURES

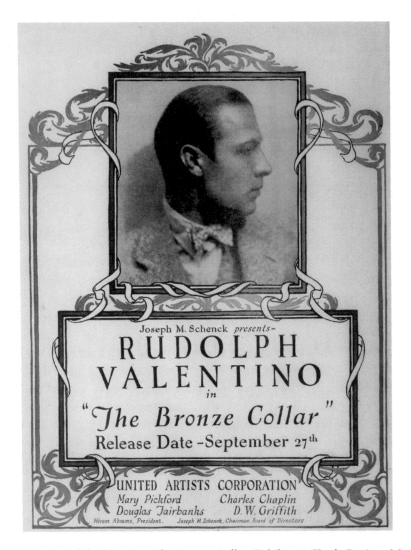

FIGURE 2.1: Rudolph Valentino, *The Bronze Collar*, Exhibitor's Trade Review, Mar-May 1925, Media History Digital Library.

If, as Bourdieu posits, recognition is necessary to win a place in the social order, then acceptance within a given society for those seen as straddling racial boundaries becomes highly problematic because of their ambiguity. Relying on Bourdieu's concepts as an approach through which to study the social world and consider "how culture figures in social inequality and how the pursuit of distinction shapes all realms of social practice" (Calhoun & Wacquant, 2002, p. 7), this

problem will involve consideration of the following issues: What underlying processes of power are at play in society to maintain existing social orders of domination, and what happens to those seen as uncategorizable as a result? Can those seen as uncategorizable negotiate their position in the existing social order? If so, how can these processes be negotiated by those seen as racially ambiguous? Finally, can the visual and culturally popular media of film provide a locus for this negotiation?

Social and historical context

Important to understanding how Southern Italian racial ambiguity may have operated in relation to film is first understanding the contentious social and historical climate to which these immigrants arrived to early twentieth-century America. To this end, Roediger (2005) argues it is essential that "white ethnics" be examined within the context of race and ethnicity within US history (p. 194).

This is important when considering early twentieth-century American and racial ambiguity. The United States was a country experiencing great anxiety around ethnicities that could not be categorized. Specifically, these concerns surrounded the arrival of Southern European immigrants to America. What was central to the immigration problem was the influx of Southern European immigrants, and more specifically Southern Italians, who were blurring the borders between white and not white enough. By 1913, even famous author Jack London, so distraught by skin color changes to the American landscape, stated that "the dark-pigmented things, the half-castes, the mongrel-bloods" of the inferior race would soon take over the "Anglo-Saxon stock" (qtd. in Highman, 2002, p. 182). In fact, Italians were second only to blacks in the number of lynching victims in the years from 1870 to 1940 United States, and after 1870, Italians were the only whites to join blacks as victims of lynching in any significant numbers (Gambino, 1998).

As an example of the contentious nature of this racial ambiguity, Barrett and Roediger (1997) cite the bitter debate over Italian whiteness during Louisiana's disenfranchising constitutional convention of 1898 that ended with the establishment of a provision to these new immigrants which was comparable to those that the "grandfather clause" gave to native white voters (p. 12), thereby deeming Italians in that state as white. Overall, it seems that Italians were neither white enough nor dark enough to be clearly categorized.

Politically, it seems the in between status of these immigrants was a contentious issue as well. For a time, politicians appealing to immigrant constituencies were able to marginalize these new immigrants, while other politicians supported them arguing that Americans could learn a lot from immigrants, and could celebrate

both assimilation and cultural differences. Even Woodrow Wilson seemed to take an in between position. For example, prior to being elected as president, while working as an academic in the South, he wrote of the dire threat to "our Saxon habits of government" by "corruption of foreign blood" and characterized Italian and Polish immigrants as "sordid and hapless." However, later as a presidential candidate in 1912, he reassured immigrant leaders that "[w]e are all Americans," and stating that he "found Italian Americans one of the most interesting and admirable elements of our American life" (Barrett & Roediger, 1997, pp. 14–15).

Jacobson (1999) further considers the depth of problems these racially ambiguous immigrants faced when he cites President Calvin Coolidge's comments about racially ambiguous immigrants in June 1924: "Biological law tells us that certain divergent people will not mix or blend. The Nordics propagate themselves successfully. With the other races, the outcome shows deterioration on both sides" (p. 4). He argues that "old stock" Anglo-Saxon backgrounds achieved superior status to other immigrants such as Italians. Jacobson (1999) provides an insightful lens with which to view this particular group when analyzing the designations assigned to Southern Italian immigrants upon their arrival to the United States. Jacobson (1999) argues that while a racial order existed in Europe with clear boundaries, upon their arrival it became unclear where the boundaries of whiteness would be drawn.

Higham's (1956) scholarship also provides us with the rationale and thinking behind the contentiousness nature of racial ambiguity. Higham (1956) argues that the main issue propelling racist views in America during this period was nativism (explained simply as an aversion to outsiders)—something he believes can be directly linked to nationhood. Higham (1956) states: "Nativism as a habit of mind illuminates darkly some of the large contours of the American past; it has mirrored our anxieties and marked out the bounds of our tolerance" (p. xi). As an example, Higham (1956) references a letter from an American citizen to *New Republic* magazine in 1924 which states:

> The old Americans are getting a little panicky, and no wonder [...] America, Americans and Americanism are being crowded out of America [...] the Ku Klux Klan and the hundred percenters are fundamentally right from the standpoint of an American unity and destiny.
>
> (p. 264)

At the center of this nativism was anxiety surrounding Italian immigrants now living in the United States. Higham (1956) cites the burning of West Frankfort, a mining town in southern Illinois where the majority of inhabitants were Italian. This attack followed a series of bank robberies and the kidnapping of two boys

blamed on Italians. This region, Higham (1956) argues, had always been volatile, but never to the extent that it reached during the period of Italian settlement there.

Anxiety surrounding the problematic category of Italian immigrants is also seen in Madison Grant's 1916 book *The Passing of the Great Race* where Grant examines the racial impurity of Italians, and many other Mediterranean populations, while juxtaposing their racial impurity against the racial purity of Nordic Europeans. Grant (1916), a proponent of eugenics, as well as a nativist, voiced the concerns of many other white Americans when arguing that mixing of the two races that would result in a "more ancient, generalized and lower type" (pp. 15–16), thereby leading to a "population of race bastards" that would ultimately lead to the demise of white America (p. 69).

The problem, which seemed to create additional anxiety for Americans, however, was the possibility of interbreeding. Grant (1916) noted Southern Italian immigrants as a prime example and argued that for Americans with a long skull who "breeded freely" with Southern Italian immigrants, the result would be a child with a round skull (p. 15). Thus, when mixing an Anglo-Saxon with an inferior, mongrel, the result would be that the inferior characteristics would take over. Grant (1916) states: "The Mediterranean race is everywhere marked by a relatively short statute, sometimes greatly depressed as in South Italy and in Sardinia and also by a comparatively light bony framework and feeble muscular development" (p. 25).

From the political front, Roediger (2005) points out that by 1912, Congressional hearings on immigration restriction debated whether these Italians were in fact "full blooded Caucasians" (p. 66). While the debate continued, Roediger (2005) argues, the decisions being made by local and regional governments with respect to these new immigrants was setting the tone for American citizens who were told by the state apparatus who was white and who was not white (or perhaps not white enough).

Within the social context of racial ambiguity, Roediger (2005) utilizes sociologist Henry Pratt Fairchild who in 1911 described the experiences of these immigrants as similar to those of the "Negroes in the United States"—an assertion that is supported by Gambino's (1998) statistics regarding lynching of Italians during this period. Fairchild (1911) argued that these new immigrants were "for the most part white-skinned" but also added that they were generally regarded as inferior (p. 58). Roediger (2005) also points out that evolutionary biologist E. D. Cope, who agreed with Fairchild's assertions regarding the treatment of Italians, was clear to point out that Italians were, in fact, morally inferior and moreover, these morally inferior immigrants would "cause general moral deterioration" to the country (p. 61).

Overall, Roediger (2005) points out that these feelings, both political and social, were not restricted to certain regions, and in fact, were widespread throughout the United States. This became evident when in the 1920s Congress was swamped with demands that racially based restrictions be placed on southern European immigrants. By the end of the nineteenth century, it was generally agreed that Italians were considered to be the most undesirable immigrants among the Europeans and were described as "swarthy, illiterate and generally slum dwellers" (Higham, 1956, p. 66).

Race as power

In considering this problem, power is a key issue as it plays a vital role in understanding the ongoing struggle and negotiation for a place in the social order by those deemed racially ambiguous. As noted previously, Bourdieu (1984) believes that all societies fabricate social hierarchies by establishing categories thereby rendering natural differences that are socially produced. This relates to issues of power as Bourdieu (1984) further argues that what is at stake in these struggles are classifying systems between groups who battle over the categories. A group's presence or absence in the official classification depends on its capacity to be recognized.

Crossley (2008) takes Bourdieu's concepts regarding distinction further to argue that "groups form themselves, in some part, by cultivating distinguishing features and signs of 'superiority'" (p. 96). To this end, Wacquant (1998) argues that what is most important in "Bourdieu's sociology" is the critique he brings to the issue of "inherited categories and accepted ways of thinking," as well as the way those in positions of power subtly wield power and the structures that support them (p. 264).

Furthermore, Bourdieu's concepts also help in understanding how existing power structures support racial ambiguity as a contentious social issue. If an individual is deemed to belong to a category or specific race (or in this case, is not), it is essential that we consider who decides and how this decision is made? Dyer's (1997) examination of skin color and race addresses the problematic racial classification of "white" since categorizing "white" is not as straightforward as one would think. Different hues of "white" exist, thereby introducing variability into concepts of whiteness (p. 11). Dyer (1997) argues that this variability is a form of social control because it limits who will and will not be allowed into any certain group at various times.

Dyer's (1997) argument is substantiated by Said (1978) who also examines the issue of categories and power, however, in the context of Orientalism and the Other vis-à-vis the West. Said explains how European countries colonized what

they perceived to be inferior Eastern countries. "Orientalism" is the generic term that Said (1978) uses to describe "the Western approach to the Orient; Orientalism is the discipline by which the Orient was (and is) approached systematically as a topic of learning, discovery, and practice" (p. 73).

Said (1978) also considers the notion of stereotypes when he notes that the categorization of this racially ambiguous group led to a theme described as "essentialist conception" where the "people and countries of the Orient come to be seen through a stereotypic lens that very soon progresses to racism" (p. 97). Using the term Orientalism entrenches a form of "radical realism" in that the very use of this word becomes a way to deal with questions and thoughts around the Orient and, in turn, these words simply become reality, to the extent that this fabricated term overtook the Orient. All of this again is related to issues of power as Said (1978) believes that the Oriental not seen as a true human being is really more about "white middle-class Westerners" who feel that it is their right to manage nonwhites because they are not quite as human as whites (p. 108). He also states that "the relationship been Occident and Orient is a relationship of power, of domination, of varying degrees of a complex hegemony" (p. 5).

In relation to both Dyer's (1997) and Said's (1978) arguments, Bourdieu believes that this struggle for power is at the center of all social arrangements, and that this struggle is not just a battle for quantifiable resources, but for symbolic ones as well (Swartz, 1997, p. 136). This battle for power is important to this chapter's understanding of how racial ambiguity was understood socially and politically in early twentieth-century America.

Capital culture and power as symbolic violence

Within this context, it is important to consider Bourdieu and Wacquant's (Schubert, 2008) concept of symbolic violence. As noted previously, Bourdieu believes that this struggle for power is at the center of all social arrangements, and that this struggle is not just a battle for quantifiable resources, but for symbolic ones as well (Swartz, 1997, p. 136). Bourdieu uses the term symbolic violence to explain the way symbolic domination is produced and maintained through existing social hierarchies and social inequality. How these structures are produced and maintained, Bourdieu argues, is not by physical force, but by symbolic domination (Schubert, 2008).

In addition, there is an ongoing struggle for these symbolic resources. For example, Bourdieu (1984) uses the term cultural capital in referencing access to symbolic items that are not only difficult to attain, but generally given only to members of dominant groups. While we may tend to think of capital in terms of

economics, Bourdieu sought to extend the definition beyond an economic one to a definition that includes nonmonetary capital that is gained socially and culturally. It is in this struggle for symbolic resources that these differences can become a focus of symbolic struggles in which members of those clusters seek to establish both the superiority of their distinctions and an "official sanction for them" (Thomson, 2008, p. 96).

The result of this is that certain beliefs are legitimized which, in turn, are used to maintain and strengthen structures of inequality (Wacquant, 1998)—a concept that helps not only to support Dyer's (1997) and Said's (1978) arguments, but offers a unique perspective through which to view racial ambiguity.

Bourdieu and practice

In terms of viewing this chapter through a cultural lens by focusing on film, Bourdieu (1993) again provides a unique perspective when he argues that culture is situated within a complex social framework, and it is within this complex institutional framework that social constructions are authorized, enabled, empowered, and legitimized. If, as Bourdieu (1993) posits, culture does not exist as an independent entity, but rather within complex frameworks, then it is important to consider the issue of racial ambiguity within this context. Bourdieu (1993) believes it is necessary to analyze and use this framework to understand cultural practice. It is within this context that racial ambiguity and the important cultural role of film in early twentieth-century America will be analyzed.

However, before considering this, an understanding of Bourdieu's notion of habitus is needed. Wacquant (2016) describes habitus as a "mediating construct" that helps us understand how "sociosymbolic" structures of society become internalized within us so that we develop dispositions and ways of thinking, feeling, and acting which then guide our responses to the limitations and "invocations of society" (p. 67).

If we go on to share concepts of conduct, right/wrong, judgment, and so on with others who were "subjected to similar social conditions and conditionings," Wacquant (2016) argues, we can then speak in terms of "masculine habitus, a national habitus" and, it can be argued for the purpose of this chapter, a racial habitus (p. 67). Because habitus is both structured (by our past social environments) and structuring (by our present ideas, emotions, etc.), it directs our practices in an almost unguided manner or, as Wacquant (2016) states, referencing Bourdieu's metaphor, our practices are "orchestrated without being the product of the organizing activity of a conductor" (p. 67). Wacquant (1998) argues that habitus provides us with an "unconscious schemata through lasting exposure to

particular social conditions and conditionings via the internalization of external constraints and possibilities" (pp. 220–221).

Furthermore, Wacquant (1998) relies on habitus and field to argue that practice is generated through parallel relations between both the disposition acquired in habitus (the mental structures) and the position in the field (social structures), with these parallel relations often functioning invisibly (when it goes without saying and agents do not really think about it) so that "dispositions are inevitably reflective of the social context in which they were acquired" (p. 22). At the same time, there is a similar process occurring between habitus and field because "social reality" exists in both field and habitus, so when habitus meets the "social world of which it is the product," it feels comfortable, taking its habitus for "granted" and not feeling the pain and suffering it generates (Reay, 2004).

To better understand the concept of field, Bourdieu uses the analogy of the football field in relation to the social field to examine human behavior (Thomson, 2008), arguing that much like a football field, the social field "does not stand alone." That is because the game that takes place in "social spaces or fields" is a competitive one whereby those with power use various strategies to try to either "maintain or improve their position," an argument that can also be connected to this chapter's earlier assertions regarding race and power. Within each field, the game is played differently, depending on the "rules, histories, star players, legends and lore" (Thomson, 2008, p. 69).

Bourdieu (1993) argues that agents act within a field. Furthermore, he believes that the structure of field is determined by the relations between the positions agents occupy in the field, stating thus: "Field as relational is key to cultural production, and we see the social world in terms of its relationships with all other elements in a system from which it derives its meaning and function" (p. 6). To enter the field and to play the game, "you must possess the habitus that pre-disposes you to enter that field and not another; you must possess at least the minimum knowledge" (p. 8).

As a result, there are boundaries and therefore limits on what can be done in or on the field, and these limits are "shaped by the conditions of the field" itself (Thomson, 2008, p. 68) with, as previously noted, various social agents using differing strategies to maintain or improve their position.

In addition, it "demonstrates the ways in which not only is the body in the social world, but also the ways in which the social world is in the body" (Reay, 2004, p. 432). Moreover, our "feel for the game" then is a "feel for these regularities," and this stems from applying the logic and knowledge gained in the habitus, which is then played through what becomes second nature to the player. As a result, we learn "our rightful place in the social world" based on the dispositions and resources we are given. The outcome of this is that players seem to instinctively

shift toward particular social fields that best match their dispositions and avoid fields that clash with it. Our actions within a given situation therefore are conditioned by the expected outcome, which is in turn based, thanks to the habitus, on experience of past outcomes (Maton, 2008, p. 58).

Film as a cultural lens in early twentieth-century America

It is now important to consider what role film may have played in relation to racial ambiguity in early twentieth-century America. However, before considering this, it is essential to ask why film should even be considered in relation to social issues/problems.

Cavell (1981) addresses this point when he asks, "What would the principle be that film cannot provide some sort of instruction?" He says we learn from the great writers such as Emerson, Marx, Nietzsche, Freud, and to "take an interest in an object is to take an interest in one's experience of the object" (p. 7). Cavell (1981) further argues that to "examine and defend" his interest in these films is to "examine and defend" his interest in his own experience and in the "moments and passages" of his life he has spent with them (p. 7).

A further point regarding film is made by Maltby (2007), who cites French film historian Michele Lagny's argument that film text needs to be considered in relation to "different forces (economic, social political, technological, cultural or aesthetic)" and that both "come into being and confront each other" (p. 3). To that end, Maltby (2007) argues that in writing the "history of cinema" we need to engage with "economics, industrial, institutional history on one hand" and the "socio-cultural history of its audiences on the other" (p. 3). While he contends that these two histories are far more closely bound together than either of them is to a film history of textual relation as argued by Lagny (as cited in Maltby, 2007), what is significant is that both scholars agree that film can be an important arena through which to consider social and historical issues.

Alice Walker (1996), author of the book *The Color Purple*, offers a similar opinion about the power of film when discussing the movie version of her book. Walker states: "I believe movies are the most powerful medium for change on earth." Walker goes on to question the cultural role of film. She asks: "If these other movies are so terrible, why were they so popular? Why did everyone who complains go to see them? What is their meaning to the culture at large?" (p. 284). Walker's conclusion is that films are indeed powerful, but powerful in that they often institutionalize "complacency, oppression and reaction" (p. 282).

Giroux (1997) agrees with Walker's statements and says that all we have to do is look at the "popular imagination and public consciousness" to see their powerful

influence. This is because films are unlike any other item a consumer might purchase; films contain strong visual "images, ideas and ideologies" that impact and form "both individual and national identities" (p. 587). It is not only in the content of the film, but, as Giroux (1997) notes, through these visual images that we learn and are impacted.

This is evident when examining the anxieties surrounding racially ambiguous immigrants to early twentieth-century America. When examining the parallel relationship racially ambiguous immigrants had with the emergence of cinema, the relationship between the social/political history of the United States, the film industry, and the audience during this period becomes even more clear. For example, 1896 was the first year of commercially successful cinema in the United States. Coincidentally, it was also the first time that immigrants from southern Europe outnumbered traditional immigrant arrivals from northern and western Europe (Musser, 2004). The cultural anxieties these new immigrants brought to America collided with a film industry still in its infancy and struggling to survive. Therefore, traversing racial boundaries in film during this period involved a delicate balance.

This is especially evident when examining miscegenation laws. Miscegenation laws in early twentieth-century America provided that individuals of different races could not have sexual relations or interbreed. However, when it came to racially ambiguous individuals, the law was not as clear. Jacobson (1999) cites evidence of this ambiguity, even in law, by examining the conviction of African American Jim Rollins of the crime of miscegenation, a crime later overturned by the Alabama Circuit Court of Appeals. This was because Rollins's partner in the relationship, Edith Labue, was a Sicilian immigrant and therefore whether she was "white" could not be conclusively determined. Jacobson (1999) argues that this inconclusiveness did not necessarily say that Sicilians were not white, but it did clearly suggest that Labue was not the sort of white woman whose purity was to be protected by the miscegenation laws of the State of Alabama.

In terms of film, the impact of this law and the cultural anxieties surrounding those seen as uncategorizable can be found in the case of Southern Italian immigrant movie actor Rudolph Valentino. In 1921, Valentino was cast in the film *The Sheik* to play the role of an Arab Sheik, who—as it turns out at the end of the film—is not Arab at all, but is actually European. This image of Valentino and his costar in the film, Agnes Ayers, shows the contrast of Valentino's skin against that of Ayers.

To this end, while making this film, Valentino's interview with *Motion Picture Magazine* (1921). When asked how he was enjoying the California sun, Valentino replied that he was careful about staying out in the sun too long because "I am very dark in complexion, an' the sun it burn me too black for pictures. I

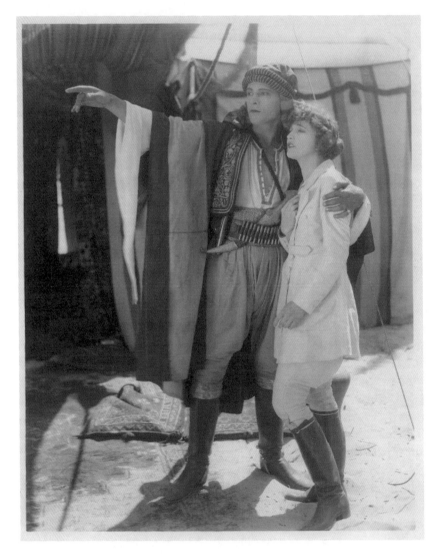

FIGURE 2.2: Rudolph Valentino and Agnes Ayers in a scene from *The Sheik* (1921), Core Collection. Production files, Margaret Herrick Library, Academy of Motion Picture Arts and Sciences.

become like a neegroe [*sic*]" (p. 92). This statement becomes even more problematic when considering George Ulman's (1926) comments about Valentino shortly after Valentino's death. Ulman, one of Valentino's closest friends and personal manager, wrote about Valentino's love for the sun, stating that Valentino was "pre-eminently fond of the sun—he could not live in a country where grey days

predominated. Day was made for him by amount of sunshine radiated" (p. 26). If, as both Valentino and Ulman clearly state, Valentino loved the sun so much, then why did Valentino feel compelled to stay out of the sun? The answer to this question can be found in Valentino's own statement, as noted above, where he felt it was necessary to stay out of the sun so his skin did not get too dark for films.

Moreover, considering Caton's (2000) contention that Valentino traversed boundaries through his racial ambiguity in *The Sheik*, arguing that Valentino would be accepted as an olive-skinned Italian playing an Arab Sheik, but his skin would have to remain only a "slightly darker shade of white" to avoid anxiety for white audiences who might see the crossing of cultural boundaries as a "betrayal of white culture" (p. 99), then this problematic notion of Valentino's racial ambiguity in relation to his films become even clearer.

Valentino himself, as noted in his earlier statement to *Motion Picture Magazine* (1921) about his skin color, repeatedly made similar comments about his problematic appearance in relation to America. For example, in 1923, two years after his interview with *Motion Picture Magazine*, and at the time, one of film's biggest film stars in the world, Valentino noted:

> I know that my foreign blood showing in my face and bearing has a great deal to do with the kind reception I had by the American public. The Anglo-Saxon has a distinct "flair" for the Latin. It is the call of strangeness. The allure of the alien. The call of the unknown. The pique of interest in what we are not ourselves.
> (My Private Diary, 1929, p. 113)

Through this complicated statement, we see that while Valentino is aware his "foreign blood" impacts the reception he receives from the American public, he goes on to describe this foreignness somewhat paradoxically, as "the allure of the alien." In noting this, Valentino is pointing out that his visible "strangeness" results in a "piqued" interest in him by the American Anglo-Saxon public that both draws him to them and, at the same time, alienates him from them. Consequently, it can be argued that although Valentino may not have been directly aware of the specific problematic issues surrounding racial ambiguity during this period, such as the Labue case or Madison Grant's statements, he had a sense his difference impacted him as a racially ambiguous actor. Thus, harkening back to Wacquant's previous argument regarding social conditions and conditioning (pp. 220–221), Valentino attempted to function within the indistinct racial constraints as a result of his exposure to the particular social conditions and conditionings surrounding racial ambiguity during this period. Moreover, it is in this way that Valentino, the racially ambiguous actor, would have had an innate sense of what he needed to do and how to work in film within the existing parameters with respect to his

racial ambiguity, as evidenced by his efforts to stay out of the sun for his role in *The Sheik* (*Motion Picture Magazine*, 1921).

Hence, in this new medium that was still trying to prove itself to Americans, Valentino would have to balance his racial ambiguity and perform whiteness, so that he was acceptable to the movie-going public. Bellin (2005) notes that as it struggled for survival while attempting to develop "artistically, culturally, and technologically," it did so in a country that was in its own battle for survival of its white identity (p. 24). To this end, Bourdieu (1993) believes that the sense of social realities that is acquired in the confrontation with a particular form of social necessity is what makes it possible to act as if "one knew the structures of the social world, one's place within it and the distances that need to be kept." As well, Bourdieu believes that practices within a given situation are conditioned by expectation of the outcome of a given course of action, which is in turn, because of habitus, "based on experience for past outcomes" (Maton, 2008, p. 58). Therefore, Valentino's statement about keeping out of the sun so his skin did not get "too dark" for movies is an example of how his practices regarding his skin color and his sense of what was acceptable were conditioned by his expected outcome of this particular action.

Further evidence regarding Valentino's sense of social realities surrounding his racial ambiguity can be found in Bertellini's (2010) assertion that a fictional biography of Valentino was created around his heritage that described him as an "Italian nobleman" with a French mother (pp. 234–235), thereby making him less of a Southern European, more acceptable to Americans, and able to traverse racial boundaries through his ambiguity.

In addition, it was during this period that that early film audiences began to rely on familiar tropes that were based on recognizable cultural patterns in order to make sense of the movies they viewed (Gunning, 1994). One such trope regularly employed in film was that of whiteness. Dyer (1997) considers racial ambiguity in relation to how actors are "lit" in film. He uses the term "northern light" in film to explain how actors have always been lit in film so they almost appear to be from the north where people are whitest white (p. 121). Dyer (1997) uses Lux Soap ads as an example of lighting and whiteness to address women in film stating thus: "Idealized white women are bathed in and permeated by light. It streams through them and falls on to them from above" (p. 122). Evidence of this is seen in this advertisement for Lux Soap showing actress Evelyn Keyes, who uses this soap to the extent that the two images of Keyes's face flanking her central image depict her skin as so bathed in light, and therefore so white that it is almost translucent.

To this end, Dyer (1997) notes actors who are not white or clearly white are deemed to shine rather than glow in films. In fact, Dyer (1997) says that cosmetics have been devoted to making women glow, not shine, and even darker women

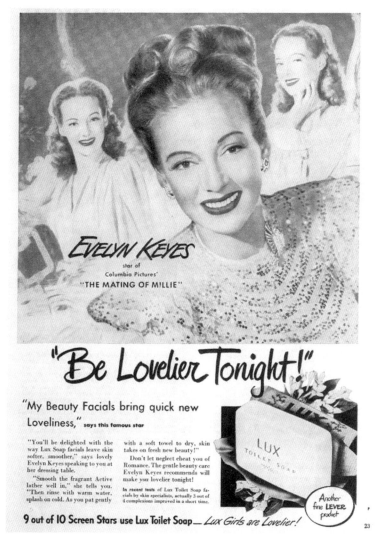

FIGURE 2.3: Evelyn Keyes in an advertisement for Lux Soap, *Photoplay*, November 1947, v.3, no. 6, p. 32. Media History Digital Library.

can get that glow with the right cosmetics thereby making themselves as close to white as possible. To appear ethnic in film invokes the "evils of shadows" and thus eliminating shine is key. In fact, photo media works to enhance what cosmetics attempt to do so by using of "haloes, backlighting, soft focus, gauzes and retouching," all of which are tropes regularly used in film (Dyer, 1997, p. 125). Dyer (1997) asserts that being as white as possible in film has historically been

the norm, and more specifically was the requirement in early American film of the twentieth century. In cinema, it seems one could never be white enough. White has been the color of choice. In fact, for many years, Hollywood actors were forced to wear whitening make-up which was copiously applied, almost like a mask, making actors appear "whiter than white" (Foster, 2003, p. 4). Lightening was also done carefully to enhance the "whiteness" of the actor's skin, a practice that continues today. Consequently, film actors have been performing in a sort of "whiteface" on screen for many years, clearly marking whiteness as a performed construct (Foster, 2003 p. 4).

Conclusion

When examining the parallel relationship racially ambiguous immigrants had with the emergence of cinema, the relationship between the ideological social history of the United States, the film industry, and the audience during this period becomes even more clear. As previously noted, 1896 was the first year of commercially successful cinema in the United States, and it was also the first time that immigrants from southern Europe outnumbered traditional immigrant arrivals from northern and western Europe. This different encounter with a new, less traditional kind of immigrant resulted in complex emotional responses. In the political realm, there appeared to be an endorsement that America was really an Anglo-Saxon based country (Musser, 2004).

It is interesting to note that what Valentino did almost 100 years ago, and the fact that what—as Dyer (1997) argues—actors such as Susan Hayward in the Lux Soap ad did in relation to whiteness in film is still being done today. For example, in the film *Money Train* Pena Ovalle (2008) describes Jennifer Lopez, a Latina actress, as being the physical mediator between her costars, the white Woody Harrelson and the black Wesley Snipes, and argues that she acted as a "convenient bridge" in this film (p. 173). Pena Ovalle (2008) notes that initially many of the roles Lopez played were overtly Latina, such as Santiago, Flores, and Quintanilla and her Latinness was eventually replaced by Italianness. This move from Latin to Italian signaled an upwardly mobile move toward whiteness and something that is similar to social whitening that Italian immigrants had to perform in the early 1900s in order to assimilate into mainstream United States (Pena Ovalle, 2008).

This question is not limited to Italians, of course: Warner Oland, a Swedish American actor, cast in the role of Honolulu police detective lieutenant Charlie Chan (1936); Susan Koehner, in *Imitation of Life* (1959), played a light-skinned black woman who is light enough to pass as white; Mickey Rooney, in a small and

racially offensive role as Mr. Yunioshi with exaggerated buckteeth and yellow face in *Breakfast at Tiffany's* (1961); American actor David Carradine, who starred in the TV show *Kung Fu*, which was originally pitched as a series for Chinese actor Bruce Lee; and Canadian actor Eugene Levy, who acted as the cruel and shrewd Mr. Habib, played with a contemptuous Arabic accent, in *Father of the Bride II* (1995), to name but a few, are examples of the ongoing contentiousness surrounding representation of race and racial categories in film (Foster, 2004, p. 4).

Similarly, as noted at the 2015 Oscars, there remains a problem that relates more specifically to the concept of representation in film, which needs to also be considered. That is because the very notion of representation presents a problem since, it can be argued, there is no such thing as an accurate representation. Representation by its very definition is something recreated. Representation by its very definition distorts. This is because it is impossible to "represent" every facet of something that is being presented. The very process of representation involves a "process of translation" by someone else from the original (Richardson, 2010, p. 9). If part of the problem lies with the act of "representation," something that cannot be removed from movies, then how do we move away from the problems associated with representation? All societies function on certain beliefs and ideologies and it is important to first understand how these function in a given society. This must be done through thoughtful consideration and understanding of how these norms were formed while, at the same time, taking into account the historical and cultural issues surrounding these norms (Richardson, 2010, p. 9). We must examine how and why ideologies are normalized and made to seem like common sense, and we then need to deconstruct these ideologies. To this end, it is important to note that while film in America began as pure entertainment, in Russia, it began exclusively as a pedagogical tool (Vera, 2003, p. 181), thus showing the power of film to produce and reproduce existing social structures, and the power of film to educate.

As stated at the outset, the case of Valentino and representations in film during this period is an issue from almost 100 years ago. As immigration laws and ideologies have changed over the years, these representations persist, although in different and sometimes less overt ways, and cannot be ignored when, almost 100 years later, we are still asking the following question: "what of the white human wreckage that skirts the edges of the falsely constructed visual fantasies of whiteness?" (Foster, 2003, p. 37). Despite this, we are seeing small changes occurring as in the recent case of Ed Skrein, a British actor who announced in August 2017 that he would be stepping down from his role in the film *Hellboy* after protests from the Asian American community that Skrein should not be playing the role of a character who was half-Japanese. In withdrawing, Skrein stated:

It is clear that representing this character in a culturally accurate way holds significance for people, and that to neglect this responsibility would continue a worrying tendency to obscure ethnic minority stories and voice in the Arts. I feel it is important to honour and respect that. Therefore I have decided to step down so the role can be cast appropriately.

(*The Hollywood Reporter*, August 28, 2017, n.p.)

At the same time, however, major actors such as Scarlett Johansson continue to not only take these roles, as she did in the 2017 film *Ghost in the Shell* where she played the role of Japanese character Motoku Kusanagi, but also defend their position by arguing that their character was not ethnic but really "identity-less" (*The Hollywood Reporter*, April 4, 2017, n.p.), showing both the contentious and complex nature of this problem. While the Skrein case is a positive sign that some changes are occurring around these issues, it is clear that this is not a problem that can be easily solved.

REFERENCES

Barrett, J., & Roediger, D. (1997, Spring). In between peoples: Race, nationality and the 'new immigrant' working class. *Journal of American Ethnic History*, 16(3), 3–44.

Bellin, J. (2005). *Framing monsters: Fantasy film and social alienation.* Carbondale, IL: Southern Illinois University Press.

Bertellini, G. (2010). *Italy in early American cinema: Race, landscape, and the picturesque.* Bloomington, IN: Indiana University Press.

Bourdieu, P. (1984). *Distinction: A social critique of the judgement of taste.* Cambridge, MA: Harvard University Press.

Bourdieu, P. (1993). *The field of cultural production: Essays on art and literature.* New York, NY: Columbia University Press.

Bourdieu, P., & Wacquant, L. (1992). *An invitation to reflexive sociology.* Chicago, IL: University of Chicago Press.

Calhoun, C., & Wacquant, L. (2002). Social science with conscience: Remembering Pierre Bourdieu (1930–2002). *Thesis Eleven*, 70, 1–14.

Caton, S. (2000). The sheik: Instabilities of race and gender in transatlantic popular culture of the early 1920s. In H. Edwards (Ed.), *Noble dreams, wicked pleasures: Orientalism in America, 1870–1930.* (pp. 98–117). Princeton, NJ: Princeton University Press.

Cavell, S. (1981). *Pursuits of happiness.* Cambridge, MA: Harvard University Press.

Crossley, N. (2008). Social class. In M. Grenfell (Ed.), *Pierre Bourdieu key concepts* (pp. 87–99). Stocksfield, United Kingdom: Acumen Publishing Limited.

Dyer, R. (1997). *White.* London, United Kingdom: Routledge.

Foster, G. (2003). *Performing whiteness: Postmodern re/constructions in the cinema*. Albany, NY: State University of New York Press.

Gambino, R. (1998). *Vendetta: The true story of the largest lynching in U.S. history*. Toronto, Canada: Gernica Editions Inc.

Giroux, H. (1997). Race, pedagogy, and whiteness in dangerous minds. *Cineaste*, 22(4), 46–50.

Grant, M. (1916). *The passing of the great race*. New York, NY: Scribner.

Gunning, T. (1994). An aesthetic of astonishment: Early film and the (in)credulous spectator. In L. Williams (Ed.), *Viewing positions: Ways of seeing film* (pp. 114–133). New Brunswick, NJ: Rutgers University Press.

Higham, J. (1956). *Strangers in the land: Patterns of American nativism 1860–1925*. New Brunswick, NJ: Rutgers University Press.

Jacobson, M. (1999). *Whiteness of a different color: European immigrants and the alchemy of race*. Cambridge, MA: Harvard University Press.

Lasky, J. (1921). Letter to Adolph Zukor. Margaret Herrick Library.

Leider, E. (2003). *Dark lover: The life and death of Rudolph Valentino*. New York, NY: Faber and Faber, Inc.

Maltby, R. (2007). How can cinema history matter more? *Screening the Past*, 22. Retrieved from http://www.screeningthepast.com/.

Maton, K. Habitus. (2008). In M. Grenfell (Ed.), *Pierre Bourdieu key concepts* (pp. 49–66). Stocksfield, United Kingdom: Acumen Publishing Limited.

Motion Picture Magazine. (1921, July 21). Gordon Gassaway, the erstwhile landscape gardener. Interview with Rudolph Valentino. Audio Visual Conservation, Motion Picture and Television. Reading Room, The Library of Congress.

Musser, C. (2004, Fall). Historiographic method and the study of early cinema. *Cinema Journal*, 44(1), 101–107.

Pena Ovalle, P. (2008). Framing Jennifer Lopez: Mobilizing race from the wide shot to the close-up. In D. Bernardi (Ed.), *The persistence of whiteness: Race and contemporary Hollywood cinema* (pp. 165–184). Abingdon, Oxon: Routledge.

Reay, D. (2004). It's all becoming a habitus: Beyond the habitual use of habitus in educational research. *British Journal of Sociology of Education*, 25(4), 431–444.

Richardson, M. (2010). *Otherness in Hollywood cinema*. New York, NY: Continuum Books.

Roediger, D. (2005). *Working toward whiteness: How America's immigrants became white*. New York, NY: Basic Books.

Said, E. (1978). *Orientalism*. New York, NY: Vintage Books.

Schubert, J. (2008). Suffering. In M. Grenfell (Ed.), *Pierre Bourdieu key concepts* (pp. 183–198). Stocksfield, United Kingdom: Acumen Publishing Limited.

Swartz, D. (1997). *Culture and power: The sociology of Pierre Bourdieu*. Chicago, IL: University of Chicago Press.

The Hollywood Reporter. (2017, April 4). Retrieved from https://www.hollywoodreporter.com/heat-vision/ghost-shell-4-japanese-actresses-dissect-movie-whitewashing-twist-990956.

The Hollywood Reporter. (2017, August 28). Retrieved from https://www.hollywoodreporter.com/heat-vision/ed-skrein-exits-hellboy-reboot-whitewashing-outcry-1033431.

Thomson, P. (2008). Habitus. In M. Grenfell (Ed.), *Pierre Bourdieu key concepts* (pp. 67–81). Stocksfield, United Kingdom: Acumen Publishing Limited.

Vera, H., & Gordon, A. H. (2003). *Screen saviors: Hollywood fictions of whiteness.* New York, NY: Rowman & Littlefield Publishers, Inc.

Wacquant, L. (1998). Pierre Bourdieu. In R. Stones (Ed.), *Key sociological thinkers* (pp. 261–277). London, United Kingdom: Macmillan.

Wacquant, L. (2016). A concise genealogy and anatomy of habitus. *The Sociological Review, 64,* 64–72.

Walker, A. (1996). *The same river twice: Honoring the difficult.* New York, NY: Washington Square Press.

3

Ink to Inkling:
Artful Messages in the Visuals of Biology

*Charudatta Navare, Homi Bhabha Centre for Science Education,
Tata Institute of Fundamental Research, Mumbai*

Introduction

The central interest of this book is to understand how visuals not only provide us with what to see but also how they help in constructing the lenses with which we view the social and natural world. As much as this is true for visuals all around us, it is no less so for scientific representations. In this chapter, I focus on the way visual representations in biology contain ideologies within them, and the way they, in turn, help in strengthening these ideologies. I begin this chapter with a brief overview of the tradition of discourse analysis of biological visuals. I will present some examples of ideologies shaping the visual representations, and some examples of visuals fortifying the ideology in turn. I will then describe and expand on the theoretical framework I have used to interrogate biological visuals, namely common coding theory and color psychology. I then present an analysis of a dataset of schematic visuals using the framework. I will conclude with the social implications of this analysis.

Discourse analysis of biological visuals

Studying biology has long involved making intricate and elaborate drawings of biological specimens. Historians of science such as Butterfield (1954) have argued that advances in the fifteenth-century art were vital for the development of modern science, and as such, Renaissance art should be a chapter in the history of science. Renaissance artists such as Otto Brunfels (Sprague, 1928) and Maria Sibylla Merian (Stearn, 1982) created exquisite botanical illustrations, and others such

as Andreas Vesalius (Calkins, Franciosi, & Kolesari, 1999) and Bernhard Albinus (Ford, 2003) created riveting engravings of the human anatomy. In his work on the history of scientific illustrations in the eighteenth century, Ford shows how illustrations emerge from complex forces that range from the need to portray objective reality to the desire to elevate the banal through exaggeration.

In a seminal work, Rudwick (1976) argued for the need of an intellectual tradition that treats visual modes of communication as an important component of scientific knowledge and its understanding. Following that tradition, researchers have analyzed the visual discourse(s) of biology. In analyzing the work of the early botanical illustrators, Kusukawa (2012) describes what he calls a "visual argument in their pursuit of knowledge" that illustrators engaged in. As the botanical illustrators endeavored to depict a "typical" plant, they sometimes disregarded the individual blemishes, merging variations in different plants of the same species to construct a typical plant. Further, they disregarded the structures that they deemed useless. Renaissance sculptor Vincenzo Danti (as quoted in Ackerman, 2002, p. 134) perfectly captures the motivation of the illustrators' attempts when he notes thus: "The difference [...] between imitation and il ritrarre [simple copying] will be that the latter presents things perfectly as they are seen and the other perfectly as they ought to be seen." Daston and Galison (1992) beautifully demonstrate how the epistemic virtues such as objectivity permeated scientific illustrations, and how the conception of objectivity itself changed from the eighteenth to the twentieth century. While seventeenth-century scientific image-makers attempted to present the "typical" or "ideal" or "characteristic" specimens (and each term denotes a different approach to creating illustrations), the idea of mechanical objectivity emerged in the nineteenth century. With the advent of technology such as photography, the creation of scientific images became possible with seemingly little human intervention.

Twentieth-century scientists began to increasingly feel the necessity of interpretive eyes while creating scientific images. The new ideal of "trained judgment" began, not to replace, but to supplement the idea of mechanical objectivity. Scientists using trained judgment were more concerned with discerning patterns rather than attempting to extract the "typical" or "perfect" specimens from the observed ones.

If observational illustrations (illustrations of objects or phenomena observed directly by the human eye) are fraught with the tension between showing what an object *is* and how it *looks*, illustrations inferred from other kinds of data are much more so. An attempt to showcase "the larger truth" in paleontological illustrations for instance is reported by Northcut (2011). Northcut describes a case in which an illustrator believed that gaps in the teeth of the dinosaur Tyrannosaurus rex would be expected. This was because of her knowledge that T. rex often lost teeth

during violent fights, and a new set of teeth replaced old ones once every few years. On the insistence of the client, however, the illustrator finally portrayed T. rex as having a full set of external teeth, prioritizing the aesthetic taste and "social facts" (as Northcut calls them) of the dinosaur's ferociousness over scientific accuracy. Gifford-Gonzalez (1993) and Wiber (1994) report similar "social facts" guiding illustrations of prehistoric human life. They comment that most illustrations of ancient human life portray men and women in traditional gender roles, rather than being informed by the rich ethnographic or archaeological research which provides evidence of the fact that division of labor in prehistoric societies was not as rigid as in contemporary ones. Such illustrations contain and reflect traditional gender ideologies of their makers and then further serve to reinforce these ideologies by making them seem historically continuous and natural.

However, visuals in biology are not restricted to seemingly realistic illustrations of natural specimens, drawn either through observation or imagination or a combination of both. Schematic depiction of entities and phenomena forms a significant part of representational practices in biology. Evolutionary biologist Stephen Jay Gould (1992, p. 171) has remarked that "scientific illustrations are not frills or summaries; they are foci for modes of thought." This is particularly true of illustrations of the cellular and molecular realms that depict phenomena inaccessible to direct observation, such as diagrams showing antibodies binding to antigens. Cambrosio, Jacobi, and Keating (1993; 2005) report how Nobel laureates Paul Ehrlich's and Linus Pauling's pictorial models of antibodies served as a crucial part of their argumentation process during the decade-long debates about the existence and characteristics of these newly hypothesized entities. Ehrlich first used these drawings (see Figure 3.1) in the prestigious Croonian Lecture before the Royal Society in 1900. As Cambrosio and coauthors show, these drawings played a vital role in establishing antibodies as being responsible for immune response. While some other immunologists believed that the immune reaction is an emergent property of blood serum, Ehrlich hypothesized antibodies as *material entities* that mounted a response against infectious agents. Ehrlich's drawings, by the very process of representing "antibodies," also defined these entities at the same time. The graphical representation of antibodies, in other words, served as ideograms (Fleck, 2012, p. 137), "in which meaning is represented as a property of the object illustrated." This immunological imagery played a pivotal role in establishing the ontological status of antibodies as material entities.

Diagrams were crucial rhetorical devices for Linus Pauling's template theory of antibody formation as well (Cambrosio et al., 2005). According to Pauling, antibody structure is nonspecific and is molded into a shape complementary to the antigen molecule after their encounter. Both Pauling and Ehrlich made liberal use of comic strip-like time-series visual narratives to present their theories, in

FIGURE 3.1: One of Paul Ehrlich's drawings, depicting his theory of antibody formation. Proceedings of the Royal Society of London. Credit Wellcome Collection. Reproduced under creative commons license Attribution 4.0 International CC BY 4.0.

stark contrast to some of their contemporaries who used only tables or chemical equations. Cambrosio et al. explain how the hypothetical mechanism postulated by Pauling got converted to a concrete mechanism when it was rendered into a series of diagrams. Through the diagrams, chemical entities of immunology were given a "stable shape and a frozen, simplistic visual identity—and readers were able to follow their transactions and interactions without difficulty" (Cambrosio et al., 2005, p. 124).

Since schematic depictions are a powerful means of visual argumentation and persuasion, they also carry the potential of steering the direction of scientific research. This is illustrated in the scientific journey of a prion, the hypothesized causative agent of fatal disorders like Kuru and "mad cow" disease that affect the nervous systems of many animals. Reeves (2011) describes how rhetorics, both visual and verbal, were instrumental in establishing the scientific community's belief in the depicted mechanism of prions that induced diseases and in influencing the field of research on this class of diseases. During the 1980s, the cause of such disorders was fiercely contested among scientists, particularly between two labs. One lab took the usual scientific route of using highly technical terms and complicated electron micrographs to describe the disease in specialized journals. In contrast, the other lab started promoting a single hypothetical causative agent called prion with simple visual and verbal rhetoric in less specialized journals and wider popular science forums as well. In a vein similar to Ehrlich's antibodies, the second lab constructed a simple hypothesized agent, the infectious prion, and promoted a simple visual schematic using "only squares and circles and a more streamlined, linear process" (Reeves, 2011, p. 260) in which infectious prions converted normal prion proteins into infectious prions by inducing a change in their structure. The prion theory gained prominence, in part, because it was illustrated as a story of a single agent which followed a straightforward process, and it soon found its way into textbooks and wider scientific and public spheres. But despite the enthusiastic acceptance, Reeves notes that three decades of research has not brought about strong experimental evidence to support the prion theory. Since mutations are generally understood to occur at the level of DNA, prion researchers (Angers et al., 2010; Supattapone, 2010), too, have acknowledged the lack of experimental proof for how a protein-only agent (the prion) is able to mutate and infect other proteins. But despite convincing empirical evidence for this material species and its role in causing the disease, the simplicity of this model coupled with powerful visual packaging helped to establish the scientific community's belief in this entity and channel resources toward its study.

Pictorial models serve as a tool for visual argumentation and persuasion; however, these models can also be restricted by the popular imagery, thus restricting the imagination enabled by them. Emily Martin (1991) writes about the discourse

on human fertilization as a "scientific fairy tale" (p. 486). Male and female reproductive physiologies, in this discourse, are cast in different lights. She observes that while researchers marvel at the feat of production of millions of sperm cells every day, female reproductive physiology is often seen as wasteful. Menstruation is described as "debris", and the production of monthly egg that eventually degenerates is seen as excessive. The biases in representing the male and female reproductive cells in scientific texts as well as visuals have also been noted by Metoyer and Rust (2011) who performed a content analysis of gynecology textbooks and reached similar results. Martin further talks about the trope—of a male's single-minded pursuit of a coy female—existing in the scientific discourse on fertilization as well. The imagery on fertilization alludes to the sperm being the active entity, and the egg being a passive participant. This conceptualization is reinforced by images of fertilization that show many sperm swimming toward and surrounding a seemingly passive egg. Such a simplistic pictorial/graphical model appeals to the cultural values of scientists and laypeople alike and its interpretations are limited by popular norms of female and male behavior. The overarching paradigm of research on fertilization laden with cultural notions of gender, then, determines what kind of questions are asked, which interpretive frameworks are referred to, and what could be the acceptable answers to those questions—all of which, until recently, took the agency of the sperm over the egg for granted.

Recent research has elucidated mechanisms by which the egg performs an active role in fertilization, implying that mutual interactions between sperm and egg play a crucial role in the fertilization process (Nadeau, 2017). The female reproductive system, more active than previously thought, and its accompanying imagery then create the possibility of generating new questions for research, and steering social discourse on gender. New research questions and their findings might present a less stereotyped evaluation of female body parts and functions, and capture the active contribution of the egg during fertilization. This would lend "scientific" credence to positive views on women and their roles in social processes. While images that depict such understandings of the reproductive processes are far fewer in the popular discourse, those which do so are markedly different from typical illustrations in how they represent the egg and the sperm, as I will show later.

While metaphors that are repetitively and extensively used are conventionally called "dead" metaphors, Martin (1991) has used the term "sleeping" metaphors to describe them. She advocates for "waking" up such sleeping metaphors by becoming cognizant of their implications. She believes this will lead to the metaphors losing their power to naturalize our stereotypes. In the same vein, I would argue that we need to "wake up" the implicit messages that scientific visuals contain. Diagrams and illustrations in science are not innocent, transparent appendages to verbal parts of a scientific text. They are employed to make an

argument and to persuade the reader. Cambrosio et al. (2005) write that visuals in science superimpose and intertwine two distinct stages of the argumentative process: the constitution of a common frame of reference and imposition of one's point of view. And we can see that both these stages allow for a range of meanings and values to be shared between the scientific visual, its creator, and the reader in a way that is not apparent immediately. Therefore, it is an important task to study scientific visuals more closely and decode the latent messages they carry. In this paper, I build on the research on illustrations of the virtual realm described above, by undertaking an analysis of the images of prions, antigen-antibodies, and egg-sperm interactions in popular biology textbooks as well as in online educational resources. I particularly focus on probing the elements of illustrations—their shapes, colors, and dynamicity—for their rhetorical effects, their hidden meanings, and implicit biases they carry. Before turning to the analysis, I will briefly highlight the frameworks that I used to analyze the rhetorical effects the elements of visuals can produce.

Making sense of visuals: Theoretical framework

The way we perceive and then make meaning out of visuals is complex and can be nonintuitive, especially the enactive and embodied aspect of perception. Delineating the way perception and understanding of visuals happen is important for analyzing the visual rhetoric of biology. The enactive view of cognition argues that perception depends upon an organism's capacities for action and thought (Noë, 2004). This would mean that perception is grounded in action (and vice versa). To understand this enactive view of perception, I specifically use the framework of common coding theory from cognitive psychology. The common coding theory posits common neural coding for perception, action, and imagination (Prinz, 1997). The rationale for the theory comes from evolutionary and ecological psychology, where organisms are thought to be primarily action systems.

Evidence for common coding of perception, action, and imagination comes from a myriad of phenomena. The first set of evidence comes from the finding that activating one modality (say, observation) in the brain activates the other (perception), a phenomenon known as associative priming. To study the link between action and observation, Calvo-Merino, Glaser, Grèzes, Passingham, and Haggard (2005) conducted fMRI studies of classical ballet dancers, capoeira dancers, and nondancers watching ballet or capoeira movements. Both these styles of dances include a set of distinctive movements that would be in the personal motor repertoire of dancers trained in those styles. The ballet dancers watching ballet showed activation of mirror areas in the brain, and this effect was more pronounced than

the one seen when capoeira dancers or nondancers watched the ballet. Mirror neurons activate when we perform an action as well as when we observe the same action being performed. The mirror system is thus a specific brain mechanism underlying the link between action, observation, and simulation. Activation of mirror areas in ballet dancers while watching ballet suggests that we integrate others' actions with our own motor repertoire, and we understand these actions by motor simulation.

Another set of evidence for common coding theory comes from the way actions in one modality interfere with another. These interference effects are measured through the increase in reaction time or the reduction in the accuracy of a task. Taylor, Witt, and Grimaldi (2012) studied participants' arm movements while they watched paintings having discernible brushstrokes. The participants were asked to swipe either leftward or rightward depending on the color of the painting—red or green. In other words, the task did not involve consciously thinking about the brushstrokes. The researchers nevertheless found that participants' reaction times increased while performing actions that were in the reverse direction of the observed brushstrokes. Looking at painted (static) brushstrokes thus leads the observers to simulate the actions that created the painting unconsciously, and it interferes with their ability to perform incompatible actions. Interestingly, this effect was not seen when the participants observed artificially (digitally) created brushstrokes that retained the visual characteristics of a typical brushstroke (thick at one end and tapering at the other) but lacked gestural information.

Motor cognition researchers have noted that the curvature and velocity of hand movements are related, the relationship described as the two-thirds power law (Viviani and Stucchi, 1992). Implicit knowledge of this relationship allows readers to judge the speed with which something is drawn based on the curvature information, and vice versa. An interesting prediction relevant to making sense of visuals is that people might be attributing character traits to cartoons partly through motor simulations. Chandrasekharan, Mazalek, Nitsche, Chen, and Ranjan (2010) argue that when people look at drawings, they mentally simulate the motion that generated the drawing, and they might then be associating this motion with the character traits of the cartoon. They compare the case of Charles Schulz's Charlie Brown and Bill Watterson's Calvin to elucidate their point. It is easier for people to believe that Charlie Brown, who can only be drawn using slow, careful strokes, is a "good boy." People are therefore more likely to ascribe to him behavioral traits like folding clothes and keeping them neatly in the wardrobe or explaining things clearly. Drawing Bill Watterson's Calvin, on the other hand, needs fast strokes, and the authors report that the people looking at the cartoon tend to think of him as an impatient kid, who is more likely to make a lot of hand gestures while talking, or someone who would jump traffic lights. The relationship between brush/pencil

strokes and character traits and personality of drawn objects which makes inert diagrams dynamic then becomes useful to understand how diagrams of scientific objects are layered with behavioral expectations.

A related phenomenon called the Kiki-Bouba effect is described by Ramachandran and Hubbard (2001). When presented with one shape that is pointed and another that is more rounded, and asked which one of these shapes would be called "kiki" and which would be called "bouba," people tend to say that the more pointed shape is kiki and the more rounded one is bouba. This nonarbitrary mapping between shape and sound, Ramachandran and Hubbard believe, exists because the sharp changes in trajectory in the pointed shape are similar to the sharp sounding nature of the word "kiki." They argue that there could be natural constraints on how we map sounds to objects, and these constraints might have played a role in the evolution of proto-language. I will argue that these mappings between different modalities as well as the dynamics that underlie static drawings provide important insights for the study of visual rhetoric.

Another theoretical framework I use for discourse analysis of visuals in biology is color psychology. Colors have meanings in as much as they are interpreted differently, and as their meanings and associations vary with cultures and contexts. Here I briefly survey the different ways to represent and describe colors and then discuss the literature on color psychology.

Color temperature is often used to describe color characteristics of light, either warm (yellowish/reddish) or cool (bluish). MacEvoy (2015) believes that diurnal or climatic changes in illumination give rise to the warm/cool contrast—blue and gray mimic the colder effects of winter/evening, while yellow and red remind us of summer or sunny days. Warmer colors thus seem more cheerful and active, while cooler colors seem dull and gloomy. Although conventional wisdom in art discourse describes colors using this warm/cool contrast, there is no agreed-upon definition for the parameter upon which colors should be considered warm or cool.

Another way to represent colors is the RGB representation common in digital mapping. RGB representation is a Euclidean mapping of colors, with values of red, green, and blue on each axis (see Figure 3.2). Although it is the most convenient method to represent colors digitally, it is not the most intuitive method for humans to understand or represent colors. It is hard to talk about differences in how color is perceived using this representation. I, therefore, use Hue Saturation and Value (HSV) representation for my discussion. Unlike RGB, HSV mapping is a cylindrical mapping of colors (see Figure 3.2). Hue is the angle variable, which represents the chroma of the color. Saturation is the radial variable, which represents the range of gray in the color space. Value is the height and represents the brightness of the color. The advantage of using HSV color mapping is that we get perceptually linear gradients (Silverberg, 2018). For example, keeping one axis

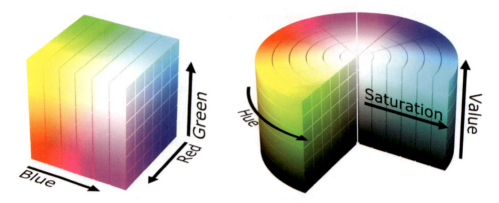

FIGURE 3.2: RGB color model represented as a cube (on the left), and Hue, Saturation, and Value represented as a cylinder (on the right). Images from Wikimedia Commons, represented here in grayscale. Credits SharkD. Reproduced under Creative Commons Attribution-Share Alike 3.0 Unported license.

fixed, lines parallel to the other two axes do not lead to anything describable in RGB mapping. However, in HSV mapping, constant contours are perceptually linear. For example, by keeping Saturation and Value fixed, we can vary the chroma systematically. By keeping the Hue and Saturation fixed, we can sift through the brightness. Hue, the angular dimension, can be divided into four quadrants. The red primary starts at 0°, the green primary at 120°, and the blue primary at 240° which morphs back to red at 360°. The first and fourth quadrants, therefore, contain reddish hues, and the second and third quadrants the bluish and greenish ones. The central vertical axis comprises neutral, achromatic, or gray colors.

There is a vast literature on colors and their meanings, both on the universal nature of color perception and on culture-specific differences in the meanings associated with colors. Color psychology attempts to study how colors affect human perception and behavior. Some of the early work on color psychology has often reported contradictory findings, owing to the complexity of the topic as well as to the methodological issues identified by researchers such as Elliot and Maier (2014), and Mehta and Zhu (2009). A key methodological issue in early studies was the failure to take into account that color is composed of multiple attributes (hue, saturation, and brightness). Each of these attributes can affect the variable to be assessed, so only one of them should be allowed to vary in a well-controlled experiment. Another methodological issue in studies on the association of colors with performance in cognitive tasks is disregarding the nature of the tasks. Mehta and Zhu (2009) suggest that colors might be activating different motivations, and thus the same color might be enhancing performance in some types of cognitive tasks while hindering performance in others. They found that the color red induces

avoidance rather than approach motivation, while blue color primarily induces the approach motivation. Also, red color facilitated performance in a detail-oriented task as against a creative task, while blue color facilitated performance in creative tasks rather than detail oriented ones. Moller, Elliot, and Maier (2009) report that US undergraduate students were faster in categorizing failure words presented in red than those presented in green (or white). Similarly, they were faster in categorizing words related to success presented in green as against red (but not white). Their study measured reaction times rather than self-reported emotional or meaning association. They found red to be generally associated with failure and negative words, while green was associated with success and positive words. Kaya and Epps (2004) report similar findings when studying the association between colors and (self-reported) emotional response among US college students. They found green and yellow colors to be most often associated with positive emotions, while red and purple to be most often associated with negative emotions. In the same study, the white color was seen to be most often associated with positive emotions among the achromatic colors (e.g., white, black, gray), while gray was most often associated with negative emotions. Color influences meaning through learned association too. The color green might be associated with positive emotions through its association with nature, while red color might be associated with negative emotions through its association with blood.

The frameworks described above are particularly relevant for researchers of visual rhetoric, as illustrators might have implicitly been using these ideas about shapes and colors for a long time, thus superimposing a layer of emotions and attributes onto otherwise simple and straightforward drawings. Bang (2000), for instance, ponders over how one would tell the story of the Little Red Riding Hood just by using simple shapes and colors and thus makes some of these ideas explicit. Bang, who is herself an illustrator, takes the readers through this process by trying out different choices of colors and shapes and simultaneously explaining her reasoning for these choices. She chooses to have a darkened background and high triangular trees leaning toward Little Red to show the sense of fear that Little Red feels in the forest. Bang opts to depict Little Red as a small red triangle that looks alert and warm, while her mother as a bigger triangle with rounded off edges, the shape that seems "huggable" and motherly. Bang picks a pale purple color for the mother, so as not to take the attention away from the protagonist. The Big Bad Wolf is equipped with sharp glistening white teeth, protruding red tongue, and slit-like red eyes pointed at Little Red, making him appear frightening and ravenous. Scientific illustrators, too, then might be mobilizing these connections between shapes and colors on the one hand and meanings and values on the other in their illustrating process, thereby injecting a range of cultural meanings, emotions, and values into otherwise seemingly objective, value-free scientific diagrams. The

choice of a particular shape and color for a part of an illustration then becomes a site where subjective, contextual values enter the (visual) discourse of science.

Therefore, in this chapter, I combine insights from common coding theory, which contends that an action and its perception are encoded in the same neural pathways, and from color psychology, which provides the theoretical space for meanings and interpretations to be attached to colors. Together common coding theory and color psychology render static illustrations dynamic; they allow the values (personal, social, cultural, and institutional), learnings, and ideologies of the scientists and the illustrators to be subtly communicated to the viewers. In other words, the whole illustration is more than the sum of its parts. Whether a component is rounded or sharp, whether it is red or gray conveys not only its role in the illustrated process, but also its significance, its worth, and how the scientific community (and the illustrator) looks at and values that entity and its contribution.

Methodology

Sample

To discern how ideology is communicated through schematic visuals in biology, I decided to look at commonly accessible images of interactions between infectious and normal prions, antigen-antibodies, and egg-sperm. I selected 55 images from popular biology textbooks such as *Molecular Biology of the Cell* by Alberts et al. (2002), and *Biology: Exploring Life* by Campbell, Williamson, and Heyden (2006) as well as from educational websites (five images each from *.org, *.edu, *.gov sites and five from popular biology textbooks) to create a dataset of visuals in biology. The dataset included twenty images of antigen-antibody interaction, seventeen images of infectious and normal prion interactions, and eighteen images of egg-sperm interactions during fertilization (less than five visuals from textbooks for prions and fertilization diagrams showing egg and sperm were chosen as these were less frequent in the popular textbooks than antigen-antibody diagrams).

Analysis

Using the methodology of discourse analysis of visuals described by Rose (2016), I studied the shapes of biological components through the lens of common coding theory and their colors through the lens of color psychology. I analyzed the textual discourse associated with the image as well. Rose notes that intertextuality, the way the meaning of any image or text depends on the meanings carried by other

FIGURE 3.3: An example image showing the interaction between normal prion protein, shown using green circles, and infectious prion protein, depicted using red spiked circles. Image from Wikimedia Commons. Credits Tecywiz121. Image under the public domain, represented here in grayscale.

texts and images, is important in discourse analysis. I, therefore, attempted to connect the visual rhetoric to the larger societal discourse.

Results

Analysis of shapes

Among the schematic diagrams of prions in the dataset where both infectious and normal prions were shown, nine out of ten used more pointed shapes for infectious prions and less pointed shapes for normal prions. The remaining one diagram used the cylindrical shape to depict both kinds of prions. While depicting normal prions, it

VISUAL FUTURES

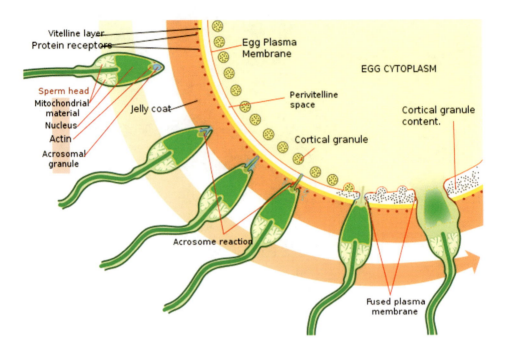

FIGURE 3.4: A typical diagram of fertilization. Figure under the public domain, adapted from Wikimedia Commons. Reproduced here in grayscale. Credits LadyofHats.

used straight lines to connect the base of the cylinder to its top. On the other hand, while depicting infectious prions, the diagram used wavy lines—lines that would be produced not by careful movements, but by fast strokes, possibly attributing more active character to the infectious prions. Given that in the corresponding textual discourse infectious prions are much more frequently referred to as the active entity than normal prions (twelve out of seventeen times infectious prions were clearly the active entities, while five out of seventeen used neutral language), the use of pointed shapes for infectious prions reinforces the active nature of prions and buttresses the hypothesis that prions are the causative agents in diseases like TSE.

A similar case is with the antigen-antibody diagrams, where the shape of twenty out of twenty antibodies were more pointed mostly looking like the shape "Y," while the antigen or the target cell had less pointed structures. Antibodies are also depicted using smaller shapes, making them look less bulky and more mobile. In the textual discourse, antibodies are much more frequently referred to as the active entity than antigens—fourteen out of twenty times antibodies were the subject in the sentences in the accompanying text (image title and caption), while only once was the antigen the subject. Five of twenty captions used neutral language. Given this pattern in the textual discourse, it can be seen that the illustrations are

reinforcing this message through the use of pointed shapes and short straight lines for antibodies. In other words, they showed shapes that would be generated using faster strokes while drawing. A point to note here is that not all these drawings were hand-drawn. Some drawings were digitally drawn as well. For the present purpose, however, I would argue that it matters less about the actual velocity of the digital or hand-drawn brushstroke, but more what the velocity would be if the shape was hand-drawn. An illustrator working with digital tools would find it more aesthetically pleasing to choose a pointed shape to depict a character with more agency in the same way as it will take faster strokes when those shapes are drawn by hand. Thus in light of the ideas of common coding theory described earlier, the pointed shapes could lead to the attribution of more agency to the antibodies, as compared to antigens, underscoring that antibodies are more important units in human physiology than antigens. The visuals, by synecdoche, construct the narrative of the immune system's triumph over the "invading" microbes.

For egg-sperm interactions, the captions of nine (out of sixteen) images suggested that the sperm were the subjects of the sentences and that they were the active entities, while only one caption suggested that the egg was an active entity. Eight images carried captions with neutral language. As for the shapes of the entities, thirteen out of sixteen showed sperm heads as pointed. This is significant, given that the normal human sperm has an oval head shape (Huser, Orme, Hollars, Corzett, & Balhorn, 2009). An interesting case differing strikingly from this pattern is from an article called "Choosy Eggs May Pick Sperm for Their Genes, Defying Mendel's Law."[1] The article describes the agency that the egg has, and the illustration can, therefore, be seen as the proverbial exception that proves the rule. The illustration uses hand-drawn pointed shapes to depict the female reproductive system while showing sperm heads using round shapes.

The use of pointed shapes and the suggestion of implicit motion in sperm can lead to the viewer's attributing agency to the sperm. This depiction provides support for Vienne's (2018) observation about "premodern" ideas subtly persisting through visual representations of fertilization. The visual rhetoric created thus can reinforce the active role of sperm that the textual discourse suggests. By synecdoche, the narrative can further lend credence to existing gender ideologies that men and their organs or bodily processes are more active, energetic, aggressive, and causally significant while women and the female body parts or processes are passive, recipient, and subservient.

Analysis of colors

I report the analysis of images in which both the components had non-achromatic colors. For prions, among thirteen of such images, eight showed infectious prions

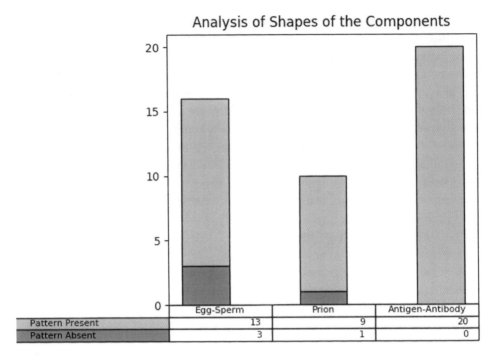

FIGURE 3.5: Analysis of shapes of the components. "Pattern" refers to antibodies, sperm, or infectious prion being depicted using more pointed shapes than antigen, egg, or normal prion protein.

having hues falling in the red quadrants and normal prions having hues falling in green quadrants. Five images showed hues of infectious prions falling in the same quadrant as the normal prion, and in those images, the differences in the two kinds of prions were depicted with the use of added structures instead of different color shades or brightness levels. In the case of illustrations depicting antigen-antibody interactions, the shapes and sizes of these molecules offer stronger contrast than their colors. Nonetheless, eight images (out of fifteen) showed antigens having hues falling in the red quadrants and antibodies having hues falling in green quadrants, while only one showed the opposite. Six images showed antigen having hues in the same quadrant as the antibody. In such illustrations, the antigen-binding site of the antibody is shown brighter than the rest of the antibody to highlight the site of action. The antigen is bigger in ten out of fifteen images and is of a solid color. The short and multiple antibodies are variously depicted as solid wholes or drawn as colored sticks.

An interesting use of color shades and brightness levels is seen in the images of egg-sperm interactions. Of these illustrations (sixteen), six showed the egg having

hues in the red quadrants and sperm having hues in the green quadrants, and only one image showed the reverse. Nine showed egg having hues in the same quadrants as that of the sperm. The hues of the human egg are mostly shown to lie in the red quadrants, even though it is yellow as are the yolk sacs of mammalian eggs. Even when the colors of both the egg and the sperms lie in the same quadrant, the egg is either off-center or occupies so much space that it becomes a second layer of the background—thus foregrounding the sperms and impressing upon the reader their causally significant motion. In such images, the outer tip of the sperms is brighter than the inner layer which directs the attention to their pointed heads and thus creates a sense of movement and agency.

The preponderance of red hues in infectious prions and antigens is likely because of the danger they might pose, and the color is probably invoking the avoidance motivation. The preponderance of red quadrant hues in showing eggs is more puzzling. Is it because of its association with menstruation and blood? Or is it consistent with Martin's analysis (1991) of male reproductive physiology being evaluated in a positive light in the textual discourse while the female reproductive physiology being treated in the opposite manner, as dirty and dangerous or foreign and suspicious? A definitive answer to this question is unlikely, owing to the cultural variations in the meanings associated with a given color, as well as a myriad of other ways in which colors can be selected.

Discussion

By analyzing the sense of dynamics that underlie static biological diagrams, I argue that visuals carry values and ideologies within them in subtle ways. The lines and shapes of particular components seem to suggest motion and agency, while those of others do not. The entity, which is supposed to be active according to the verbal discourse ("sperm penetrates the egg," "antibody binds to an antigen") often is narrow, has a pointed or spiked shape, while the "passive" agent is bigger, has a rounded shape. The illustrator's choice of implicit motion for particular objects thus suggests agency and by extension, the significance accorded to it in the scientific discourse (or the lack thereof). The line strokes, shapes, and colors serve a rhetorical function in constructing visual narratives.

This kind of analysis affords us a chance to appreciate how visuals in biology or in science, too, exist between the delicate space of structure and agency, between encoding and decoding. It enables us to reflect on how visuals can depict only a certain range of meanings whose inflections are fixed by the overarching ideology of the scientist or the illustrator, both of whom are a part of the prevailing scientific discourse. This opening up of the visual-discursive space also allows us

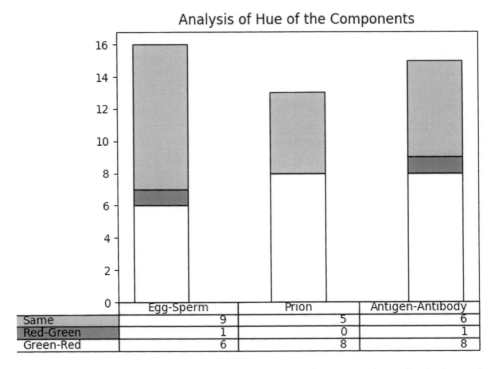

FIGURE 3.6: Analysis of hue of the components. (Legend: Green-Red—antibodies/normal prion/sperm hues in green quadrants, antigen/infectious prion/egg hue in the red quadrants; Red-Green—antigen/infectious prion/egg hue hues in green quadrants, antibodies/normal prion/sperm in the red quadrants; Same—Hues of both the components either in green or red quadrants.)

to understand how tinkering with the creation of visuals has emancipatory or resistive potential from reigning ideologies which govern who can be an agent and who is not. Such decisions have consequences for which entities are studied in more scientific detail and subsequently in the investigation of whose properties and behavior on which more human and economic resources are spent. In other words, this kind of analysis also has the potential to generate new hypotheses and ideas that can be taken up for scientific investigation.

Embodied view of perception generates a host of questions relevant to the study of visual discourse too. What are the ways in which understanding visuals can be embodied? Would making sense of metaphors that allude to imagery also be embodied? What implications would enactive view have for studying socioscientific or sociocultural visual discourse? What rhetorical functions do the components of images serve? How do these compare with the illustrators' explicit intended message? These are some exciting questions that I hope further research

can answer. These answers can take the study of the visual discourse of science forward into yet uncharted territories.

There is, therefore, a need to analyze the wider presence of visual messages in the discourse of science, in addition to the analysis of verbal messages. Like I have illustrated, analyzing shapes through the lens of common coding theory and analyzing colors through the lens of color psychology might lead to valuable insights. The present study found a possible association between the shape of the components and their suggested agency, and between the color of the components and their hinted origin. Implications of the study, therefore, exist for rhetoric studies—rhetoric scholars need to pay closer attention to these associations, and how persuasion can be done in subtle ways through these connections. Educational resources can be designed to exploit this link as well.

As Fox Keller (2003) reminds us, colloquialism of visual metaphors for knowledge and understanding is abundant—"picture this," "I see," "focus on," "drawing on a concept," "illustrating a concept," "fuzzy idea," "point of view," and so on. Messages conveyed through visuals can be part of a pervasive cycle, where those messages can be reinforced in the next iteration, effectively multiplying the message. Science communicators and educators need to be aware of the implicit messages that images carry and should make informed choices about which messages they want to be received. For effective communication, there also needs to be a diversity of visuals as well as of messages and values. As novelist Chimamanda Ngozi Adichie eloquently observed in her TED talk, "The single story creates stereotypes, and the problem with stereotypes is not that they are untrue, but that they are incomplete. They make one story become the only story" (2009, 13:01).

Acknowledgments

I would like to thank the editors of this book, Tracey Bowen and Brett R. Caraway, and the anonymous reviewers for their helpful suggestions. I am grateful to Sugra Chunawala, Sanjay Chandrasekharan, and Deepika Bansal for their incisive comments on earlier drafts. The research for this chapter was supported by the Department of Atomic Energy, Government of India, under Project Identification No. RTI4001.

NOTE

1. The article and the illustration can be accessed at https://bit.ly/eggs-pick-sperm.

REFERENCES

Ackerman, J. S. (2002). *Origins, imitation, conventions: Representation in the visual arts*. Cambridge, MA: MIT Press.

Alberts, B., Johnson, A., Lewis, J., Raff, M., Roberts, K., & Walter, P. (2002). *Molecular biology of the cell* (4th ed.). New York, NY: Garland Science.

Angers R. C., Kang H., Napier D., Browning, S., Seward, T., Mathiason, C., Balachandran, A., McKenzie D., Castilla, J., Soto, C., Jewell, J., Graham, C., Hoover, E. A., & Telling G. C. (2010). Prion strain mutation determined by prion protein conformational compatibility and primary structure. *Science*, *328*(5982), 1154–1158.

Baldasso, R. (2006). The role of visual representation in the scientific revolution: A historiographic inquiry. *Centaurus*, *48*(2), 69–88.

Bang, M. (2000). *Picture this: How pictures work*. London, United Kingdom: Little, Brown & Company.

Butterfield, H. (1954). Renaissance art and modern science. *University Review*, *1*(2), 25–37.

Calkins, C. M., Franciosi, J. P., & Kolesari, G. L. (1999). Human anatomical science and illustration: The origin of two inseparable disciplines. *Clinical Anatomy*, *12*(2), 120–129.

Calvo-Merino, B., Glaser, D. E., Grèzes, J., Passingham, R. E., & Haggard, P. (2005). Action observation and acquired motor skills: An FMRI study with expert dancers. *Cerebral cortex*, *15*(8), 1243–1249.

Cambrosio, A., Jacobi, D., & Keating, P. (1993). Ehrlich's "beautiful pictures" and the controversial beginnings of immunological imagery. *Isis*, *84*(4), 662–699.

Cambrosio, A., Jacobi, D., & Keating, P. (2005). Arguing with images: Pauling's theory of antibody formation. *Representations*, *89*(1), 94–130.

Campbell, N. A., Williamson, B., & Heyden, R. J. (2006) *Biology: Exploring life*. New York, NY: Pearson Prentice Hall.

Chandrasekharan, S., Mazalek, A., Nitsche, M., Chen, Y., & Ranjan, A. (2010). Ideomotor design: Using common coding theory to derive novel video game interactions. *Pragmatics & Cognition*, *18*, 313–339.

Daston, L., & Galison, P. (1992). The image of objectivity. *Representations*, *40*, 81–128.

Ehrlich, P. (1900). Diagrams illustrating the side-chain theory of antibody formation. Proceedings of the Royal Society of London. Wellcome Collection Gallery. Retrieved from https://wellcomecollection.org/works/bren2n3n.

Elliot, A. J., & Maier, M. A. (2014). Colour psychology: Effects of perceiving colour on psychological functioning in humans. *Annual Review of Psychology*, *65*, 95–120.

Fleck, L. (2012). *Genesis and development of a scientific fact*. Chicago, IL: University of Chicago Press.

Ford, B. (2003). Scientific illustration in the eighteenth century. In R. Porter (Eds.), *The Cambridge history of science* (Vol. 4) (pp. 561–583). Cambridge, MA: Cambridge University Press.

Gifford-Gonzalez, D. (1993). You can hide, but you can't run: Representations of women's work in illustrations of palaeolithic life. *Visual Anthropology Review, 9*, 22–41.

Gould, S. J. (1992). *Bully for brontosaurus: Reflections in natural history*. New York, NY: W. W. Norton & Company.

Huser, T., Orme, C. A., Hollars, C. W., Corzett, M. H., & Balhorn, R. (2009). Raman spectroscopy of DNA packaging in individual human sperm cells distinguishes normal from abnormal cells. *Journal of Biophotonics, 2*(5), 322–332.

Joyce, K. (2005). Appealing images: Magnetic resonance imaging and the production of authoritative knowledge. *Social Studies of Science, 35*, 437–462.

Kaya, N., & Epps, H. (2004). Relationship between colour and emotion: A study of college students. *College Student Journal, 38*(3), 396–406.

Keller, E. F. (2003). *Making sense of life: Explaining biological development with models, metaphors, and machines*. Cambridge, MA: Harvard University Press.

Kusukawa, S. (2012). *Picturing the book of nature: Image, text, and argument in sixteenth-century human anatomy and medical botany*. Chicago, IL: University of Chicago Press.

LadyofHats (2006, April 11). Diagram that shows the steps of an acrosome reaction as it happens in the Sea Urchin. Wikimedia Commons. Retrieved from https://commons.wikimedia.org/wiki/File:Acrosome_reaction_diagram_en.svg.

MacEvoy, B. (2015, August 1). Color temperature. *Handprint*. Retrieved from www.handprint.com/HP/WCL/color12.html.

Martin, E. (1991). The egg and the sperm: How science has constructed a romance based on stereotypical male-female roles. *Signs: Journal of Women in Culture and Society, 16*(3), 485–501.

Mehta, R., & Zhu, R. J. (2009). Blue or red? Exploring the effect of colour on cognitive task performances. *Science, 323*, 1226–1229.

Metoyer, A. B., & Rust, R. (2011). The egg, sperm, and beyond: Gendered assumptions in gynaecology textbooks. *Women's Studies: An Interdisciplinary Journal, 40*, 177–205.

Moller, A. C., Elliot, A. J., & Maier, M. A. (2009). Basic hue-meaning associations. *Emotion, 9*(6), 898–902.

Nadeau, J. H. (2017). Do gametes woo? Evidence for their nonrandom union at fertilization. *Genetics, 207*, 369–387.

Ngozi, A. C. (2009, October 7). *The danger of a single story* [Video]. TED. Retrieved from https://www.ted.com/talks/chimamanda_ngozi_adichie_the_danger_of_a_single_story?language=en.

Noë, A. (2004). *Action in perception*. Cambridge, MA: MIT press.

Northcut, K. M. (2011). Insights from illustrators: The rhetorical invention of paleontology representations. *Technical Communication Quarterly, 20*, 303–326.

Prinz, W. (1997). Perception and action planning. *European Journal of Cognitive Psychology, 9*, 129–154.

Ramachandran, V. S., & Hubbard, E. M. (2001). Synaesthesia—A window into perception, thought and language. *Journal of Consciousness Studies, 8*(12), 3–34.

Reeves, C. (2011). Scientific visuals, language, and the commercialization of a scientific idea: The strange case of the prion. *Technical Communication Quarterly, 20*, 239–273.

Rose, G. (2016). *Visual methodologies: An introduction to researching with visual materials* (4th ed.). London, United Kingdom: Sage.

Rudwick, M. J. S. (1976). The emergence of a visual language for geological science 1760–1840. *History of Science, 14*, 149–195.

SharkD. (2010, March 22). HSV cylinder. Wikimedia Commons. Retrieved from https://upload.wikimedia.org/wikipedia/commons/3/33/HSV_color_solid_cylinder_saturation_gray.png.

SharkD. (2008, January 12). The RGB color model mapped to a cube. Wikimedia Commons. Retrieved from https://upload.wikimedia.org/wikipedia/commons/0/05/RGB_Cube_Show_lowgamma_cutout_a.png.

Silverberg, J. (2018, July 18). Heuristics for better figures. *On Your Wavelength*: A Physics blog from the Nature Journals. Retrieved from blogs.nature.com/onyourwavelength/2018/07/18/heuristics-for-better-figures/.

Sprague, T. A. (1928). The herbal of Otto Brunfels. *Botanical Journal of the Linnean Society. 48*, 79–124.

Stearn, W. T. (1982). Maria Sibylla Merian (1647–1717) as a botanical artist. *Taxon, 31*, 529–534.

Supattapone, S. (2010). What makes a prion infectious? *Science, 327*, 1091–1092.

Taylor, J. E. T., Witt, J. K., & Grimaldi, P. J. (2012). Uncovering the connection between artist and audience: Viewing painted brushstrokes evokes corresponding action representations in the observer. *Cognition, 125*(1), 26–36.

Tecywiz121 (2009, June 19). Prion replication mechanism [Diagram]. Wikimedia Commons. Retrieved from https://en.wikipedia.org/wiki/Prion#/media/File:Prion_propagation.svg.

Vienne, F. (2018). Eggs and sperm as germ cells. In N. Hopwood, R. Flemming, & L. Kassell (Eds.), *Reproduction: Antiquity to the present day* (pp. 413–426). Cambridge, MA: Cambridge University Press.

Viviani, P., & Stucchi, N. (1992). Biological movements look uniform: Evidence of motor-perceptual interactions. *Journal of Experimental Psychology: Human Perception and Performance, 18*(3), 603–623.

Wiber, M. G. (1994). Undulating women and erect men: Visual imagery of gender and progress in illustrations of human evolution. *Visual Anthropology, 7*, 1–20.

4

Visualizing Gentrification: Resistance and Reclamation Through the Writing on the Walls

Tracey Bowen, University of Toronto Mississauga

Introduction

What does resistance look like when it lives on concrete pillars under freeways, stenciled on sidewalks underfoot; when it is found between the layers of peeling walls in alleyways, and integrated into the littered peripheral spaces hidden behind commercial streets? What do we see when we look, when we give attention to spaces that may otherwise be classified by officials as the periphery of urban life? The visual residue of marginalized histories and the manifestations of present-day voices of resistance are found in these spaces, found in murals and graffiti of San Diego's Chicano Park and the San Francisco Mission. Artists, come activists, have used the very spaces identified as needing urban renovation as sites for resistance through the visuality that embodies alternative voices within the cacophony of designer condos, neighborhood renovations, and organized gentrification. The increasing desire to "rescue" downtrodden urban spaces has helped foster a new visual rhetoric and collective attitude regarding the aesthetics of our private and public spaces. The institutionalized acts of demolition, disposal, and covering up unwanted sites/sights are not only applicable to the material structures, but also to the historical pasts and stories that are embedded in these places and spaces.

The neoliberal visualization of urban progress may well be the image of the construction crane, an "instrument of ideology" suggested by Caraway and Kinnear in Chapter 1 of this book. Visualizing the future of cities includes the tangible images of construction cranes as symbolic of progress; a progress tied to capitalist agendas and economic growth figures. However, seeing the future city beyond the cranes requires a more intimate look, at the peripheries, the nonspaces, and the

commodified spaces—the spaces marked for the next construction crane. Often these spaces harbor traces of an opposing ideology, one that sees neoliberal progress as erasure and the gentrification of the city as a whitewashing of cultural histories in exchange for a particular class of urban aesthetic. The lenses through which we see the city are not all equal or given credence as part of an official view sanctioned by politicians, developers, or privileged citizens. Visualizing the future of urban spaces requires close attention by all of its inhabitants to the ways in which we imagine where, and how, we live together, inclusively.

Gentrification is manifested through a physical change—an economic and aesthetic "cleaning up" visualized through the taking over of a traditionally working-class area by upper-class incomers. Gentrification has an aesthetic based on replacing and restructuring, often considered as positive action by architects and designers—a way to a better future—but only for a select few. Displacement, however, has an aesthetic based on resistance and removal. In many cases these two concepts are intertwined. Gentrification does not occur without displacement. Displacement is rooted in social and economic power—displacement is disruption, disruption that is sanitized by power, money, and decoration.

Muralissmo has long been a Mexican tradition of painting history and culture into a place (Jacoby, 2009), particularly in neighborhoods where Mexican culture is lived and celebrated. Complementary to the traditional muralissmo, graffiti and street art in the form of provocative and dynamic murals have long been evolving in urban spaces around the world. Graffiti itself is a textual form of communication, a visual practice of marking territory (Brighenti, 2010; Halsey & Young, 2006), while street art murals and muralissmo are narrative forms of communication. Graffiti creates "informational surfaces" through the residue of the layered history of the space (Quintero, 2007). The visual activity within the Mission includes traditional murals, street art and graffiti, all of which "animate surfaces that have been taken for granted, bringing new attention to the rundown, older, less manicured parts of the city," and instilling a lively cultural communal spirit (Kessler, 2015, p. 110). Romero (2017) states that "[g]raffiti and gentrification have the conquest and politics of urban space in common" (p. 3). The murals in the Mission and Chicano Park claim space and resist gentrifying attitudes through visualizing the history of the space and its people. Graffiti claims space to resist forgetting and visualize power differentials.

Muralissmo, graffiti, and street art have more recently colluded, creating a visual discourse, around the challenges of gentrification and its erasure of cultural histories and voices through the aestheticizing of power. These street aesthetics have the potential to "refigure the relations of power that structure socio-spatial life and to revamp the social spaces of everyday life in ways that produce new

political subjects" (Cobarrubias & Pickles, 2009, p. 42) thereby "provoking a community conversation" (Holmes, 2014, p. 36).

The relationship between mural art—often considered an official, municipally sanctioned form of urban art—and street art or graffiti—activities often linked to unsanctioned painting of private property or in the case of graffiti, vandalism—has been contentious in the past. Traditional mural painting has been employed by graffiti abatement programs as it is considered a more acceptable "official" aesthetic by those who have decision-making power; it is used to cover over graffiti tags and pieces with the intention of deterring further graffiti activity (Latorre, 2008, p. 104). Pitting one form of artistic social expression against another, one community of artists against another, has been used as a powerful tool for establishing aesthetic control over neighborhoods, thereby establishing what is acceptable and valued from one particular position. More recently, however, graffiti murals have become more acceptable forms of artistic expression. Community organizations such as Precita Eyes[1] in San Francisco help to facilitate spaces for graffiti-styled murals and even help graffiti writers hone their craft alongside the traditional mural painters. The cooperative actions of muralists, street artists, and graffiti writers claim space on behalf of unheard and/or underrepresented communities, and disrupt the political intentions of municipal offices trying to position one form of urban expression over another through their official rhetoric. Both graffiti—through symbolic language that is sometimes very explicit in its message, and sometimes more nuanced—and street art murals—through their narrative structure—visualize histories and narratives that have otherwise been stifled. Furthermore, both are subject to "the same mechanisms of social control" that at times have pitted one against the other (LaTorre, 2008, p. 106). However, as the construction cranes and the designer developers move in, street artists, whether graffiti writers or trained muralists, find solidarity in their fight against physical demolition and cultural erasure. Gentrification and cultural displacement have heightened the urgency to reclaim communities and resist dominant (European) notions of urban space, erasing cultural histories and voices through the aestheticizing of power. What counts as aesthetically pleasing within the urban environment and who makes that determination are at the core of this urban power struggle.

Visuality, visual practices, and the complexity of marginal spaces used for historical reflection and educative practices intersect when rewriting narratives of displacement and gentrification. Displacement in these spaces is cultural, historical, material, and physical. Displacement is the collateral damage of the struggle over urban aesthetics. The visuality of displacement is found in the alleyways of the San Francisco Mission and Chicano Park in San Diego. These spaces use the visual rhetoric of resistance related to gentrification, and reclaim culturally

significant stories that record and visualize a historical past. The painted murals and graffiti found in these areas stand in contrast (and defiance) to the visual transformation of neighborhoods that rhetorically reference the future of smart designer cities. Visuality in this case is embodied in the voices along the margins of metropolitan areas that seek to communicate with diverse publics in open spaces. Who is doing the looking is of grave importance. The messages of resistance are meant for those within the community, expressing the importance of history and speaking out of staking ground. The messages are also meant for those who do not otherwise look, for those who consider these spaces to be of little value aesthetically, but to be appropriated as real estate. Not looking has implications too.

Architects and designers must also be accountable for critically seeing their work on new and improved structures of gentrification in relation to the destructive aspect of the process. In Chapter 5, Matthew Dudzik and Marilyn Whitney examine the ways in which architects and designers "must critically engage in cultural conversations, studying the complex relationships between the people and places for whom they are designing" (p.74). Dudzik and Whitney present a case for "intentional viewing" where architects and designers must look at the human context of their work empathetically and understand the historical-cultural context. However, this empathy appears to be focused on the new inhabitants and does not include those who are impacted by the process through displacement and erasure. A critical examination of the context must include the power relations involved in decision making about what gets built, for whom, and at what cost. Architects and designers must consider the writing on the walls as the voices of the inhabitants that are affected by and are implicated in their work. "Intentional viewing," then, must include sensitivity for the history of a space and empathy for all those impacted by the rebuilding of environments—those who come to the community, those forced away, those who write on the walls, and those made invisible by newly designed facades.

As recent political bantering has demonstrated, a wall, both materially and ideologically, can be divisive. But it can also be a site for reclaiming space and representation by writing history and questioning the future in ways that illuminate the visual-political conditions on which it develops. Writing history through the traditional representational forms of muralissmo and the contemporary forms of street art and graffiti provide the opportunity for those who have traditionally been disallowed to speak up in mainstream discourse, to write their history, and voice their claim for the future into these spaces through their own collaborative action and conscientização.

Paolo Friere's (1993) coined the term conscientização to describe individuals who recognize and become empowered by their place of oppression and

build resistance through collective action. This chapter uses the concept of conscientização to examine aspects of visualizing gentrification and displacement and to develop a pedagogy that is emerging from the streets to enlighten the community conversations and often implicates a broader audience within the struggle. The street art and graffiti art found at Clarion Alley in the San Francisco Mission, and the murals in Chicano Park, San Diego, are used to illustrate how rewriting cultural and communal representations is a form of public pedagogy that reclaims space by the peoples who live there.

Conscientização: Provoking a pedagogy from the street

Stuart Hall (2003) asks us to closely analyze the visual representations circulating amongst the status quo, through advertising, film, and screen-based texts to name but a few. He asks who is visible and who is not, and in what ways? Individuals look to find themselves within those visual representations and many do not see their place. Moreover, seeing oneself represented within the collective visual imagination also pertains to seeing oneself within the image of cities. However, displacement disrupts the chance for representation and belonging. How do individuals see themselves within the networks of neighborhoods, suburbs, and open spaces? Where does one situate their image within this fabric? Writing visual histories is a way of rewriting power relations within public places and a way for those at the margins to construct a "decolonized frame of self representation" (LaTorre, 2008, p. 2).

The activity that takes place in alleyways, side streets, behind garbage cans and skids, and underneath a foreboding freeway ramp speaks to the importance of illuminating margins and borders as pedagogical spaces. Recognizing how space is part of the organizing factor for visualizing resistance is a call to action. The imagery produced is a form of conscientização, individual and collective responses and resistance to issues and actions that oppress, displace, and erase. Conscientização develops out of an individual's awakening through a critical awareness of their position and responsibility within the social sphere. Freire (1993) suggests that in order for individuals to see the world through a critical consciousness, they must integrate themselves into the fabric of society, not merely adjust, adapt, and live on the surface. He claims that the integrated person is "person as subject" whereas those that merely adapt become objects to be manipulated (p. 4). When individuals follow the "prescriptions" of the dominant institutions, they are destined to a "domestication" that renders them voiceless (p. 6). Freire (1993) warns thus:

If individuals are unable to perceive critically the themes of their time, and thus to intervene actively in reality, they are carried along in the wake of change [...] they are submerged in that change and cannot discern its dramatic significance.

(p. 7)

Freire (1993) contends that without a critical spirit individuals cannot perceive "the marked contradictions which occur in society" (p. 7). If individuals who are at risk of displacement lack the understanding to critically perceive the changes happening around them as a call to action, they are predisposed to become "a pawn at their mercy" (p. 8). If individuals from surrounding neighborhoods do not critically examine what is happening to their neighbors, the sustainability of distinct community histories is at risk. If individuals who are the benefactors of gentrification—those who move in to a "new and improved area" or those who benefit from rising property values, or those who only pay attention to issues that affect them directly—do not look at what is happening to their community, their city, and their fellow citizens, they are complicit in displacement and disruption. Critical consciousness drives a "pedagogy of/from the street" that uses graffiti, murals, and the writing on the walls as "a form of education enabling people to reflect on themselves, their responsibilities and their role in the new cultural climate" (p. 16), resulting in an increased capacity for agency and voice.

The pedagogical spaces of the streets help inhabitants of the community to critically analyze their position within the present before they can foresee what needs to be done to build a more desirable future. This criticality is crucial to the project of visualizing the displacing consequences of gentrification, not just in the transformation of real estate, but also in the bulldozing of cultural values and seeing the individual as valued subject rather than objectified as property to be appropriated.

Friere's work suggests that individuals within a community must problematize "the natural, cultural and historical reality in which s/he is immersed" (Goulet, in Freire, 1993, p. ix). Problematizing does not put the act of solving or finding remedies or solutions as the focus of actions. Problematizing within Freire's context is a way of mobilizing individuals into "codifying total reality into symbols which can generate critical consciousness" in ways that shift their relationships to the social, thereby positioning the individual as active "subjects rather than objects of their own history" (Goulet, in Freire, 1993, p. ix). The process of problematizing is enabled through the praxis of writing on the walls. The collective action around the symbolic writing of the histories, struggles, and rights of the individuals who inhabit these communal urban spaces, however, is compromised by officially sanctioned remedies of presumably well-meaning community members who understand gentrification as protecting and improving what they see as a disintegrating neighborhood (sometimes evidenced by the very presence of graffiti).

The mural/street art/graffiti dialogue woven into the fabric of the Mission in particular transforms the usual everyday act of taking up space into a conscious and tangible visual practice, "a gauntlet against forgetting" (Alejandro Murguia, cited in Jacoby, 2009, p. 98) and a pedagogy from the street. The visually dynamic works on the street demonstrate the empowerment of individuals who "become conscious [...] of their own potential and power to bring about change at an individual and collective level" (LaTorre, 2008, p. 8). However, mere consciousness of a problem, particularly one of domination, will not bring about transformation or, as Freire (1994) says, "a critical perception of the fabric, while indispensable, is not sufficient to change the data of the problem" (p. 24). However, it is the hope for a better world that fuels action. Collective action driven by hope is crucial to the problematization process that leads to conscientização.

Daspit (2000), however, suggests that we take this proposition a step further by reconsidering who is doing the teaching and who is to be enlightened, and replacing a pedagogy that is of or with those that are marginalized and oppressed to one that emerges from them as an education for others (p. 125). A pedagogy from the street emerges from those who inhabit the spaces and places and have been part of the history and community formation, often from marginalized or ignored urban spaces. This pedagogy offers a "route to re-viewing the world" (Freire, 1993, p. 34) by redefining what needs to be said and heard, and by whom. Holmes (2014) suggests that collective discourse, the pedagogy provoked by street art and graffiti, initiates "a community literacy that demands engagement across difference" (p. 40). The route to enlightenment in this context arises out of the redirection and redistribution of power, privileging cultural history and development as well as human rights over real estate development. In some cases, the route to enlightenment may also lead to one being implicated in the problem.

The murals as well as the street art and graffiti act pedagogically in at least two ways. The first is providing a historical account and "public diary" (Alarcon & Pablo Gutieriez, in Jacoby, 2009, p. 215) of the people who live in these spaces, and the people who came before them. Many works provide a history and cultural narrative that is often not part of official institutionalized educational curriculum. The second is an account of the issues at stake within the community, the cost of displacement and gentrification, the cost of a "refined" creative city, and the identification of those who are implicated in these issues, including those that are viewing the writing on the walls as tourists, developers, architects, real estate buyers and sellers, and other community members standing by.

Organized collective action has been the foundation for both Clarion Alley in the Mission through the Clarion Alley Mural Project (CAMP) and Chicano Park through their community steering committee. The collective structure is crucial for seeing and understanding the issues as human issues that require dialogue, and

not as problems to be measured in relation to European, patriarchal notions of success that perpetuate the position of the powerless through political and economic structures. The hope of those involved within the struggle with the support of the messages and narratives written and painted on the walls drive the project of educating those with limited perspectives on what progress looks like. The role of dialogue here is horizontal reciprocity according to Freire (1993), not a process of the dominant groups "issuing communiqués" (p. 46). He criticizes projects that superimpose solutions from other contexts without critical analysis of the difference in power structure and culture of these contexts. In some cases, these solutions include a superficial appropriation of culture that is antithetical to the community at risk.

The subversive "creative cities" effect

Ley (2003) connects the gentrification tendencies of some urban areas to the cultural capital brought about by artists who live and work in the area. He suggests that "gentrification is a field of relationships, practices and historical traces" that sees an association with aesthetic dispositions as a possible predictor of desirable areas for renewal (p. 2532). Individuals look to gain proximity to artists and creatives in order to gain cultural capital that eventually translates to economic capital. Gentrification in this case becomes a conduit through which the creativity of one group is appropriated and commodified for capital gain by another.

Gentrification has also been fueled by another form of power relation, namely that of the desire for creative cities and a neoliberal aestheticizing. Schacter (2014) claims that

> city authorities all over the world have become entranced by a concept. They have become entranced by the possibilities of what is termed the creative, by the Creative Class, the Creative City, the Creative Economy, entranced by a cultural policy in which urban regeneration and renewal are linked intrinsically, inseparably, to the arts and other "creative" practices.
>
> (p. 163)

In some cases, the presence of graffiti and street art murals in a neighborhood signals its creative potential, thereby attracting its own demise. The raw creativity of the graffiti presence and the imagined bohemians that live in the place are an exoticism that is commodified for purchase. While the murals and graffiti works are "place making," the gentrifying push is "place marketing" (Schacter, 2014, p. 163).

The creative cities effect sets up a paradoxical tension through the desire to appear as an inspiring place where artists are privileged as essential for the growth and "creative" well-being of urban communities; yet the creativity of course is exclusive, void of marginal cultures and histories. This form of selective creativity is what Schacter and others have called an "art washing" of diversity and like IKEA everything, a homogenized version of life (Ledin & Machin, 2017). Schacter (2014) points out that "the last decade has borne witness to the globally dominating authority of this now ideological norm, the capital C 'Creative' takeover of civic public policy" (p. 163). Everything becomes commodified, including the cultural narratives of the people displaced. The creative cities effect denies street art and graffiti their radical edginess in favor of sanctioned, urban aesthetics. The potential for resistance is compromised because the imagery is "co-opted" for marketing the Creative City brand (Schacter, 2014) instead of a means for marking the history of a space and place. Graffiti itself "offers a visual expression of resistance within an urban landscape saturated with directives to consume" (Kessler, 2015, p. 115). The potential for refiguring relations of power has been appropriated for potential economic gain. However, it is the connection to the street and to the historical context of the neighborhood (Chicano) that prevents the imagery from becoming, as Schacter (2014) states, "beholden to the strategic, acquisitive desires of the contemporary, neo-liberal city" (p. 162).

Like the inherent promise of the creative city, the promise of safety is also problematic as gentrification has become a "cheap and quick fix" denying the underlying social problems of racism, class oppression, and whitewashing. When asked what they thought about the gentrification that was slowly covering over the character of their neighborhood, two muralists/graffiti artists in Logan Heights, San Diego, where Chicano Park is located, suggested that the "clean up" might be good for the community as the changes were pushing out some of the gang activity claiming "that has to be good right?" Community safety has been a neoliberal promise of gentrification, although the promise is skewed toward the safety of a white middle- to upper-class population. One could view many of the Chicano Park murals as asking what is the cost of "cleaning up the neighborhood" and what is the cost of a creative city. How is the tale of a safe creative city being sold?

The Mission and Chicano Park both present the tactile materiality of displacement and gentrification that fight the influence of tech (an economic influence because high-paying tech jobs provide young urban dwellers with the means to gentrify) and use the materiality of those spaces at risk to write their history into physical existence and the collective imagination. The materiality reinforces the pedagogy that emanates from these streets. The visuality of the alleyways highlight "a flow of information circulation" (Bowen, 2013) and a visceral materialism to the resistance against an ideology manifested through construction equipment

under the guise of progress for all. The visual practices of graffiti writing can be dialectical in that they present a distraction from traditional narrative and, in some cases, contribute to gentrification rationales; however, the graffiti responses are also a confirmation of the multiple voices entrenched in the fight.

A pedagogy of resistance: Clarion Alley Mural Project

The Clarion Alley Mural Project (CAMP) emerged in 1992 when a group of six artists, who were inspired by other street art activity in neighboring alleys, expressed their anger over the growing human rights issues within their community by writing their sentiments on the walls and garage doors of the 560 x 15 foot wide alleyway stretching from Mission and Valencia streets in the block between 17th and 18th street.[2] The graffiti along the edges "butts up" against more structured street art murals bearing political messages, memorials, and collages of popular culture imagery, many of which were sponsored by a community organization. The graffiti covers the ground, hydro poles, and other street accoutrements. CAMP was organized around the vision of creating "a place that wants to be free where culture and dignity speak louder than the rules of private property" (Clarion Alley Mural Project, 1992, n.p.).

The street art and mural activity in Clarion Alley creates a dialogue with both the spontaneous graffiti writing along the edges and across the sidewalks and pathways (see Figure 4.1), and the more traditional, historically inspired murals that have become a major tourist attraction in the San Francisco Mission. The space is a "limited free zone, maintained and nurtured by the community" (Kessler, 2015, p. 114) where the murals speak to history from particular political positions, inspiring activity in the surrounding area, particularly Valencia Street—an area with increasing gentrification targeting a young, hipster, tech industry worker audience. The images presented in Figures 4.2 and 4.3 are just a few of the pieces that speak to the outrage and consequences of the bulldozing effects of the gentrification activity in the immediate area. The poster-plastered walls and stenciled sidewalks seen in Figures 4.4 and 4.5 are the peripheral activity that both speak to and support the writing on the walls in the alley. This cacophony of voices and messages support a pedagogy from the street, raising awareness of the whitewashing transformation, and calling attention to the displacement and cultural erasure. Writing activity—both in the alley and at the edges—speak to new challenges of gentrifying practices brought about by the boom of the tech industry and the rise in income of "hip" millennial tech creatives and developers. The writing on the wall implicates us all in this struggle.

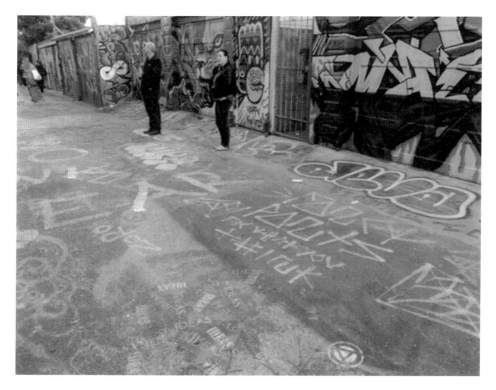

FIGURE 4.1: Clarion Alley, San Francisco, California.

The gentrification occurring in the Mission supports the argument that creative cities are promoting a sense of globalized neoliberal creativity tied to economic growth of the tech industries in this expanded Silicon Valley region. The pedagogy from the street is made concrete through creativity and political activism driven by the outrage and desire to open up spaces of dialogue. However, the forms of resistance through the layered posters, stenciled sidewalks, and the very alley spaces claimed by the street art create a tension between the groups who are unofficially and officially licensed to claim what is best for the community. The pedagogy from the street exists within this tension, and, as Freire (1970) says, "in this struggle this pedagogy is made and remade" (p. 33) through reflection by both those developing (architects, developers, and consumers) the area in the name of progress and those that hold on to the edges where they write and paint. The very existence of the pedagogy from the street within Clarion Alley is dependent on the interweaving of all voices, the very public-ness of the discourse, and its continual remaking.

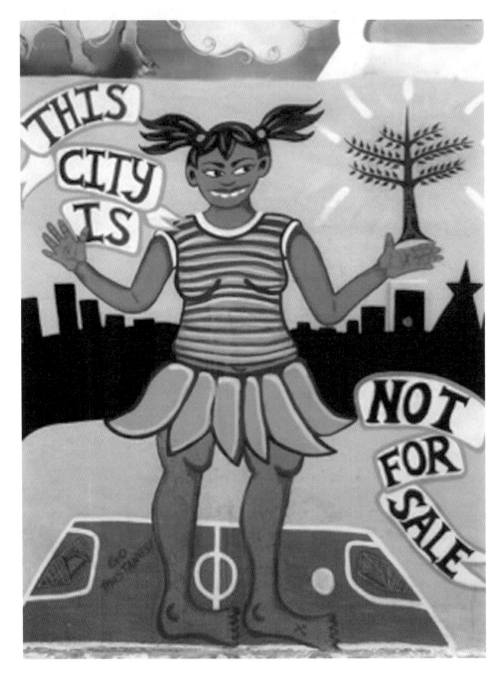
FIGURE 4.2: This city is not for sale, Ivy Jeanne McClellend, 2014.

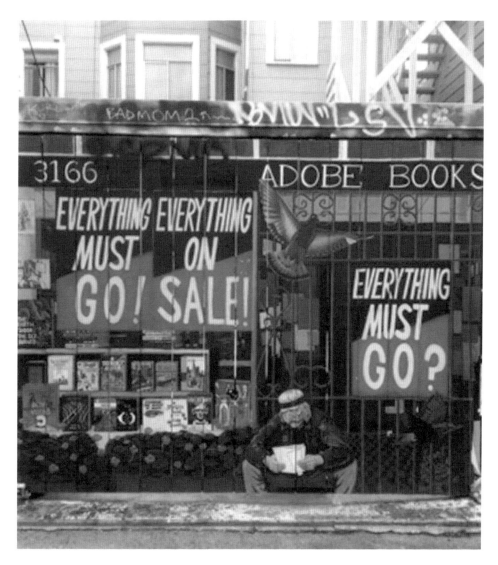

FIGURE 4.3: Everything must go, Daniel Doherty, 2015.

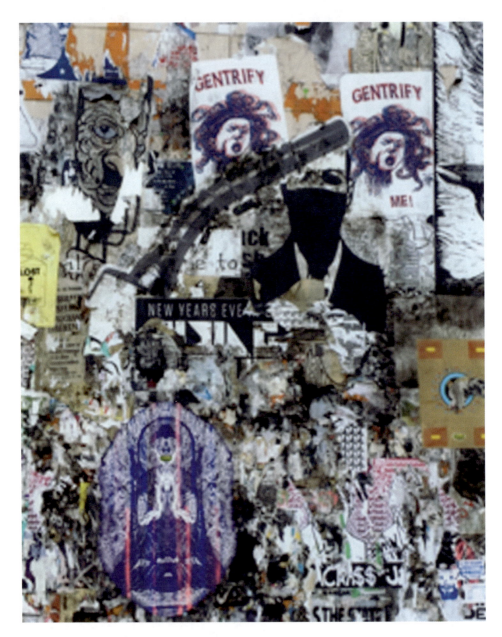

FIGURE 4.4: Valencia Street, San Francisco.

VISUALIZING GENTRIFICATION

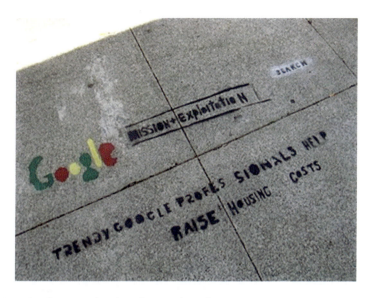

FIGURE 4.5: On the ground, sidewalk stencils, Valencia Street.

A sacred space of cultural reclamation: Chicano Park

The Chicano Park Monumental Public Mural Program was initiated by Salvador Torres in 1969.[3] The program was conceived because of a new policy that enabled small parcels of land under freeway overpasses to be used for community parks. However, on April 22, 1970, bulldozers arrived to start construction of a California highway patrol station on the very land that was assumed to become a community space. A resistance began. By August 1971, after community resistance and a great deal of political maneuvering, the park was turned back to the Chicano people of Logan Heights to develop a space that was good for the neighborhood.[4] By 1974, the murals in Chicano Park began appearing, and these created a visual history of the struggle of the Chicano people and their struggle using the visual practices that are part of their tradition (see Figures 4.6 and 4.7). The artists and writers that have adorned the marginalized space of the park, a peripheral place underneath the Coronado Bridge overpass, have used this particular "edge" of San Diego to write the narratives of displacement. The space occupied by Chicano Park is part of a long contentious history about displacement. Marco Anguiano of the Chicano Park Steering Committee notes thus:

> The Park is where our history is enshrined in monumental murals. It is where we keep making history as we fight to preserve and defend a small piece of Aztlán known as Chicano Park in Barrio Logan, San Diego […] By claiming Chicano Park,

67

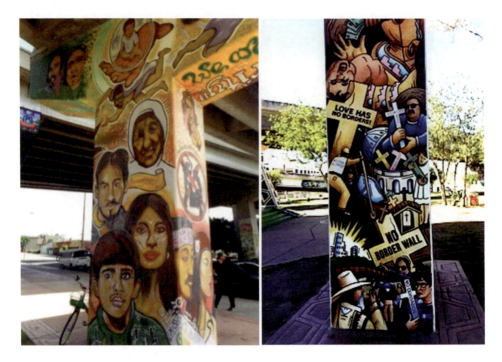
FIGURE 4.6: Chicano Park, San Diego.

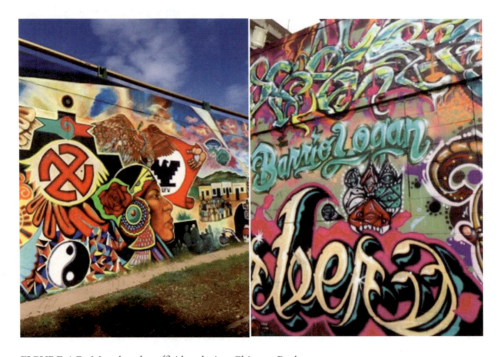
FIGURE 4.7: Mural and graffiti bordering Chicano Park.

the descendants of the Aztecs the Chicano Mexicano people begin a project of historical reclamation.

(Chicano Park Steering Committee, 1969, n.p.)

The murals in the Mission and Chicano Park must be considered as more than street art, more than tradition; countering the impulse to see them within the street art genre where imagery is viewed as more decorative for the purposes of being attractive rather than critical and provocative in a way that questions the status quo and the human issues that are subverted (Schacter, 2014). Street art in creative cities, in the name of aesthetic refurbishing, focuses on aestheticizing for profit within the creative neoliberal city, rather than asking questions about the power relations that are affecting change. What is seen may be beautiful, in the same way that political struggles have been aestheticized over time, like anesthesia against complex social and historical relations. The murals of the San Francisco Mission and Chicano Park are "a gauntlet against forgetting" (Alejandro Murguia, in Jacoby, 2009, p. 98).

The visuality of spatial reclamation

Over twenty years ago, Maxine Green (1995) asked educators to challenge the status quo and ask, what else is possible? We are still asking that question. However, if the visuality of place is to be inclusive of diverse histories, and resistant to gentrifying sanitization through designer condos and smart spaces, what is the future to look like—what else is possible? What would it look like if we visualized urban space through the eyes of the people who are the foundation of its community—if history was learned from the writing on the walls? What would it look like if top-down economic gain was not part of the vision? The gentrification of the San Francisco Mission is occurring through the annexation and renovation of property, evicting the very individuals who have created the cultural community that has made the neighborhood so attractive to outsiders through the visuality of the Mexican culture written on the walls. Chicano Park, however, deploys the visuality of the murals as a mechanism for claiming territory (an intent of graffiti) that was to be claimed by others for municipal use. The space of Chicano Park was a marginal space now made beautiful through the reclamation work of the multiple voices of the artists. As LaTorre points out, "Chicano community murals are dialectic" (p. 12) in their role of unifying oppressed communities on the margins as well as disrupting the rebuilding/rebranding of those communities by outsiders with other agendas such as gentrification. They are a site for a pedagogy from the street and from the people to flourish.

Conclusion

The artists and writers of places such as the Mission and Chicano Park are visual activists, opening up and claiming public spaces for rewriting narratives of displacement and erasure, for making visible histories that have been skewed or commodified. Deploying visual practices of narrativizing struggle helps to reinstate the materiality of the spaces, put faces to the consequences of displacement, and opens up the possibility for refiguring relations of power thereby empowering place-makers. As social beings we must identify and acknowledge the superficial decoration of public spaces as an artificial lure of creative cities, and recognize the role of community-grounded visual practices in claiming the history of urban spaces and imagining what else those spaces, places, and peoples can be. Visual practices of writing and painting on walls can be the conduit for highlighting the margins, empowering communities, and reclaiming histories that bulldozers have tried to erase.

The murals in Chicano Park create a visual history of the struggle of the Chicano people using the visual practices that are part of that tradition. The murals in the San Francisco Mission are inspired by activity in the margins of alleyways and streets that speak to new challenges of displacement through gentrifying practices brought on by the boom of the tech industry. The artists and writers of these spaces have used the margins to rewrite the narratives of displacement. These spaces present us with a space of public education—a pedagogy from the street where history is learned from alleyway garages and freeway overpass pillars. This pedagogy is not taught through devised, imposed narratives, but rather by the stories and protests of people's lived experiences and realities presented by the people themselves. A pedagogy from the street enriches the social fabric by including a multitude of voices in a multitude of ways, all to be acknowledged, heard, and recognized as an urgent call for action.

Acknowledgments

The photographs included in this chapter were taken by the author during numerous visits to San Francisco and San Diego. However, readers are encouraged to learn more about the Clarion Alley Mural Project by accessing http://clarionalleymuralproject.org/, and the history behind Chicano Park through their website http://www.chicanoparksandiego.com/index.html.

I would also like to identify the position from which I have written this chapter. As a privileged white woman, I do not know what it is like to be displaced, nor have I experienced this level of struggle. I am implicated in the gentrification through

my use of technology, and have enjoyed the street art and murals as a lover of graffiti and writing on the walls and a curious academic tourist. However, I seek to open up the dialogue about how we are all implicated in these issues, not mere bystanders adapting to our own version of everyday life.

NOTES
1. Precita Eyes is a nonprofit organization founded in 1977. http://www.precitaeyes.org/.
2. http://clarionalleymuralproject.org/about/.
3. Chicano Park community.
4. Chicano Park History, Project Coordinator and historian, Richard Griswold del Castillo http://www.chicanoparksandiego.com/murals/history.html.

REFERENCES

Bowen, T. (2013). Graffiti as spatializing practice and performance. *Rhizomes; Cultural Studies in Emerging Knowledge*, *25*. Retrieved from http://rhizomes.net/issue25/bowen/index.html.

Brighenti, A. M. (2010). At the wall: Graffiti writers, urban territoriality, and the public domain. *Space and Culture*, *13*(3), 315–332. http://dx.doi.org/10.1177/1206331210365283.

Chicano Park Steering Committee (1969). The battle of Chicano Park: A brief history of the takeover. Retrieved from http://chicano-park.com/cpscbattleof.html.

Cobarrubias, S., & Pickles, J. (2009). Spacing movements: The turn to cartographies and mapping practices in contemporary social movements. In B. Warf & S. Arias (Eds.), *The spatial turn: Interdisciplinary perspectives* (pp. 36–57). New York, NY: Routledge.

Daspit, T. (2000). Rap pedagogies: "Bring(ing) the noise" of "knowledge born on the microphone" to radical education. In T. Daspit & J. A. Weaver (Eds.), *Popular culture and critical pedagogy: Reading, constructing, connecting.* (pp.125–137). New York, NY: Garland Publishing.

Freire, P. (1994). *Pedagogy of hope, reliving pedagogy of the oppressed.* (Trans. R. Barr). New York, NY: Bloomsbury.

Freire, P. (1970). *Pedagogy of the oppressed.* New York, NY: Seabury Press.

Freire, P. (1993). *Education for critical consciousness.* New York, NY: Continuum.

Green, M. (1995). *Releasing the imagination.* San Francisco, CA: Jossey-Bass.

Hall, S. (2003). *Representation: Cultural representations and signifying practice.* Thousand Oaks, CA: Sage.

Halsey, M., & Young, A. (2006). Our desires are ungovernable: Writing graffiti in urban space. *Theoretical Criminology*, *10*(3), 275–306. http://dx.doi.org/10.1177/1362480606065908.

Holmes, A. (2014, Fall). Street art as public pedagogy & community literacy: What walls can teach us. *Journal of Literature, Literacy and the Arts*, *1*(1). Retrieved from http://ed-ubiquity.gsu/wordpress/holmes-1-1/.

Jacoby, A. (2009). *Street Art San Francisco: Mission Muralismo*. (Prod. Precita Eyes). New York, NY: Abrams.

Kessler, M. (2015). The licit and illicit vandalizing of San Francisco's early garages. *Change over Time*, 5(1), 96–118.

LaTorre, G. (2008). *Walls of empowerment*. Austin, TX: University of Texas Press.

Ledin, P., & Machin, D. (2017). The neoliberal definition of "elite space in IKEA kitchens." *Social Semiotics*, 27(3), 323–334.

Ley, D. (2003). Artists, aestheticisation and the field of gentrification. *Urban Studies*, 40(12), 2527–2544.

Quintero, N. (2007). The screen on the street: Convergence and agonic Coincidences between graffiti and new media objects. *Artnodes*, 7. Retrieved from http://www.uoc.edu/artnodes/7/dt/eng/quintero.pdf.

Romero, R. (2017). Bittersweet ambivalence: Austin's street artists speak of gentrification. *Journal of Cultural Geography*, 35(1), 1–22, http://dx.doi.org/10.1080/08873631.2017.1338855.

Schacter, R. (2014). The ugly truth: Street art, graffiti and the creative city. *Art and the Public Sphere*, 3(2), 161–176.

5

Intentional Viewing: Decoding, Learning, and Creating Culturally Relevant Architecture

Matthew Dudzik, University of Canterbury, Christchurch New Zealand, and Marilyn Corson Whitney, Independent Scholar

Cultivating powers of seeing with perspicacity aids architects and designers in creating culturally relevant spaces. Through investigation, contemplation, and iterative inquiry, a visual lexicon can be built from the analysis of cultural data. This practice is especially pertinent to the digital native, who has grown up bombarded by visual stimuli, but lacking an understanding of the basic cultural coding of this medium. By bringing academic rigor and analysis to the practice of seeing, one can decode images and use that knowledge to create a culturally sensitive design. Utilizing mind's eye envisioning, architects and designers can apply this visual literacy to both real and imagined spaces thereby aiding the speed and accuracy of the design process. Thus, it allows both students and professionals to activate creativity, drive analytical inquiry, and study the interconnectivity of design factors in our built environment. This visual-spatial data analysis informs visual practice and the construction of ethical environments.

 This chapter explores visual practice through the lens of architecture and design with the deployment of intentional viewing—viewing based on analysis of what is, what is not, and of what could be. With the globalization of architecture, designers of the built environment need to develop an awareness of cultural practices. These include what we will refer to as experiential considerations: social norms and cultural practices, and technical considerations: appropriate environmental responses, building practices, material availability, and governing economic realities. By decoding the underlying meaning in the images, one can address cultural realities. However, visual practice transcends reflections of visual data and must encompass the application of the visual to classic notions of research and inquiry. Uniting experiential and technical consideration in a way that is appropriate for a given

society is a complicated endeavor, and one which necessitates a deep cultural understanding. As global practice has become standard practice for architects, the profession must implore all available resources to address both local and international best practices. This type of critical cultural response is necessary to create architecture that responds to the complex needs of a given place or people.

Visual exploration allows the viewer to use his/her mind's eye—the mechanism through which an individual can process, manipulate, or create spatial data internally—to study the complexities of our built environment. Starting with images pertinent to a given project, the designer can envision depicted conditions, study implied technical or experiential factors, and even contemplate that which lies beyond the frame of reference and potentially beyond reality. However, visual practice relies on the application of that data analysis to the creation of something new. Defining unique project parameters is the beginning of a process that involves interpretation, research, and creative synthesis to construct meaningful places.

The processing of visual data for the propose of architectural exploration must be both an informed and an intentional study. We live in a time when we see a myriad of images daily—images that often have embedded symbology—which is overlooked by the viewer. While the complexities of the global political arena and pervasiveness of product placement have alerted us to the need for intentional viewing, even digital natives—who have grown up with technology—have difficulty deciphering these, at times, subversive messages.

Intentional viewing is a study that requires us not only to recall and to reflect but also to question. It is this type of informed investigation which pulls data from the visual, which can then be explored and researched through a myriad of modes of inquiry. The application of this analysis becomes integrated through the iterative process of design, where one studies, creates, critiques, and revisions.

This sort of intentional exploration can be done through model building, hand drawing, three-dimensional (3-D) digital imaging, and other virtual or analog tools of inquiry. In this process, technology is merely a tool that relies on the user in the same way that images rely on the viewer to unlock their latent potential. Advancements in technology have altered the tools and sometimes the speed of the design process but have not fundamentally changed the need for the architect to adapt to the experiential and technical complexities of a given place or culture.

With the global practice of architecture, visual study is critical for buildings to respond to their users and environments. The art of intentional viewing allows architects and designers (terms we will use interchangeably in this chapter) to both decode images through anthropomorphic investigation and create spaces through completing the volume in their mind's eye. As such visual literacy is both a tool of investigation and one of contemplation, where analyzed data comingle with imagined alternative realities. Both these two significant paths of inquiry stem

from the process of intentional viewing. This application is especially pertinent to the Digital Native (Prensky, 2001).

Marc Prensky established the term Digital Native for someone who has grown up with technology embedded in their lives. He asserts that interconnected global media bombards them, and they are familiar with the free trade of knowledge across borders. We posit that, even with this exposure, they often lack the ability to unpack the inherent meaning within images. Visual and analytical research methods expose the Digital Native student to the study of cultural data inherent in images, which they then apply to create buildings and spaces that are more connected to their users.

As architecture practice is ever-increasingly global, design professionals must critically engage in cultural conversations, studying the complex relationships between the people and places for whom they are designing. Modern architecture's conception, which was established by Le Corbusier as "a machine for living," led to the International style that has disintegrated into the banality of global practice we see today—here somewhere and nowhere are as indiscernible as the culture in which they are placed.

Critiques of architecture

Critiques of modern architecture often posit that buildings are not responsive to the people using the space and even that designers lack an understating of the building's role in a larger cultural context. For example, in 1976, Brent Brolin states that architecture has "failed wherever the architect disregards the social and aesthetic values of the user" (p. 8). Brolin continues that this happens when buildings do not fit into the "environmental, social, or cultural context" in which they are placed. He charges that "the disillusionment with modern architecture came about because architects imposed their values on a public that did not share them" (p. 44). We can see the modern application of his theories though ineffective assimilation of western designers who create with their own cultural context in a place where it is not accepted or appreciated. Prevalent examples include William McDonough's Huangbaiyu, a design for a sustainable town in China (Sacks, 2008) and Michael Graves's Miramar Resort on the Red Sea (ElMasary, 2006).

Robert Venturi (1966) extensively discusses the topic in his book *Complexity and Contradiction*, in which he states that "a valid architecture evokes many levels of meaning and combinations of focus: its spaces and its elements become readable and workable in several ways at once" (p. 16). He laments that "the building becomes a diagram of an oversimplified program for living—and abstract theory

of either-or" when the architect fails to address the complexities of place-making (p. 17).

Rem Koolhaas (1996) discusses globalization and regionalization as crucial components of modernism, which he admits are contradictory ideas. While discussing postmodernism, contextualism, and regionalism, he states that "the important thing is that they are all seamlessly and effortlessly part of an overall process of modernization a process which in no way is connected to modernity as an ideological, let alone artistic, movement" (p. 235). He laments that design is no longer connected to meaning and place-making but instead has become an aesthetic stamp applied without attention to the culture or climate in which it is placed. He joins Venturi in his concern that placelessness "may be the real essence of globalization" (p. 235).

Brolin, Koolhaas, and Venturi address the need for architecture to be born from its context and designed for the people who will ultimately inhabit its spaces. While Brolin advocates for a more traditional notion of cultural relevancy, Koolhaas (1996) argues that "architects have to develop the humility to see ourselves as part of a process, as particles that submit to laws other than those of our genius" (p. 235).

To be responsive to diverse cultures in their designs, architects need to address not just that which is, but dive into the complexity of tensions to visualize what can be. While the Digital Native is immersed in technology and is hyperconnected, they still need to be trained to see with perspicacity.

Digital Native

Prensky (2001) asserts that Digital Natives learn differently from other generations because of their hyperconnectivity on the internet. Inversely, he refers to the Digital Immigrant as someone who has adopted technology after adulthood. He addresses how Digital Immigrant educators need to alter their teaching methods to be responsive to their Digital Native students, stating that these students "think and process information fundamentally differently from their predecessors" (p. 1). Digital Natives are not just accepting of the technology but have grown up immersed in it and therefore find that emerging technologies are an extension of their native language.

Graham MacPhee (2002) reiterates that as a member of the global integrated web from birth, the Digital Native has been fully engaged in the "development of modern mass societies" as the "new global cultural space," which is born from global awareness and the sharing of values (p. 3). Prensky (2001) suggests that in education the Digital Immigrant educator can utilize this connectivity by

instigating assignments whose structure enhances exploration of the local rather than the universal (p. 3). The authors of this chapter posit that multilayered research methods help students to decode and differentiate the embedded meaning found in images of a given place or people.

It is through these explorations of the diverse social, economic, and political realities of place-making that we begin to unpack cultural meaning, which can then be refined through traditional notions of research. This process is ultimately about empathy and consideration for the other. Architects must move beyond their worldview and societal rituals to understand the people for whom they are building. This process of inquiry and analysis can germinate a new understanding of the genius loci—the spirit of place—of a given context.

Because architectural educators understand the importance of seeing, many offer fieldtrips, visual presentations, and in situ investigations of the site. The students often document these enhancement trips with hand-drawn images. This technique fosters drawing skills as well as develops seeing skills to ascertain the details of the environment (Figure 5.1). Through these organized visual explorations, awareness is brought to experiential, technical, and ephemeral considerations. This type of immersion offers more data input than the study of images alone can. However, images help to democratize the study of architecture, making more buildings accessible than anyone people can see in a lifetime. Understanding the visual can, therefore, be done through both immersive and remote viewing.

There are benefits to the limitations of the photograph as well. Through the focus presented in each framing section, the photographer can direct the viewer's gaze. Collecting, sorting, and manipulating images can give the processor an understanding of the inherent complexities of our built environment. They allow the shifting gaze of the viewer to analyze and decode various parameters affecting human experience and construction realities. This process extracts data and allows the designer to respond to the inherent complexities of architecture while being responsive to the culture of a particular location. These visual experiences have validity in the focus and the ability of designers to extract coded cultural data. This information is then filtered through the client and ultimate user group to a meaningful framework for the project. Visual analysis allows architects to make connections that may have been previously unseen, but it is mind's eye processing that allows them to envision beyond that which can.

Mind's eye envisioning

When discussing mind's eye envisioning, Colin McGinn (2004) refers to the imagination as the capacity of the mind to reconstitute components of an experience

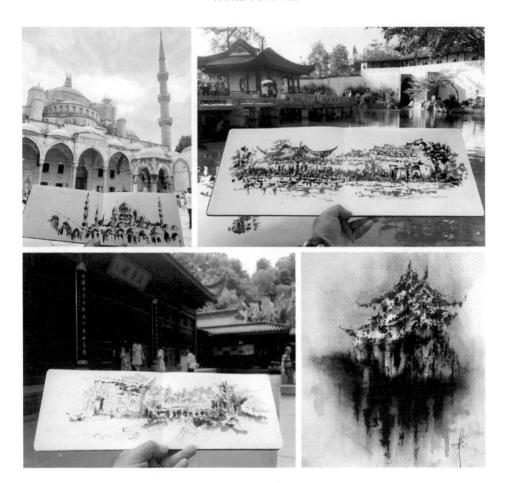

FIGURE 5.1: Hsu-Jen Huang. Travel Sketches. 2019. Watercolor sketches. Courtesy of Artist.

rather than a more traditional theory that the image in one's mind is just a memory of a sensory experience (p. 3). As such, the mind's eye does not just recall that which it has seen but constructs new realities within this inner vision (p. 43). It is the formation of alternative spatial scenarios that directly benefits the architect and helps to expedite the iterative design process. McGinn purports that imagery occurs separately from the perspective of the mind and is not dependent on the quality of what has been seen or on the sensory object itself. An example he gives is dreaming of an image is no less real to the mind than an object on the table. As such, the mind must determine the reality of objects in the imagination.

Through the process of collection and construction, the designer can select and test various input data. This ability to envision and shift the plane of ocular reality offers the architect the possibility of creating empathetically and therefore acting

FIGURE 5.2: Matthew Dudzik. Shifting Perspectives Mexican Identity. 2017. Photomontage. Courtesy of Artist.

with a sense of cultural plasticity. An example of the design process using visual literacy is the study by Kavakli, Stephen, and Ball (1998) where they had individual students sketch chairs from memory, enhancing the seeing of a familiar object. After which they were asked to create a new design of a chair. The researchers found that "there is an intimate relationship between the cognitive and perceptual processes that are brought to bear on the recall and design tasks and idea sketching" (p. 485). Another study by Donna Wilson (2012) takes this envisioning further by stating that persons who are creating by the use of "mental imagery" techniques have "better cognition and recall" of the texts that they read (p. 1).

McGinn (2004) purports that the manipulative mental process is called "cognitive imagination" (p. 128). It is through cognitive imagination that one can shape unrelated images or parts of images into a new cohesive whole that has never been seen before (Figure 5.2). This ability can be utilized by architects to internally create 3-D constructs forming space and experience with cognitive imagination, therefore aiding the architect in the iterative design process. These imaginary spaces can be built from previous experiences, cultivated through remote viewing or, for experienced architects, can be based on informed intuition. When viewing space in

one's mind, the architect can both complete the frame of the section and imagine alternative realities. This process of dissection and recreation can help the designer understand various factors at play in the design of the built environment. By creating internally, especially when aided by images with latent cultural content, the designer can reconstitute fragments of information in ways that allow for innovation that is sensitive to the experiential and technical considerations of the project.

The complexity of this condition is exacerbated by the myriad of functional, technical, social, cultural, and environmental concerns the architect needs to address. In addition to envisioning spaces, exploring them through iterative process supports comprehension and understanding. The profession explores the zeitgeist's evolution of creative practice through the synthesis of known conditions, elements, and factors. This analytical and creative manner of assembly, dissection, and recreation is aided through cognitive imagination and allows the architect to hypothesize new relationships of and between elements. This also allows the designer to shift the lens and scope of inquiry so that he/she may either focus on a distinct element or "zoom-out" to have a generalized understanding.

By being able to place oneself outside of a known condition, the architect can envision that which is unrealized and to do so with great empathy. By using techniques of visual literacy to decode and unpack data from images, and through the cultural study of a given place, the designer can use iterative practice in the pursuit of a meaningful design (Figure 5.3). McGinn (2004) urges that the inner eye is an

FIGURE 5.3: Matthew Dudzik. Alternative Realities. 2010. Photomontage. Courtesy of Artist.

anatomical system of both memory and creation by one's cognitive imagination. He continues through this process: "we are able to suspend judgment and effectively survey endless possibilities" (p. 162). Architects must couple the intuitive and analytical with the use of technology to produce new environments. This innovation can be both aided and inhibited through the use of technology.

Technology

Among other things, diverse technologies are used to explore the image, to educate through gaming, to transform environments through 3-D imaging, and to communicate the designs through plans and specifications. This is where visual practice becomes an active participant in the formation of architecture.

Digital Natives' instinctive use of the World Wide Web has allowed them to connect with people and cultures across the globe. To harness this digital processing and create specific learning outcomes, educators have used gaming software to teach the complex interrelationships between various elements of architecture practice. Other software, including Unreal Engine, Rhinoceros, and Revit, has been used by designers to create digitally interactive environments allowing them to examine a building through iterative exploration. Additional applications of technology to the built environment involve a myriad of expanding technologies used for the communication of design ideas through the production of construction documents.

Jane McGonigal (2011) argues that gaming is an advanced learning environment where virtual reality aids in the development of spatial cognition and rule orientation. To engage the player and build knowledge effortlessly, she discusses four rules-of-the-game:

1. the goal—something for which to strive for: a sense of purpose.
2. the rules—constraints that push players into "more creativity and foster strategic thinking."
3. a feedback system—real-time feedback is like a "promise to the players that the goal is achievable and provides motivation to keep playing."
4. voluntary participation—the freedom to enter or leave a game at will ensures that intentionally stressful and challenging work is experienced as a safe and pleasurable activity (p. 21).

These rules could also apply to the framing of design projects aiding architects in designing with empathy through placing them within a virtual 3-D constructed

environment. This immersive approach to design can advance architectural knowledge through a greater understanding of its prebuilt condition.

An example of gaming being used as an architecture education tool is Disentanglement and Gates, a game designed to teach professional practice in architecture. Greg Hall et al. (2013) note that "new technology offers potential to drastically reinvent design education and better prepare students for professional careers" (p. 31). The authors worked with the National Council of Architecture Registration Boards (NCARB) to utilize gaming software for an interactive game to teach students the complex interactions of decisions made in the professional practice of architecture. The authors state that "collaborative and competitive aspects allowed students to interact with architects" (p. 31). They continue that the process of gaming allows them to "further simulate practice settings by factoring in issues such as multidisciplinary teams, time management, client relations, economic factors, energy use, and international practice" (p. 31). They also note that the game uses "the concepts of entanglement and gating—key concepts to interactive game design and relevant to architecture practice" to explore the confluence of seemingly disparate decisions (p. 32). The possible experiences in the game allow students to interact with and make decisions based on real-world conditions from their textbooks or case studies.

Another gaming software utilized by architects is Unreal Engine, which gives designers the ability to create digitally interactive environments, allowing them to take that which is in their mind's eye and explore its spatial conditions digitally. The experiential progression through a building is manifested digitally, allowing their speculative notions of movement through space to be further explored (Figure 5.4). By doing so, architects can create buildings that are more sympathetic to the inhabitants while studying 3-D spatial progression and its association to a given place or environment.

A negative aspect of these tools is that they allow short cuts in the process. Advanced 2-D and 3-D design software create imaging systems that allow a project to look complete while the design may be ill-conceived. The fact that designers can cut and paste 3-D constructs allows one to form space quickly; however, that ability is not necessarily conducive to a responsive design. Also, the predetermined parameters created by advanced computer-aided design software can lead many offices to follow the path of least resistance rather than explore alternative conditions that may be more responsive to the ultimate user.

Advanced and emerging technologies are tools, like hand drawing, model making, and cognitive imagination, to envision, explore, and document designs. A lack of evidence-based design and a misunderstanding of cultural conditions can lead the architect to rely on the medium of technology as the driving force of

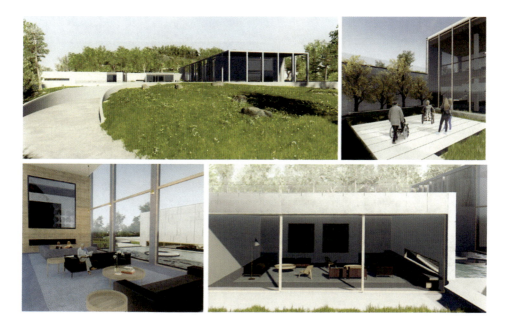

FIGURE 5.4: Felipe Palacio Trujillo. Polyphony. 2018. Unreal Engine video stills. Courtesy of Artist.

the design. Instead, it should be the architect him/herself working with the client to bring an understanding of these complex factors to the design.

Importance of culture

The critique at the beginning of this chapter could be summarized as the fear of ubiquity. Brolin (1976) laments that the international style of architecture lacks a cultural understanding of place, which makes buildings seem generic and listless. He outlines arguments that others have stated about the international style: "The proponents of modern international architecture say that its universal form-language is the logical outcome of a rational approach to design with new materials and techniques" (p. 10). He continues that "[t]he bewildered onlooker is told that these new forms, devoid of heritage are 'functional' or 'economical' or 'dictated by new materials and techniques'" (p. 15), but these are simply rationalizations for stylistic preferences. "There is no practical inevitability to modern forms" (p. 8). Brolin finalized this thought by stating that "public apathy [about modern architecture] is largely due to the fact that the majority of people are disturbed by the sterile appearance of modern buildings and are not interested in intellectual ideas

that the buildings represent" (p. 9). However, a more advanced understanding of modernism would note successful examples of cultural adaptations, such as those seen in Brazil and Japan. Through a response to place, its people, its history, and its environment, architects can craft culturally potent buildings within either a modern or historical framework.

Two examples of how prevailing cultural currents can affect architecture in the ancient world are the Parthenon in Athens and the temple site at Machu Picchu. Both are public religious sites located in arid climates, in earthquake prevalent zones, and have processional scared paths that lead to the sites with gates framing spectacular views. While this categorization is a simplification of a complex design process and years of construction refinements by these two ancient civilizations, it expresses the overarching cultural ideology of these people. According to Kitto (1951), the Polis [the city-state]

> originally a local association for common security, became the focus of a man's moral, intellectual, aesthetic, social and practical life, developing and enriching these in a way in which no form of society had done before or has done since.
> (p. 11)

The Polis is represented in stone at the Parthenon in Athens. Once one emerges from the Propylaea Gate, the view is of a building with refined and exquisite proportions, grounded in natural stone, framed by the sky—it is a monument to social construction and human proportions. Myths posit that Athena and Poseidon, the main gods of this site, battled for the hearts of the Athenian people. Athena won, and the Parthenon is a temple celebrating her victory. This view reflects a religion and philosophy based on humanistic centered gods. The site demonstrates "that the Greeks consciously strove to make the life both of the community and of the individual more excellent than it was before" (Kitto, 1951, p. 11). The refinement of the buildings demonstrates humanity conquering nature.

An alternative example is offered by Humberto Rodriquez-Camillion (2007) in a lecture at Virginia Tech about Machu Picchu in Peru. He states that when one enters the sacred gate to the temple at Machu Picchu, the double-jamb doorway frames a sacred mountain. He explains further how different this is to that of Parthenon, where the view from the gate was of a human-constructed object. Wright and Zegarra (2001) agree when they say that "time and again we are impressed by the effort and thought that went into framing and incorporating the natural beauty of the place and its surroundings" (p. 16). For example, at Machu Picchu, the doorway frames the sacred mountain of Huayan Picchu. In this site, the first view of the processional gate is that of the sacred mountain. It demonstrates the importance of Mama Pacha to the religion of the Incas and other civilizations in

Peru before them (p. 16). Wright and Zegarra continue thus: "The natural features not only satisfied their aesthetic sense but also held great religious significance and fit into the Inca worldview" (p. 16). The Incan religion was based on the worship of the earth goddess Mama Pacha. The main components of this religion were the Condor, the Puma, and the Snake, which are nature-based entities.

Thus, one can see how the inclusion of culture in the built environment was essential to ancient civilizations to instill a deep connection between the buildings and the people who occupy them. The need for architecture to respond to the genius loci and our collective cultural zeitgeist remains today. Culture is a broad term and encompasses many attributes of society. Jani (2011) holistically defines culture as that which

> represents the cumulative knowledge, experiences, beliefs, values, attitudes, meanings, hierarchies, religions, notions of time, roles, spatial relations, concepts of the universe, and material objects and possessions acquired by a group of people over the course of generations through individual and group striving.
>
> (p. xx)

Jani's (2011) definition speaks to how these collective aspirations weave together to form a model for society as a whole, one that guides human behavior while also providing the social structure upon which these actions hare judged. A dominant culture is often born from and controls key social institutions such as education, communication, political process, law, business, and artistic practice (p. xx).

King (2019) parallels these ideas when he states that all "professions which deal with the realities of the built environment need (and in many cases, also want) to understand questions concerning the long term economic, social or political outcomes of particular design policies or decisions." By doing so, architects and designers can utilize culturally relevant practices to create meaningful and appropriate spaces (p. 397).

Other researchers are also exploring various ways to make architecture more responsive to the social, economic, and cultural needs of society. Amos Rapoport (2019) is examining how environmental-behavior studies, anthropology, and other relevant fields can create better and more supportive environments. He states that many advocates of modern architecture think that technologically advanced societies share a collective background, but he posits that each culture reflects its past. He notes that "one way of expressing this connection is through visual traditions, but these have been intentionally excluded from modern cities throughout the world," lamenting that "the spiritual loss is real and people of all cultures sense it" (p. 12).

In response to these critiques, Susan Winchip's (2010) book examines visual culture through a nonlinear approach rather than the traditional sequential study of events. The book divides the study of the built environment into six categories: politics and government, the effects and conditions of the natural environment, technological developments, life and work styles, visual and performing arts, and business and economics (p. xix). These are presented using a global interdisciplinary framework and by such study, both the divergence and convergence of world events.

An example of the complexity of this process is the redesign of Paris in 1850–70. Winchip (2010) outlines multilayered concerns present during the period of instability in the sixteenth and seventeenth centuries, when revolutionaries took advantage of the crooked and narrow street patterns of the old city and blockaded certain areas (p. 13). She further notes that this unplanned cityscape gave the revolutionaries a tactical advantage. City streets were blockaded with each period of civil unrest from the 1789 French Revolution to the 1848 February Revolution. These blockades were made famous by the painting Liberty Leading the People by Eugene Delacroix and in the book Les Misérables by Victor Hugo. Consequently, a new street layout was needed to accommodate the army and limit the ability of people to block the streets. Georges-Eugène Haussmann's new design for Paris included "large, open areas and wide boulevards" (pp. 13–14).

The new city plan was not only a defensive strategy but also a visual one. Winchip (2010) states that "Napoleon [III] wanted a city plan that reflected the glory and power of France by adding more civic buildings, parks, gardens, and modern amenities, such as gaslighting, underground sewers, and adequate healthy water" (p. 14). This urban plan, which reinvented the formal order of city planning, was constructed from 1853 to 1870. This city planning model "establishes a formal architectural order with grand processionals and open public spaces" that harken back to Roman public structures and "reflect the power and glory of Paris" (p. 14). This project, which began with military concerns grew into a publicity campaign for the state grandiosely expressing the economic and political climate of the time, while incorporating technological advances that improved the health and welfare of the public. It demonstrates the complexity of the forces that affect the built environment and how visual means not only relate to but also propel political power and national identity.

Winchip's (2010) arguments expand to include other aspects of the built environment including how technological developments such as elevators, steel frame building, and the development of glass technologies led to the "Chicago School [of Design] and skyscrapers" (p. 19). She summarizes her approach to this study by noting thus: "In the 21st-century era of globalization, these discussions are included to help understand culture as well as other non-traditional topics that

are excluded from most traditional history formats." She finishes with the following statement: "To have a contextual understanding rather than memorized facts, a reader needs a narrative that discusses the causes and effect of visual culture" (p. xx).

Jani uses a similar technique to examine culture through another nonlinear nonhistorical approach in her 2011 book, where she examines cultural diversity through case studies of seven distinct nonwestern cultures. She states that her reason for this systematic examination "is to focus on the cultures and traditions of selected countries in order to understand how social and physical influences have affected contributions in the development of architecture and design in the nonwestern world" (p. xv).

Jani (2011) notes that "Western culture, as we know it today, [was] developed based on ideas of democracy and civil liberty of Greek philosophy, Judeo-Christian religious belief, Roman law, and the ideals and values of the Renaissance in Europe (1400–1650)" (p. xix). She discusses the nonwestern world as various cultures that developed independently over millennia in various areas of the globe that grew from unique belief systems and philosophies. She continues that "these civilizations also developed a virtual athenaeum of literary, artistic, political and scientific principles" which "differed widely from Greco-Judaic-Christian traditions of Western culture" (p. xix).

She begins her book by stating that different environments and cultures need to be deeply examined so that our designs "reflect the ideas and attitudes of our rapidly emerging global society." Her book is written to underscore the need to "design from an inclusive perspective that acknowledges the contributions of all world cultures" (Jani, 2011, p. xiv).

Jani (2011) outlines that to address culture in design, one needs "information on the country's cultures, design philosophies, theories, principles, and symbolic meanings evident in its built forms, furnishings, and applied arts." She also examines how the environment of a given place affects construction. Jani goes on to speak of vernacular design strategies and how these traditional methodologies can inspire a global green future (p. xv).

In a more focused study, Jack Travis (2010) delves deeper into a unique culture—his own. He discusses the details of African American and black design to understand their cultural reflection in the built environment. Travis spent much of his career researching and describing components of black ethos used in interior design and architecture. These are vital components giving a building depth of meaning, and like Brolin, Venturi, and Koolhaas before him, he stresses the importance of culture as "emerging connectivity between those who do the work and those for whom the work is done" (p. 319).

Travis (2010) states, "I contend that it is when a building, buildings, set of buildings, or spaces/places reflect and serve the people of the community for which they are intended" that design is successful. He feels that culturally responsive design "lifts the spirit and provides shelter and functional use that fosters positive aesthetic and tactile relationships" (p. 317). He states that there is a dearth of awareness of how architecture can produce "a sensual environmental design interpretation that speaks to African or black sensibilities in ways that other art forms have evolved." He expounds that "concepts or themes of blackness reveal themselves in art, music, sculpture, writing, poetry, dance, religion, and so many other aspects of the African or black experience" (pp. 317–318).

In addition, he defines parameters for the inclusion of African or black culture in the built environment. The principles he has established for understanding and being sensitive to black culture begin with four points: "Economy, simplicity, ease of construction and ease of maintenance" (Travis, 2010, p. 322). Just like earlier architectural treatises from Vitruvius and Palladio, his list of ten principles gives architects and designers a framework from which to work.

The authors of this chapter posit that cultural relevancy in design engages the public in a critical conversation of a given place or people. Culture can also transcend place to be part of a global conversation operating locally and collectively at the same time. Since culture can be defined so broadly, the architect must assimilate different factors into a design. However, one project cannot correlate to the full complexity of a given culture, and therefore, must be met with an understanding of place in order to incorporate the individual, the environment, and its users.

By activating the mind's eye with cultural content and using an integrated approach to design, architects cultivate the ability to see cultural realities and to ask the essential questions about governing societal conditions. These are accomplished through structured explorations of viewing without a singular expected outcome. Through this process, designers are anthropomorphically decoding information captured in the image as well as utilizing the mind's eye and cognitive imagination to understand current and conjure up new, spatial conditions. This iterative process engages a deep cultural understanding to build a visual lexicon that aides in actively exploring issues of design.

The complexity of cultural integration within a project must be embraced. Architects and designers can hold contradictory thoughts as true and valid while finding a balance between these ideas for a more responsive, holistic, and inclusive environment. This training in complex thinking is why architecture and design education is so strategic and useful in today's society.

Also, we believe that to foster creativity, one must remove preconceived notions and allow research and evidence-based design to create the foundation of a project. By letting go of the known and immersing oneself in the search and evaluation

of new inputs, designers can construct a more comprehensive and meaningful environment.

Visual literacy allows for this democratization of information by making representations of cultural spaces available to everyone. As the complexity of modern practice increases, it is vital to holistically examine architecture through fusing embedded technology with creativity and innovation. To achieve this balance, a synthetic intentionality must be impelled. There is perhaps no better tool available than visual exploration, empowered by both traditional and developing technologies, to enable creativity and unpack the complex social, economic, and political contexts of design.

The Digital Native's natural affinity for technology can be harnessed through intentional viewing and cognitive imagination to process and explore critical cultural issues in design. Through a shifting frame of reference, intentional viewing can explore various social, economic, political, and environmental issues. Digital Native's innate proclivity for technology is an asset that can be expanded through bringing an analytical eye to the various layers of cultural information embedded in the design. It is through this application of intentional viewing that the architect's perspectives on design can be founded on critical cultural discourse. This ability to transcend our reality and place ourselves in distinct cultures allows designers to engage with the complexities of the built environment in ways that are meaningful for those who will ultimately occupy those spaces.

REFERENCES

Brolin, B. C. (1976). *The failure of modern architecture*. New York, NY: Macmillan Publishing.

ElMasary, S. (2006). Design must fit culture. Interview by Marilyn Whitney. December 12.

Hall, G., et al. (2013). Disentanglement and gates. *Design Intelligence—Technology Trends and Innovation Survey*, 31–35.

Jani, V. (2011). *Diversity in design: Perspectives from the non-western world*. New York, NY: Fairchild Books.

Kavakli, M., Stephen, S. A. R., & Ball, L. J. (1998). Structure in idea sketching behavior. *Design Studies*, October, 485–517.

King, A. (1990). Architecture, capital and globalization of culture. *Theory, Culture & Society*, 7(2–3), 397–411, Retrieved from https://journals.sagepub.com/doi/pdf/10.1177/026327690007002023.

Kitto, H. D. F. (1951). *The Greeks*. Baltimore, MD: Pelican.

Koolhaas, R. (1996). Architecture and globalization. In W. Saunders (Ed.), *Reflections on architectural practice in the nineties* (pp. 232–236). New York, NY: Princeton Architectural Press.

MacPhee, G. (2002). *The architecture of the visible*. New York, NY: Continuum.

McGinn, C. (2004). *Mindsight*. Cambridge, MA: Harvard University Press.

McGonigal, J. (2011). *Reality is broken*. New York, NY: Penguin.

Prensky, M. (2001). Digital natives, digital immigrants. *On the Horizon*, 1–6.

Rapoport, A. (2019). *Culture, architecture and design*. Chicago, IL: Locke Science. Retrieved from www.lockescience.com.

Rodriquez-Camillion, H. (2007). Machu Picchu sacred site [Classroom lecture], 28 October.

Sacks, D. (2008, November 1). Green guru gone wrong: William McDonough. *FastCompany*. Retrieved from fastcompany.com/1042475/green-guru-gone-wrong-william-mcdonough.

Travis, J. (2010). Black culture in interior design—Hidden in plain view; 10 principles of black space design for creating interiors. In C. S. Martin and D. A. Guerin (Eds.), *The state of interior design* (pp. 317–325). New York, NY: Fairchild Books.

Venturi, R. (1966). *Complexity and contradiction in architecture*. New York, NY: Museum of Modern Art.

Wilson, D. (2012, 9 July). Training the mind's eye: "Brain movies" support comprehension and Recall. International Literacy Association hub. *The Reading Teacher*, 66(3). http:// dx.doi.org /10.1002/TRTR.01091.

Winchip, S. M. (2010). *Visual culture in the built environment*. New York, NY: Fairchild Books.

Wright, R. M., & Zegarra, A. V. (2001). *The Machu Picchu guidebook*. Boulder, CO: Johnson Publishing.

6

Visualizing Art-Science Entanglements for more Habitable Futures

Kylie Caraway, OCAD University

Introduction

Humans are tangled up with a plethora of other living beings who cohabitate with us here on Earth. Yet, whether because of differing scale, proximity, or temporal relations, many of these beings are hidden from view, going unnoticed in our modern worlds. Nevertheless, they are still impacted by human activity and climate change. Similarly, while there is scientific consensus on humanity's ability to cause significant planetary changes, now commonly referred to as the Anthropocene, it seems that scientific information has difficulty gaining visibility in public discourse (Crutzen & Stoermer, 2000, p. 17). According to the Yale Program on Climate Change Communication, in 2018, 70 percent of US citizens believed that climate change is happening, yet only 57 percent believe it is caused mostly by human activity. Furthermore, 36 percent of US citizens discuss global warming only occasionally, and only 22 percent state they hear about global warming in the media at least once a week (Marlon et al., 2018). These findings indicate that existing media coverage of climate change and its ecological effects remains inadequate given the severity of the global crisis. How are we to persuade humans to change their behaviors when they are neither confronted with nor discussing the environmental changes that are transforming the planet and its future?

Similar to Navare's chapter on the use of visuals in biology illustrations (Chapter 3), I understand that visuality is an important mode of communicating scientific information. Due to dense, complex, and particular terminology, scientific information can be difficult for general audiences to comprehend. And in a time of ecological collapse, it is crucial that we focus our efforts on sharing this information with the general population. Through visual literacy, I believe that environmental communication can use visual practices to convey complex

information. In doing so, it can inspire small actions that will in turn evolve into large-scale change. In this chapter, I assert that a promising avenue for environmental communication is through artistic realms, and in particular, interactive media. Art can communicate scientific research in creative, interesting, and easily comprehensible ways. It provides a space to imagine new perspectives, thoughts, and futures. Today, interactive media is not only a popular form of entertainment, it is also a powerful experiential learning tool. In order to explore the potential for collaboration between interactive media and environmental advocacy, I created an immersive and interactive environment using virtual reality that focused on one of my favorite places impacted by climate change: the sequoia forest in California.

Forests are important for the survival of many species. Trees provide oxygen, food, and habitat for the rich array of creatures residing within the forests of the world. In addition, forests themselves provide for those of us on the fringes of these ecologies. Forests function as carbon sinks, providers of oxygen, food, and shelter—they even lower our psychological stress levels.[1] Yet many forests are vanishing due to agriculture, logging operations, and human development. With this in mind, I decided to focus my creative work on a particular species and its ecosystem: the *Sequoiadendron giganteum* (giant sequoia) in the Sierra Nevadas of California. Renowned for their size and longevity (they can live beyond 3,000 years) sequoias are featured prominently on the US National Park Service logo. Currently, the International Union for Conservation of Nature has categorized the giant sequoia as an endangered species (Schmid & Farjon, 2013). And while these trees are important to conserve in their own right, they are also vital elements of a much grander, complex ecology. When given the opportunity, sequoias promote a flourishing forest, as they produce a tangled web of connections among their fellow species.

In order to explore the concept of trees as species, storytellers, and ecosystems, I created *Mother of the Forest* (Caraway, 2019). *Mother of the Forest* is a virtual reality immersive experience that explores the complex entanglements between creatures in an ecology through various speculated perspectives of species within a sequoia ecosystem. The species highlighted in this experience are all significant characters within a sequoia ecosystem: a Douglas squirrel, mycorrhizal fungi, and a sequoia tree. Taken together, these species' stories give us some indication of the aspects that keep this ecology healthy and lively. Taken individually, their embodied perspectives involve different senses of scale, space, and time, allowing us to consider how individual actions combine to form a system with large-scale effects across vast stretches of space and time. This research-creation[2] combines immersive technology with scientific information and speculative design methods to create an enmeshment between science and art, scientific

fact and fiction, information and speculation, physical and digital environments, pasts, presents, and futures.

Storytelling, becoming-with, entanglements, and symbiosis

In my research-creation, I investigate the notion of tree as storytellers, and the grander concept of "multispecies storytelling" (Haraway, 2016, p. 10). In her 2016 book, *Staying with the Trouble*, Donna Haraway theorizes the importance of working alongside other species for better relations during ecological crisis. While she notes that "anthropogenic processes have had planetary effects, in inter-intra-action with other processes and species, for as long as our species can be identified (a few tens of thousand years)," she explains that there is now a shift from an Earth with humans to an Earth by humans (p. 99). Although Haraway recognizes the effects of humanity on the planet, she abandons terms like Anthropocene and Capitalocene, arguing that they focus solely on humans and their stories. She argues that we do not make history in isolation; rather we work alongside other species (p. 49). Thus, Haraway employs a new epochal term, the Cthulucene, which she describes as

> made up of ongoing multispecies stories and practices of becoming-with in times that remain at stake, in precarious times, in which the world is not finished and the sky has not fallen—yet. We are at stake to each other.
>
> (p. 55)

The Cthulucene changes the narrative of the Anthropocene: it positions human beings as "with and of the earth, and the biotic and abiotic powers of this earth are the story" (Haraway, 2016, p. 55). Haraway declares that it is time to break with individualism, as it destroys our ability to care for others. Instead, Haraway calls for living by and for each other through species entanglements, inviting us to "become-with" in the Cthulucene (Haraway, 2016, p. 16). "Becoming-with" is a "model system in which scientists, artists, ordinary members of communities, and nonhuman beings become enfolded in each other's projects" (Haraway, 2017, M35). "Becoming-with" is learning how to produce stories and lives with one another, both humans and beyond. It is the ability to craft partnerships, to learn how to survive through the care and attention of others.

Other human and animal assemblages are less literal in form, instead taking the shape of relationships, from "companion species" to hidden strangers we share our habitat with (Haraway, 2016, p. 11). These relations are important, as they make up our ecologies. Such entanglements are envisioned in Tsing, Swanson, Gan, and

Bubandt's 2017 anthology, *Arts of Living on a Damaged Planet*. A collection of essays from scientists, creative writers, anthropologists, artists and scholars, the book describes stories between species and landscapes, in order to emphasize the urgent need for multispecies relations in the Anthropocene. Through scientific research, theory, creative writing and artistic practice, *Arts of Living on a Damaged Planet* urges humans to look at both our forgotten past and our complicated present to determine the fate of our uncertain future. It pushes us to respond, to not give up, and to never forget those that are living amongst us.

Species entanglements and relations may seem like imaginative tales out of a storybook—yet, they are situated in our tangible existence. These relationships drive the evolutionary systems of life. The scientific term for these relationships is symbiosis. Symbiosis was conceptualized by German botanist Anton de Bary, who defined it simply as "living together of differently named organisms" (qtd. in Margulis, 1998, p. 33). In her book, *Symbiotic Planet: A New Look at Evolution* (1998), renowned evolutionary theorist and biologist Lynn Margulis explores the connection between symbiosis and the Gaia hypothesis, a concept developed by chemist James E. Lovelock that theorizes Earth as a living system (p. 2). Margulis claims that living systems and evolution are made possible through symbiosis, rather than through the Darwinian theory of natural selection. Symbiosis has many forms: relationships can be mutualistic (both species benefit), parasitic (one species benefits while the other is harmed), and commensalistic (one species benefits while the other is not affected). These relations can be mandatory to survive, or they can be optional. In their own exploration of symbiosis, Tsing et al. (2017) state that "symbioses are vulnerable; the fate of one species can change whole ecosystems [...] This is one of the challenges of our time: entanglement with others makes life possible, but when one relationship goes awry, the repercussions ripple" (M5). Therefore, when a species becomes entangled in another, it makes it difficult to understand it independently from the other, as they change each other's worlds. Like a nesting doll, symbiotic relations occur on both vast and minuscule scales, oftentimes hiding beneath the surface and blurring what it means to be an "individual" in isolation from others. These entanglements necessitate more holistic views of nature.

I argue that collaborations between science, technology, and art can provide the type of multidiscipline practice needed to effectively confront ecological crises. For example, in their article, Ahn, Bailenson, and Park (2014) assert that immersive virtual environments (IVEs) have the ability to influence a user's behavior, and in particular, environmental behaviors (p. 235). In one of their experiments, they compare the effects of cutting down a tree in a virtual environment to reading or watching media about the same subject. They found that those who interacted with the subject matter in the IVE consumed 20 percent less paper than those

who merely read or watched content on the same subject. In another example, Lyons, Silva, Moher, Pazmino, and Slattery (2013) explore the use of "effortful interaction" in educational games to communicate information to users (p. 400). They define "effortful interaction" as a form of human-computer interaction where different types of physical interactions are used to communicate information, relying solely on feedback from the user's own body (p. 400). The researchers demonstrate to users the physical fatigue polar bears experience due to melting sea ice through sensor controllers worn on the head, hands, and feet. In doing so, they created a pedagogical tool for communicating complex scientific information. These examples provide compelling evidence of the potential of an alliance between technology and art to produce new ways of seeing, understanding, feeling, and synthesizing scientific research.

Creative process

The intermingling of science, technology, and art enables *Mother of the Forest* to flip what some might describe as academic collisions into visual collaborations, as it blends scientific fact and fiction, the present and future, with real and imaginary worlds. This intermingling facilitates a better understanding of the sequoia ecosystem while also opening up space to reconsider the role that art might play in scientific discourse. *Mother of the Forest* distinguishes itself as an "art science activism" that relies on the strengths of objective scientific research and subjective poetic creations to illustrate a world that could, in fact, be situated in our present reality, yet hidden from our limited human perspective (Haraway, 2017, M25). It draws connections between the history of these forests, their current state, and their unknown futures.

Stories

In both a scientific and poetic sense, trees are storytellers. We are storytellers together, co-telling and archiving the histories of our world. We are also world-makers. While I create imaginary worlds using technology, I am also a physical world-maker. I am a terraformer, shaping the Earth every day with my consumptions, travels, and experiences. I make worlds for myself, and unintentionally, I make worlds for others. Trees also make worlds for themselves and for others. In order to continue in the spirit of world-making, I wanted to create *Mother of the Forest* using an analogous methodology. Therefore, I used didactic and experiential learning methods to shift the focus of storytelling away from human-centered worlds and histories, to focus instead on stories of worlds created through

collaboration. I asked questions such as how do our limited perspectives shape how we view the world? What do other species perspectives look like?

The first step in my creative process was to collect scientific information about the sequoia forest and its precarity due to climate change. Although there is plenty of information about sequoia ecosystems online, this was no substitute for standing in the forest and absorbing a different kind of information. As I strove to implement experiential learning methods into my project, it became important for me to experience this place directly. I began by reaching out to park experts in the Sequoia and Kings Canyon National Parks. I contacted the Sequoia Parks Conservancy to inquire if there were any individuals available for me to interview. I was put in contact with two individuals: Krista Matias, the programs and volunteer coordinator for Sequoia Parks Conservancy, as well as Dr. Christy Brigham, the chief of resources management and science for the Sequoia and Kings Canyon National Parks. I travelled to Sequoia and Kings Canyon National Parks in November 2018 (Figure 6.1).

The first interview took place over the course of a day-long hike with Matias (Figure 6.2). We trekked through various sections of Sequoia and Kings Canyon National Parks. I asked Matias about the park, the sequoia trees, their ecosystem, the Sequoia Parks Conservancy, and the future of these forests. Matias provided me a great deal of information about the sequoia groves, ranging from their history on earth, to the changes in their lives as they are increasingly surrounded by human civilization. We discussed the impact of climate change on this region,

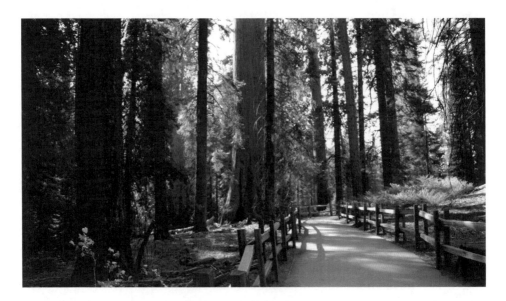

FIGURE 6.1: Grant Grove in Kings Canyon National Park.

VISUALIZING ART-SCIENCE ENTANGLEMENTS

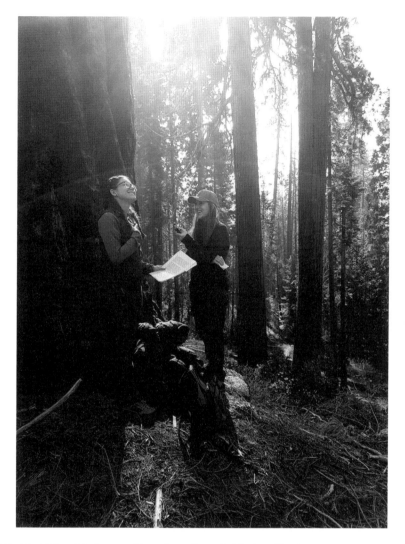

FIGURE 6.2: Krista Matias speaking about Sequoia National Park.

and whether this ecosystem is experiencing biodiversity decline. Matias (2018) noted the importance of California as a biodiverse region, stating that "just here in Sequoia and Kings Canyon National Parks we have 317 different wildlife species and over 1,500 plant species, so there is a great diversity of organisms here supporting sequoia ecosystems" (n.p.). Matias continued by listing some of the critters currently entangled with sequoia trees, including Douglas squirrels that munch on sequoia cones, bats which roost inside sequoia trunks, and mycorrhizal fungi that are literally entwined in the roots of sequoias. These species are

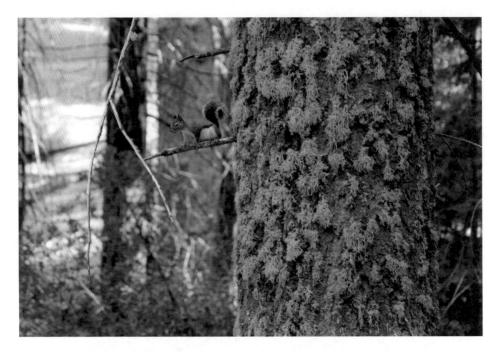

FIGURE 6.3: Douglas squirrel barking at visitors in Sequoia National Park.

in symbiotic relationships in one way or another with sequoia trees, entwining their lives together in collective worlding. I also interviewed Dr. Christy Brigham, the Chief of Resource Management and Science for Sequoia and Kings Canyon National Parks. We discussed some of the broader issues surrounding human impact on the environment, along with more scientific discussions of how sequoia ecosystems operate, how they are impacted by climate change, and the difficulties we (humans) face as we plan for the future. These interviews reiterated to me just how important it is for us to work together in symbiosis to keep these stories, this world, thriving. This reminded me of the Cthulucene: learning to live and die, by and with one another. This is our home. These are our kin. This is someone's future.

When I began this project, I knew I wanted to include the stories of different species. I wanted to tell the story of an ecology, not of a particular species in isolation. Ultimately, I decided to choose perspectives that I encountered while hiking through the sequoia forest: a human, a Douglas squirrel (Figure 6.3), mycorrhizal fungi, and a sequoia tree (Figure 6.4).

I proceeded to develop a script and storyboard. I began this process by brainstorming the following questions: how do humans, squirrels, fungi, and sequoia trees make history? What are their stories? How are they different, and how are they the same? How are they connected to each other, and what happens when one vanishes?

VISUALIZING ART-SCIENCE ENTANGLEMENTS

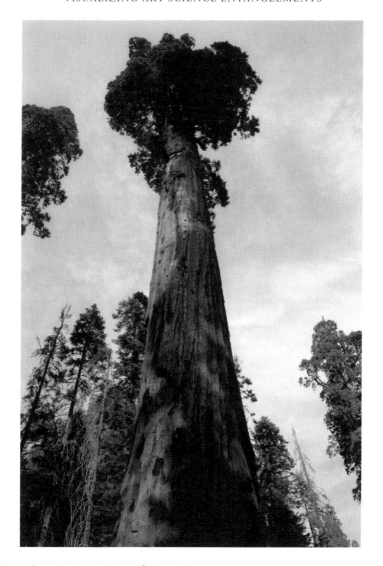

FIGURE 6.4: Sequoia tree in General Grant Grove.

With these inquiries in mind, I began a rough storyboard, teasing out how to change between different stories, perspectives, and worlds through the use of flow charts. I chose to begin *Mother of the Forest* as a human in order to introduce the user to the immersive environment, and to provide history, context, and agency to humanity's impact on these ecologies. This became the introductory, didactic moment to introduce the contextual information of the sequoia forest. I then shifted from a human's perspective to a Douglas squirrel's perspective, beginning

the journey through a sequoia tree's life. After the Douglas squirrel munches on a sequoia cone, the user shifts from the squirrel into a mycorrhizal fungi's perspective, as it feeds nutrients to a sequoia seedling. Then, as the seedling grows, the user shifts to a growing sequoia tree's perspective. The experience finally comes to a close, with the embodied perspective returning to the human in the sequoia forest, closing on a didactic, more philosophical conclusion. This movement through varying perspectives allows for a cyclical experience, as the user shifts from their own perspective to other perspectives of nonhuman subjectivity, scale, space, and time, before finally returning to their original state as human.

My next step was to flesh out the informative and interactive elements in each scene. I divided the script into two sections: scientific fact and speculative fiction. I spent weeks collecting scientific research, transcribing my interviews, and placing scientific facts within each scene. This was a tedious process, as many facts became tied to other facts, causing various pathways to emerge. While I originally believed that dividing these pieces up individually would be easier than creating connections, it came to be the reverse: everything was connected to everything. I kept returning to this theme of entanglement as I edited and condensed the scientific facts of the story.

Once I selected the scientific information to visualize, I weaved the facts and visuals together into a coherent story. Speculating the future was a fairly predictable task. I wanted to focus on the big trends, the climatic reports coming from sources such as the Intergovernmental Panel on Climate Change and the World Wildlife Fund, as well as the smaller effects of climate change. I followed climate projections, and considered what the impacts of biodiversity decline would be in this region; I reflected on what was said in the interviews, and I read other anthropocentric speculations and fictions. And, while speculating the future is an important part of my project, ultimately this question is left open-ended at the end of *Mother of the Forest*—I did not feel a need to answer, because I do not know what the future holds, though it is probably precarious. Tsing (2015) describes precarity as "life without the promise of stability" (p. 2). This uncertain future became the open-ended question that I handed off to the user to walk away considering.

Another major challenge of *Mother of the Forest* was envisioning other species' perspectives. While considering the scale and space of each species seemed fairly straightforward, I also decided to experiment with different perceptions of time. Using Healy, McNally, Ruxton, Cooper & Jackson's (2013) study of species' perceptions of temporal information based on body size and metabolism, I wanted to explore what time would be for a Douglas Squirrel, mycorrhizal fungi, and a sequoia tree. I felt that this might provide a sense of how they experience changes in their climate and ecology.

Following Healy, McNally, Ruxton, Cooper & Jackson's (2013) research, I extrapolated that a Douglas Squirrel might perceive time as passing a bit slower than it does for humans. I also wondered how I might apply this concept to other species, particularly plants and fungi? How might I represent how a tree perceives time when they possess no eyes to test their temporal resolution? Plants respond to cyclical notions of time, from circadian rhythms causing some plants to open in the day and close at night, to transformations in plants from season to season. Furthermore, sequoia trees are known for their immense body masses. If, following their 2013 article, we speculate that a sequoia's large mass and slow communication results in a low "temporal resolution," could we consider that a tree's sense of time, even over a lifetime of thousands of years, would look like a swift passage of time in our eyes? In *Mother of the Forest*, the passage of time for a sequoia tree is visualized like time-lapse photography. This particular shift in time scale is about experiencing the concept of deep time, a time period that lasts longer than human lifetimes. Converting from our time, to a Douglas squirrel's time, to sequoia time, to ecological time, exemplifies how, over a long period of time, things seem to change far more rapidly than we experience in our own subjectivity.

I continued to speculate the various species perspectives. How do they see, and what do they see? What do their interactions with other species look like? How do they perceive or notice the changes around them? How are their stories connected to the ecology? While creating these species perceptions, I became concerned that I would fall into the trap of anthropomorphism or anthropocentrism. Initially, I attempted to embody other species as completely devoid of human traits. No emotions, no sadness, no first-person voice-over, no expression, just scientific facts. Yet, something felt cold and isolating. As I attempted to become as objective as possible, this left a feeling of absence. While there is no doubt a sliding scale to anthropomorphism and anthropocentrism (I was not going to create talking squirrels, trees, or mushrooms), I realized that I could not escape some human traits trickling into this process. I, the human that is creating this artwork, am inherently wrapped up in this creative process. Over time, I realized that my subjectivity would emanate throughout this experience, because it is my thoughts and my efforts that have pushed this project along. Precarity comes up again, "the condition of being vulnerable to others" (Tsing, 2015, p. 20). I think this is what it means to become-with, or at least for me. I am learning how to feel empathy and consider other species, but I am also wrapped up in the empathy I feel, and the actions that result. As I attempt to become-with these species, I can learn things beyond my human form, but I cannot entirely let go of my humanity either.

VISUAL FUTURES

360° Video

My next step in this journey was to ground this creative endeavor in the sequoia forest. I decided to introduce the user to this ecosystem through immersive, 360° footage of the specific, physical forest in California (Figure 6.5). I use this footage to bookend the experience. Each piece of footage embodies a sense of scientific objectivity, as digital archives of the physical forest in California. I felt that this setting would give me an opportunity to tell users about the forest before diving into the digital representations, speculative perspectives, and interactive elements. I also felt like this would be an appropriate medium to close the experience with, to have users walk away from an archive of a physical location, rather than a digital representation.

The first collection of 360° footage introduced at the beginning of *Mother of the Forest* begins with Grant Grove, transitioning to Redwood Mountain Grove, and then to Lost Grove. I chose this trio for the introduction because they captured three important aspects: national parks, ecosystems, and sequoia trees. Grant Grove is the archetypal visual of national parks, particularly of sequoia groves. The forest is manicured—there are paved walkways, sturdy fences, informational plaques, trees with names, and tours throughout the trail. This is a managed park.

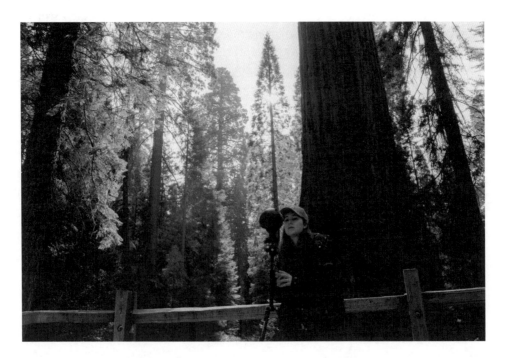

FIGURE 6.5: Setting up the 360° camera in Sequoia National Park.

But while it is beautiful, it feels more like a museum than nature. I transition into Redwood Mountain Grove to consider what a more natural ecosystem looks like. Here, bears dwell, the paths are less clear, and the forest is messy. It is alive. It is not manicured for humans the way Grant Grove is. Finally, the last shot is Lost Grove. Here, the camera is embraced by two large sequoias. I wanted a shot where the user could get up close and personal with these trees, to feel their size and stamina. With the sunlight cusp at the tops of the trees, this was my favorite shot captured over the entire trip. It felt like the best space to transition the user into the speculative environment.

For the conclusion of the experience, I also created a collection of 360° footage from the parks. In this assemblage, I used Big Stump Trail, Redwood Mountain Grove, an overlook on Generals Highway, and Lost Grove. Big Stump Trail is a clear patch that shows the history of human destruction to sequoias. This is a graveyard, a testament to "human progress." This scene shows what past human interventions in this forest looked like, in hopes that future relations can be more mutualistic. This scene transitions to Redwood Mountain Grove where life, death, and renewal are displayed, as the user stands near a sapling, healthy trees, the cavity of a damaged yet living tree, and the remains of trees destroyed by fire. This is the life cycle of many trees of the forest, condensed into one shot. From this scene, the user is transported to an overlook of the forest from Generals Highway. This scene provides a macro perspective, an ability to look out over the forest in order to contemplate what the future of this place might be. In the final moment of *Mother of the Forest*, the user is placed back in Lost Grove, but this time, surrounded by ancient sequoias—both fallen and standing. The implementation of 360° footage in this experience compels the user to ponder the real-life implications of human activity on our present and future world. It allows the user to see their kin archived rather than digitally represented, reducing the cognitive dissonance some may experience while using VR technology to interact with digital depictions of this forest.

Digital worlding

After finalizing the 360° film portion, I jumped straight into the digital worldbuilding, what I consider to be the heart of this project. Using Unity Game Engine and various other resources, I constructed visuals and interactions to complement the voice-over narrative. This portion of *Mother of the Forest* allowed for more creative liberty and freedom; however, I still wanted this part of the experience to be rooted in science. My first step was to produce the digital ecosystem (Figure 6.6).

FIGURE 6.6: Digital ecosystem.

While I was more interested in creating a representation of this environment rather than a simulation, I still wanted to find ways to integrate scientific information with my creative style. My first step was to create the terrain. Rather than loosely model what I envisioned the topography of this section of the Sierra Nevadas to look like, I downloaded a physical, political, and height map of the section of the forest I visited. I used the data from the height map to create a 3-D model of the terrain, while using the other maps to pinpoint distinct locations I visited.

I used photogrammetry models of the vegetation and species native to the area, rather than attempting to model them myself. The photogrammetry models allowed me to incorporate a sense of realism because the models were based on scientific references. Using National Park Service records to document what species were native to the region, I downloaded plants in the general vicinity to the parks. I also took creative liberty and included some assets whose origins were unknown by me, yet nonetheless helped me fill out the ecosystem for aesthetic purposes.

After producing the ecosystem that would be used throughout the project, I began to focus on each species individually. This particular part of the creative process became the most obvious implementation of "becoming-with" for me. With Douglas squirrels, my script focused on their interactions with sequoia pinecones. Therefore, I had to find a way to visualize their physical interactions with the pinecones. In order to do this, I imagined myself as a Douglas squirrel in the top of a sequoia tree, as it moves down the tree to the forest floor. As I moved to the

VISUALIZING ART-SCIENCE ENTANGLEMENTS

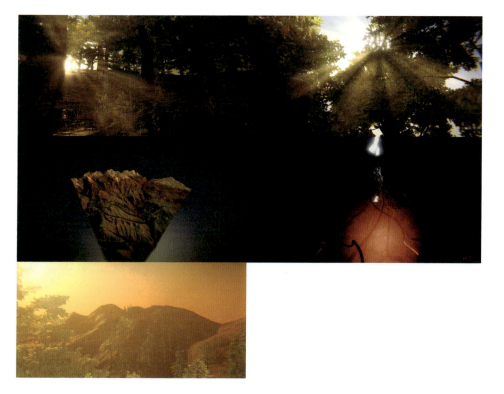

FIGURE 6.7: Various perspectives in the ecosystem. From left corner, clockwise human digital perspective, squirrel perspective, mushroom perspective, tree perspective, ecology perspective.

next species, mycorrhizal fungi, my designs became a bit more abstract. I wanted to find a creative way to form simple interactions to visualize entanglements between the roots and fungi. I decided that, for this species, I would visualize a transfer of resources between fungi and tree roots. This illustrates symbiosis: a sharing partnership between two entwined creatures that promotes liveliness.

When I finally moved to the sequoia tree, I felt a bit stuck. This was the central character of the story. They have so many stories to tell. Which story did I want to highlight? What would be the most effective visualization? I narrowed it down to two visualizations. I would visualize the passage of time by speeding up their life trajectory, from their initial attempts to find sunlight, to their endurance as ancient giants. I would also visualize their absorption of carbon dioxide through animated particle effects.

The theories of deep time, and species' perceptions of time were important for me to visualize in this project. To represent these concepts of time, I focused on creating three different time rates (human, squirrel, and tree) with three different

visuals: lighting, animation, and perspective. My first step was to focus on lighting. Lighting is an essential tool in film and photography for emphasis, tone, narrative meaning, and more. Lighting becomes an even more powerful instrument to signify changes in time. I used a cyclical sky, moving from day to night to emphasize the change in time. To pair this passage of time in the atmosphere simultaneously with the rest of the experience, I animated elements of the environment to move with the flow of time. To further accentuate these movements and passage of time, I also generated a slight motion blur effect on the user's camera for the tree. While the change in the passage of time between human and squirrel is not as obvious, the passage of time as a tree becomes noticeable from the user's perspective.

Once I created the general ecosystem, specific species visualizations, and different perceptions of time, my next step involved constructing the interactions in virtual reality. This would create the sense of interactive play and perception that remains important for the success of this project, as a world-making, making-with research-creation. As Haraway (2016) notes, "perhaps it is precisely in the realm of play, outside the dictates of teleology, settled categories, and function, that serious worldliness and recuperation became possible" (pp. 23-24).

Ironically, I was initially against using virtual reality for *Mother of the Forest*. There were a few reasons for this: (1) the common conception that virtual reality is an "empathy machine" and a sort of gimmick; (2) the fact that many people do not own virtual reality headsets makes it difficult to disseminate; and (3) I often experience motion sickness from virtual reality. These factors worried me. Yet, I was persuaded otherwise by my supervisors, colleagues, friends, family, and several articles I read on the medium. In her article, "Is Virtual Reality the Secret Sauce for Climate Action?," O'Reilly (2018) discusses the use of virtual reality for climate change education and advocacy. She discusses several campaigns and films that use virtual reality to visualize the effects of climate change on the globe. In using virtual reality as a pedagogical, empathy, or advocacy tool for climate change, O'Reilly (2018) claims:

> It's one thing to logically know that humans are inflicting largely irreversible damage upon the natural world. It's another to see, hear, and in a sense feel what's happening from the perspective of those plants and animals at the front lines of drought, fire, and melting ice caps.
>
> (para. 1)

Furthermore, the previously mentioned research on immersive virtual environments impacting users' stance on cutting down trees as well as the use of effortful interaction for polar bears and melting ice caused me to reconsider virtual reality and interaction as effective tools for environmental communication.

Another aspect of virtual reality production that can prove tricky is moving users around an environment. Virtual reality can produce motion sickness for many users, whether it stems from lagging graphics, latency in movements, or a cognitive discord as our bodies move in virtual space while stationary in physical space. This last point is commonly fixed through teleportation locomotion. Luckily, *Mother of the Forest* involves a standing human, an entwined fungus, and a rooted tree. I only had two movement obstacles to overcome: the squirrel's movement throughout the tree, and a growing sequoia. For each of these, I created slow movements between locations, from branch to branch, ground to sky. Although it can be a bit jarring to move between locations, I felt like movement was an important aspect of becoming a squirrel and growing like a tree. While I tried to minimize the likelihood of motion sickness, I also find that a bit of discomfort can provide the sensation that you are no longer human, that this experience is about moving away from the individual to a collective understanding.

Because my target audience for *Mother of the Forest* is not virtual reality or digital game enthusiasts, but general audiences, I observed how different people (friends and family ranging from age 12 to age 82) without previous experience in virtual reality interacted in various virtual reality games. I remained committed to reaching general audiences with an experience that did not require prior knowledge or skills. During these observations, I received feedback from some users that they experienced a lack of embodiment because they could not see arms attached to the controllers, and in many scenes, they did not possess a body/form. While I understand that looking down and seeing no body, or not having arms that match movements may feel at odds with virtual reality embodiment, this ultimately was not negotiable for me. If I were to include these assets, the interaction would either be uncomfortable (e.g., tree branches move slowly, which would require the user to move slowly), the interaction would need latency introduced to keep a sense of realism, which can be nausea inducing, or it would potentially become silly and distracting. I did not want to create a squirrel holding controllers or pointing a furry finger. A fungus does not have arms, and I did not want to produce hyphae tentacle entities holding controllers. This is not *The Wizard of Oz*: I do not want branches to become arms that flail around. I felt that such an approach risked descending into trivial anthropomorphism. As stated throughout this process, I wanted to strike a balance between scientific validity and artistic creation. And while this might be a way of becoming-with, and it may produce something fun, entertaining, or compelling in other experiences, this was not the kind of experience I wanted to create.

Soundscapes

Finally, in order to complement the visual and interactive elements of this multispecies storytelling experience, it was important for me to devote time to audio production. I wanted to recreate the vibrations, rhythms, and oscillating sounds that I encountered in the forest. I wanted to strike a balance between recorded sounds of a forest, created sounds in a studio, and human articulations of these unfamiliar stories in the sequoia ecosystem. Within the sequoia forest, I encountered moments of human noise pollution, moments of natural sounds, and moments of silence. During my hike through the forest, I attempted the simultaneous tasks of interviewing and field recording. In doing so, I practiced a new layer of becoming-with these species and ecosystems. I intently observed and noticed the ephemeral and ever-present sounds surrounding me. It was a somewhat strange experience for me. My first realization was that I do not typically notice sound in my day to day experiences. When I consciously began to notice the sounds around me, it was an extremely visceral experience, akin to a form of information overload. In the sequoia forest, there were undulating waves between melody, cacophony, and silence. A Douglas squirrel barks at a neighbor, followed by sounds of something scurrying away; a woodpecker diligently digs out a spot to place an acorn; a swift rush of wind whistles through the trees; a car drives by, windows rolled down, music ringing; road construction blares through the canyon; fighter jets fly across the sky; and then, silence. While I am unsure if I was perceiving genuine silence, or if my brain was fatigued from exercising this new level of sensory awareness, it felt like every time I grabbed the audio recorder, silence would swallow the area. Silence seemed to envelope the sequoias deep within the canyon, away from roads, construction, and civilization. The trees are so tall that it is difficult to hear the wind in the treetops. Yet, even in that silence, there were brief moments of noise: species movement, snapping twigs, falling branches, human voices, car locks, or traffic horns in the distance.

In order to produce audio for *Mother of the Forest*, an assemblage between four audio sources emerged: forest recordings, the creation of Foley sound effects, voice-over, and score. Matias put me in contact with a National Park Service scientist Erik Meyer, an ecologist from Sequoia and Kings Canyon National Parks. Meyer and Dr. Jacob Job of the Colorado State University Listening Lab record sounds of ecosystems to measure changes in biodiversity. Through acoustic recordings, they archive soundscapes of the forest. I was able to access forest recordings from Meyer, who provided me recordings from Dr. Job, as well as voice-over from Matias. This was an important step to this process: working in collaboration with those who devote their lives to these forests. Through this collection of recorded sounds, created sounds, voice-over, and musical scores, I practiced yet another

experiment of worlding: finding the rhythm of an enduring ecology in precarity, as vibrant materials, species, and systems work together and against one another. In order to use the various pieces of audio, I had to find a way to weave them into one another, as one fades into the next, complements the other, drones out the former, and anticipates the latter. Overall, by tuning in with this ecosystem, I attempted to listen to my complete surroundings, in order to understand the sense of immersion sound can create when one becomes aurally present in a space. Through the observation of sound in the forest, the speculation of sounds and feelings experienced by these species, voice-over narration, and the digital production of sound effects and melodies, my intent was to create a resonance between the digital bodies of *Mother of the Forest* and the tangible bodies of our world.

Exhibition results

Once the immersive experience was finalized and ready to view, I exhibited *Mother of the Forest* at art exhibitions, film festivals, events and, most importantly, to the scientists from Sequoia and Kings Canyon National Parks who helped me create this experience. During my exhibition at the parks, I had the opportunity to engage with the scientists who knew about this project, as well as those unaware of its existence. It was an interesting moment for me, as I watched a different kind of audience experience my work. I was used to artists and filmmakers analyzing my work on its artistic merit and learning the scientific information along the way. Instead, these park employees were primarily interested in the visualizations and technology, rather than the content they already knew and lived amongst. As we talked about why I made certain decisions in my visualizations and the limitations that come with virtual reality, it was encouraging to hear their overall excitement of seeing their research envisioned for general audiences outside of the park and away from its vicinity. I was asked: where will this be exhibited? Who will have a chance to see it? What is the response from audiences? And what is your next project? I had several scientists interested in a future collaboration that featured their research.

After this exhibition, I was invited by the Sequoia Parks Conservancy to be a part of a public lecture on sequoia trees and climate change in Los Angeles, California. Sitting alongside Dr. Christy Brigham and Savannah Boiano, executive director of Sequoia Parks Conservancy, I had the opportunity to exhibit *Mother of the Forest* and speak about the changing world for these sequoias. This was the impetus of this project: creating a connection between scientific data, visuality, and environmental communication; and providing a space to contemplate

the future by crafting new avenues to have a discourse between scientists and their grander community.

Conclusion

In *Mother of the Forest*, I carefully balanced science, art, truth, and beauty as it materialized. These seemingly disparate approaches and fields were combined into one cohesive form, resulting in an interactive, immersive virtual environment. The storytelling and world-making practices interact, both intentionally and unintentionally, resulting in a collection of interwoven stories, spaces, interactions, and times for the user to consider. Throughout this assemblage, I strived for holism, an essential ingredient in ecological thought, communication, and advocacy.

For me, experiencing a species perspective in any format is intriguing in itself. But even introducing the slightest change in experience, from a computer screen to something strapped onto your head, can create a very different feeling of immersion and embodiment. For many, virtual reality is about performance, as much about producing entertainment for a spectating audience as it is about being the user within the experience. Yet, I find virtual reality possesses greater potential and impact when used in solitude, as a medium of contemplation. If you let it, virtual reality has the ability to move you to a faraway place, away from your sense of self. If the content is compelling, it can provide a moment of introspection sometimes lacking in other media, a moment to viscerally consider a new perspective.

My hope is that in *Mother of the Forest* I have leveraged this capacity in such a way as to help scientific information about ecological crisis and climate change finally gain a foothold in public discourse—one user at a time. Through the collaborations between scientific fact, creative rhetoric, and emerging technologies, visuality can apply new avenues to illustrate the world around us—to introduce us to new ways of seeing that can influence the actions we take to build more habitable futures for the world we leave for future generations.

NOTES

1. According to Florence Williams's article in *National Geographic* entitled "Call to the Wild: This Is Your Brain on Nature," (2016), nature has an effect on our stress and ability to improve our cognitive functioning.
2. According to Owen Chapman and Kim Sawchuk (2012) of Concordia University, research-creation projects "typically integrate a creative process, experimental aesthetic component, or an artistic work as an integral part of a study" (p. 6).

REFERENCES

Ahn, S. J., Bailenson, J. N., & Park, D. (2014). Short- and long-term effects of embodied experiences in immersive virtual environments on environmental locus of control and behavior. *Computers in Human Behavior, 39*, 235–245.

Caraway, K. (2019). *Mother of the forest: Contemplating species entanglements in a sequoia ecosystem* (Unpublished MFA thesis). OCAD University, Toronto, Canada.

Chapman, O., & Sawchuk, K. (2012). "Research-creation: Intervention, analysis and "family resemblances." *Canadian Journal of Communication, 37*, 5–26. Retrieved from www.concordia.ca/content/dam/artsci/cissc/docs/Owen%20Chapman%20%20Kim%20Sawchuk%20Research-Creation%20Intervention%20Analysis%20and%20'Family%20Resemblances'.pdf.

Crutzen, P. J., &. Stoermer, E. F. (2000, May). The "Anthropocene." *Global Change Newsletter*, pp. 17–18.

Fabbula Magazine (2018). Donna Haraway/Speculative fabulation. [YouTube video]. Retrieved from www.youtube.com/watch?v=zFGXTQnJETg.

Haraway, D. (2013, November). SF: Science fiction, speculative fabulation, string figures, so far. *ADA: A Journal of Gender, New Media, and Technology, 3*. Retrieved from https://adanewmedia.org/2013/11/issue3-haraway/.

Haraway, D. (2016). *Staying with the trouble: Making kin in the chthulucene*. Durham, NC: Duke University Press.

Haraway, D. (2017). Symbiogenesis, sympoiesis, and art science activisms for staying with the trouble. In A. L. Tsing, H. A. Swanson, E. Gan, & N. Bubandt (Eds.), *Arts of living on a damaged planet* (pp. M25–M50), Minneapolis, MN: University of Minnesota Press.

Healy, K., McNally, L., Ruxton, G. D., Cooper, N., & Jackson A. L. (2013, October). Metabolic rate and body size are linked with perception of temporal information. *Animal Behaviour, 86*(4), 685–696.

Lyons, B. L., Moher, T., Pazmino, P. J., & Slattery, B. (2013, June 24). *Feel the burn: Exploring design parameters for effortful interaction for educational games*. [Paper presentation].12th International Conference on Interaction Design and Children, 24 June, New York, NY, USA.

Margulis, L. (1998). *Symbiotic planet: A new look at evolution*. New York, NY: Basic Books.

Marlon, J., Howe, P., Mildenberger, M., Leiserowitz, A., & Wang, X. (2018, August 7). *Yale climate opinion maps 2018*. [Map]. Yale Program on Climate Change Communication, Yale University, New Haven, CT, USA, Retrieved from https://.www.climatecommunication.yale.edu/visualizations-data/ycom-us-2018/?est=happening&type=value&geo=county.

O'Reilly, K. (2018, July 29). Is virtual reality the secret Sauce for climate action? Sierra. Retrieved from https://www.sierraclub.org/sierra/virtual-reality-secret-sauce-for-climate-action.

Schmid, R., & Farjon, A. (2013). Sequoiadendron Giganteum. The IUCN Red List of Threatened Species. Retrieved from https://www.iucnredlist.org/species/34023/2840676#threats.

Tsing, A. L. (2015). *The mushroom at the end of the world: On the possibility of life in capitalist ruins*. New Jersey: Princeton University Press.

Tsing, A. L., Swanson, H. A., Gan, E., & Bubandt, N. (2017). Introduction. In A. L. Tsing, H. A. Swanson, E. Gan, & N. Bubandt (Eds.), *Arts of living on a damaged planet* (pp. M1-M12, M23, M71, M141, M176, G1-G14, G31, G65, G143). Minneapolis, MN: University of Minnesota Press.

Williams, F. (2016, January). Call to the wild: This is your brain on nature. *National Geographic*. Retrieved from https://www.nationalgeographic.com/magazine/2016/01/call-to-wild/.

7

Seeing, Sensing, and Surrendering the Inside: Expressions of the Adolescent Self in a "Structured Illustrative Disclosure"

Edie Lanphar, Knox School, and Phil Fitzsimmons, Alphacrucis College

Introduction: The rationale of sensing to seeing

The following chapter unpacks the findings of a qualitative case study (Flick, 2014) that sought to explore middle school students' perceptions of "self" through the use of Heard's (2016) "heart mapping" exercise as a "structured illustrative disclosure" (Korol & Sogge, 2018). The student respondents were twenty Hispanic middle school students from one Catholic school in southern California. As a scaffolding process leading up to the "illustrative disclosure," these students first engaged in a "reader-response" study (Rosenblatt, 2005) of Harper Lee's *To Kill a Mockingbird*, the completion of a personal essay, and a series of class discussions. A focused discussion on one particular student's response is used to prompt further questions about heart mapping as a new way to think about visual literacy as it relates to middle school students' identity construction. The focused analysis of one heart map provides insight into the potential of visual literacy as a process of knowledge construction, not just the outcome of critical analysis.

The pedagogical rationale for using this multipronged approach is related to two current sociocultural perspectives. First, as Ulin (2018) clearly points out, the teaching of reading and the idea of reading has become a lost art in this current decade. We would add that despite the research available, using visual texts in schools as both a means of enhancing empathetic appreciation and meaning-making in conjunction with reading and writing has also become a lost art in schools. Neuroscience clearly indicates that "empathy is an integral part of learning" (Kumar, 2019, p. 66) Second, from our perspective, the "literacy wars" of the 1990s have not subsided but were subsumed by a focus on teaching reading

through phonics at the elementary level, using transmission of teacher thought as the primary mode in the secondary arena. These conditions fly in the face of current research in that the human brain and neural pathways increase significantly if we "look at meaningful symbols as opposed to meaningless doodles" (Ulin, 2018, p. 45). In other words, the use of cross-semiotic referential connections, which entails the activation through discussion of representations in one system, can be further enhanced and activated by representations in another system. Referential connections are not theorized "as being one to one but one to many interpersonal and intertextual linkages in both directions" (Sadoski & Paivio, 2000, p. 42). More simply put, the teaching of reading in this case study aimed to be reflexive and reactive through the use of a high-quality text, vibrant discussion between all participants in the classroom, writing and sharing reflective responses, and the completion of an intentional visual summation.

Harper Lee's *To Kill a Mockingbird* was the text chosen to be the central interactive focus as it provided a clear melding of the overall teaching aim of seeking to explore the concept of empathy as well as created numerous opportunities for critical personal connectivity for the students. The "daily read aloud" was the core of each language arts session during which the students were encouraged to begin to reflect analytically by responding to teacher questioning regarding the writing craft used by Lee. This reflective process quickly evolved to a point where students were also asked questions concerning their opinion regarding emergent themes; their understanding of concepts such as integrity, empathy, and shame; as well as how these affected the character's lives and how these could underpin their lives.

The visual linkage of drawing "heart maps" arose out of Heard's (2016) assertion that that writing and illustrating personal connections in the form of a heart allows children to identify what "can be seen with the heart" (p. 4), and deeply matters to them as stepping off to illustrating their true identity. The human condition has many ways of finding truth; however, it is through the eye and the ways we visually perceive the world that we primarily find how and where we fit in the world. Heard suggests that this is part of an overall semantic system that children naturally possess. Our eyes provide the mechanism by which we perceive the colors, physical shapes, and movements that surround us, as well shape the meanings of the countless intangibles that bombard each of us on a daily basis. It is perhaps the latter that have the most profound effect and affect on us all, as it is our eyes that initially provide us with a raft of intuitive details, albeit abstractions, that facilitates the translation of "perception-centered" sensory information to logically organized concepts through language.

In the elementary and middle school educational spheres in many educational systems, the term visual literacy has become a part of the English or language curriculum with the aim of providing an opportunity for students to engage with

texts through a personal perception-centered form of reader-response. However, while acknowledging the length of time visual literacy has been a component of many English curricula, Attar and Maybin (2016) also acknowledge that this has become a very confused space given the enormous amount visual material in the current context of young people. However, these researchers note that the main issue is that visual literacy is being downplayed in many classrooms as textual literacy has been privileged, and the opportunity for a critical review of children's literature, often represented with a strong pictorial element, is frequently dismissed.

Summary of research literature: Issues and ideals in the field

As stated, the role of visual literacy in education has been linked mainly to the ideals of critical literacy and the personal understanding of age-related texts that contain visual elements. This entire concept of visuality has become an increasingly contested space within academe, with issues over who is the actual audience of children and young adult literature. These concerns appear not to be a component of school-based practice as the entire concept of visual meaning has begun to drop out of many teachers' classroom practices. While shifting curricula toward national courses and the tensions these create could perhaps be a reason, we would argue that the main reasons are moves toward a supposed back to basics which have overshadowed the long-held research ideal that visual elements in texts provide an opportunity for students and teachers to engage in meaningful dialogue: dialogue that is often unpredictable (Quinn Patton, 2016). As many teachers have received little to no professional development in how to implement visual literacy, and have become embroiled in the reductionist arguments of the back to basics call, it would appear they tend to be hesitant to move their classes outside the required narrow parameters of the emerging curriculum demands. Researchers in other fields have also seen a shift toward a reductionist view of the visual toward a flat-based singularity approach in their respective fields. Spiedel (2016) has summed this shift calling it the "photographic convention."

This singularity and linearity flies in the face of current student experience who typically are seen to have entered a hypertextual world with its multiplicity of genres and ever-increasing use of visual aspects. Through computer usage, the latter have become pastiche of computer-generated graphics, animations, and text. Many including Bolter (1991) believe that hypertext and the emphasis on the visual allow students to experiment with writing texts across modalities. However, it would appear that the advent of computer literacy as a component of classroom

practice has only served to add ever-increasing pressure on teachers as well as increasing resistance. While computer usage alone has the potential to provide "two-way communication so that the student may benefit from or even initiate dialogue," leaders in this field such as Kress and Van Leeuwen (2000) have complained for several decades that teachers and students have received little training in how to read or engender authentic interaction with visual texts of all kinds. While more recently Robinson (2015) has concurred, believing that the critical issue is the lack of proof that visual literacy actually works in classrooms and that this lack of proof has led to a negative impact on curriculum development and educational programs, which consequently is particularly harmful within this visual/digital age.

This previous comment in itself is somewhat puzzling given the actual research history of visual literacy that reveals its efficacy. Indeed, the tools of visual literacy, as outlined in Appendix 7.1, have formed the basis of numerous studies revealing its potential and power to engage children. However, what has not been fully unpacked is that these semiotic tools are designed to be potentialities only, and in classroom discussions they are designed to engender and enable each student's understanding of their personal identity. Christianson (2000, p. 9) argues that this is actually the central core reason for using visual literacy in classrooms as it helps "students excavate and reflect on their personal experiences, and connecting them to the world of language, literature, and society."

This concept has been lurking in the research commentary and findings for some time but seemingly never fully explored. While there has been discussion centered on how the use of these tools can develop realization of cultural identities and issues hidden as a polyvalent voice or palimpsests in literature such as sexism, racism, and ageism, these tools are really designed to engender "disorienting experiences." It should be noted that these should not be destabilizing classroom interactions but times of critical reflection through which students gradually become empowered in an interactive process of self-discovery. The teacher's role is not so much to teach, but act as *reflective foil* so that students discover through self-interrogation and comparison who they are, and what possibilities of personal understanding they could reach.

It perhaps goes without saying that reflection on visual texts is the modality through which greater narratives of self can be achieved. In general, the self-concept is the set of meanings based on our observations of ourselves; our inferences about who we are, based on how others act toward us; our wishes and desires; and our evaluations of ourselves.

Case study design

The design of this project was based on an inside-outside case study within the qualitative paradigm. As such, the first author was able to be an integral component of the classroom while engaging the respondents' classroom artifacts through an etic or outsider perspective. As insider, the first author was able to flesh out the emic perspective of the students in her care, allowing the researchers to gain qualitative distance in order to fully appreciate the entire visual perspective. Or as Flick (2014) states *how it really was*.

The method of analysis incorporated the visual literacy tool developed by Harris, McKenzie, Chen, Kervin, and Fitzsimmons (2008) is included in Appendix 7.1. As stated, the class was asked to complete a reader-response drawing in regard to their understanding of their sense of self and the key memories of their life. The tools of visual literacy were then used as a holistic lens to capture the possible individual essences of identity. It should be noted that although the respondents set in this project were twenty middle school students, one particular student's map has been analyzed as an exemplar of the findings for this chapter. This student's illustration as seen in Figure 7.1 was been chosen as a holistic representation, exhibiting the typical qualities of the group. Thus, to paraphrase Langman and Pick (2019), the purpose of this focused analysis is provided as "an invitation for the reader to think more deeply about their own reactions, reflections of feelings, becoming an interpreter of them and exploring the different subjectivities and identities" (p. 34) and gain insight into visual literacy, not just as a competency or outcome, but potentially a process for critical evaluation of the self in relation to the world.

Compartmentalization of current self

Several thematic elements emerged when applying the visual literacy tools (see Appendix 7.1) to a close examination of the heart map. One of the first visual elements that a viewer is drawn to in this instance is the use of lines to crop and create different sections of the illustration. Each section has been discretely cordoned off into three clear aspects. As Cabiria (2001) found, distinctive compartmentalization is indicative of feelings of loneliness and/or isolation, including the negative impact of marginalization and powerlessness against heteronormative forces.

A second aspect that leaps to the fore when first inspecting this visual text is the use of vector lines, which further reinforces this visual modality of withdrawal. The first of these is a clear central horizon line that almost extends across the central axis, but then meeting a double-colored spiral like intertwined set. These mixed forms and directionality tend to suggest ambivalence or uncertainty. While the intensity and overlaying of the lines suggest a "solidity of a person," the other

FIGURE 7.1: A middle school student's schematic representation of self.

uses indicate a vector of contradiction or uncertainty. As seen in Appendix 7.1, this student's use of a central horizon line is an indicator of a need for security and the lack of certainty related to a notion of self. This horizon line also clearly meets with a line moving down and to the right. This kind of intersection and down focus is often a marker of sinking. Indeed, the zigzag line connected to the central vector, with its heavy emphasis and shift in direction often appear in art, children's drawing, and graffiti as metaphoric markers of "dynamic vibration" and also "perceived disfigurement" (Cabiria, 2001). Further to this point, the downward focus of lines such as these often represent depression.

Dissociation of an authentic self

As seen in the example provided, the majority of lines, iconic representations, colors, and shading occur in the bottom half of the page. The segmentation of line and image has a definitive meaning that provides insight into the student's sense of self. Kennedy (1995) believes that any iconic image below the horizon line is cast as being below the height of the actual viewer or creator of the visual text. Thus, by inference, while seemingly important to this child, the entire scene is actually being socio-emotionally cast as less than. In this lower part of the page, the entire section is often coded as feminine, and the images-as-icons in this lower section of the page are also somewhat ambivalent. This aspect of the overall set of illustrations is divided by a shift in the zigzag line veering to the left. The center to left portion reveals a heavily shaded city nightscape with an overarching rainbow cultured Ferris wheel and rectangular block with sloping down left to right. The word *highroller* has been written at the top of this block. This heavily shaded left-hand section appears to be an attempt at bring in a 3-D aspect through cropping and framing. With its position well below the horizon line and situated within the bottom left with ensuing implications of loss of hope, these framed images would typically be coded as emotionally sinking. There is an interesting contrast with the colored Ferris wheel that, according to Connors (2012), with its circular form is often viewed as wholeness and unity. Again, these sets of visual items speak to a degree of confusion.

Revelation of a transcendent self

While it may seem self-evident, within the overall illustrative framework that tends to speak to a gloomy outlook there are aspects of an existential or a spiritual connection. Appearing in the top half of the page which often denotes a sense or need to rise above the current personal schema and find fulfillment is what appears to be a sketch of the last supper with the words "God Bless" written above it. To the

left is an obvious drawing of the Virgin Mary. While iconically feminine in itself, it also clear that the lines throughout this student's work connect the top half of the illustration with the bottom section. There is literally and psychically a desire for a higher purpose and the realization that there are apparent issues. Thus, this illustration has become an embodiment of the student's self-worth and sense of self. In this instance, the visuality is an extended body that clearly defines a disconnect between the student's body-identity and perhaps gender schema. De Vignemont's (2007) work has classified this disengaged or disjointed personal visual representation as "asomatognosia," or where "parts of the body are felt to not belong to the person and may explain a body-identity dichotomy" (p.439). The issue de Vignemont describes is similar to the sensation felt "by amputees where they can feel the prosthesis to be part of their body" (p. 440).

Conclusion

Although only one student was used as an exemplar in this chapter, there is clear evidence, throughout this cohort's illustrations, that their concept of self was fragmentary and in the process of seeking some form of identity balance equilibrium. While there is obviously a spectrum of self-disassociation, this small-scale project and the single student discussion reveal the possible capability of visual literacy to reveal how students view themselves from a psycho-socio-emotional perspective. This could create a dilemma for both teachers and students in that it could be an uncomfortable and emotional confronting classroom experience. It is therefore crucial that these forms of exercises be carefully crafted reflective interactions and discussions. Visual literacy is much more than an exploration of pictorial strategies but as much a process that can facilitate the exploration of the authentic self and perhaps create authentic classrooms. Further research is needed to better understand how developing visual literacy may also provide processes and tools for understanding identity and concepts of the self.

REFERENCES

Attar, D., & Maybin, J. (2016). The contribution of children's literature studies. In A. Hewings, L. Prescott, & P. Seargeant (Eds.), *Future for English studies: Teaching language, literature and creative writing in higher education* (pp.179–196). New York, NY: Palgrave Macmillan.

Bolter, J. (1991). *Writing space: The computer, hypertext, and the history of writing*. Hillsdale, NJ: Lawrence Erlbaum Associates.

Cabria, J. (2001). Virtual worlds and identity exploration for marginalised people. In A. Peachey & M. Childs (Eds.), *Reinventing ourselves: Contemporary concepts of identity in virtual worlds* (pp. 301–322). New York, NY: Springer.

Christensen, L. (2000). *Reading, writing, and rising up: Teaching about social justice and the power of the written word*. Milwaukee, WI: Rethinking Schools.

Connors, S. (2012). Toward a shared vocabulary for visual analysis: An analytic toolkit for deconstructing the visual design of graphic novels. *Journal of Visual Literacy, 31*(1), 71–92.

de Vignemont, F. (2007). Habeas corpus: The sense of ownership of one's body. *Mind and Language, 22*(4), 427–449.

Flick, U. (2014). *An introduction to qualitative research*. London, United Kingdom: Sage.

Hamburger, J., & Bouché, A-M. (2006). *The mind's eye: Art and theological argument in the Middle Ages*. Princeton, NJ: Princeton University Press.

Harris, P. J., McKenzie, B., Chen, H., Kervin, L. K., & Fitzsimmons, P. R. (2008). A critical examination of the nexus between literacy research, policy and practice. *English in Australia, 43*(1), 57–65.

He, K. (2000). *Theory of creative thinking: The establishment and evidences of DC model*. Beijing, China: Beijing Normal University Publishing.

Heard, G. (2016). *Heart maps*. Portsmouth, NH: Heinerman.

Keegan, D. (1996). *Foundations of distance education*. (3rd ed.). London, United Kingdom: Routledge.

Kennedy, J. (1995). *A psychology of picture perception*. San Francisco, CA: Jossey Bass.

Korol C., & Sogge, K. (2018). The development of a contemplative art program for adolescents and adults: Challenges and unexpected benefits. In B. Kirkcaldy (Eds.), *Psychotherapy, literature and the visual and performing arts*. Cham, United Kingdom: Palgrave Macmillan.

Kress, G., & van Leeuwen, T. (2000). *Reading images: The grammar of visual design*. London, United Kingdom: Routledge.

Kumar, S. (2019). *Elegant simplicity: The art of living well*. Toronto, Canada: New Society Publishers.

Langman, S., & Pick, D. (2019). *Photography as social research method*. Singapore: Springer.

Melrose, A. (2012). *Monsters under the bed: Critically investigating early years writing*. London, United Kingdom: Routledge.

Mersmann, B. (2012). Nature's hand writing abstraction in the work of Henri Michaux. In P. Crowther & I. Wünsche (Eds.), *Meanings of abstract art: Between nature and theory* (pp. 198–216). New York, NY: Routledge.

Mezirow, J. (2009). Transformative learning theory. In J. Mezirow (Ed.), *Transformative learning in practice: Insights from community, workplace, and higher education* (pp. 18–32). San Francisco, CA: Jossey-Bass.

Nowicka, M., & Louise, R. (2015). Beyond insiders and outsiders in migration research: Rejecting a-priori commonalities. *Forum: Qualitative Social Research, 16*(2), 89–112.

Quinn Patton, M. (2016). State of the art and practice of developmental education: Answers to common and recurring questions. In M. Q. Patton, K. McKegg, & N. Wehipeihana (Eds.), *Developmental evaluation exemplars: Principles in practice* (pp. 1–24). London, United Kingdom: Guilford Press.

Robinson, R. (2015). Foreword. In D. M. Baylen & A. D'Alba (Eds.), *Essentials of teaching and integrating visual and media literacy* (pp. i–ii). London, United Kingdom: Springer.

Rosenblatt, L. (2005). *Making meaning with texts: Selected essays*. Portsmouth, United Kingdom: Heinemann.

Sadik, A. (2008). Digital storytelling: A meaningful technology-integrated approach for engaged student learning. *Educational Technology Research and Development, 56*(4), 487–506.

Sadoski, M., & Paivio, A. (2000). *Imagery and text: A dual coding theory of reading and writing*. New York: Routledge.

Speidel, K. (2016). Can a single still picture tell a story? Definitions of narrative and the alleged problem of time with single still pictures. *Diegesis*. Retrieved from https://www.diegesis.uni-wuppertal.de/index.php/diegesis/article/view/128/158.

Stets, J., & Burke, P. (2003). A sociological approach to self and identity. In M. Leary & J. Tangney (Eds.), *Handbook of self and identity* (pp. 128–152). London, United Kingdom: Guilford Press.

Ulin, D. (2018). *The lost art of reading: Books and resistance in a troubled time*. Seattle, WA: Sasquatch Books.

APPENDIX

Tools of Visual Literacy adapted by Fitzsimmons, Harris, McKenzie, and Kervin

Visual Tools	Characteristics and Associated Interrogatives
Actions and Vectors	• What are the lines that "catch" the eye? • What action(s), mood, or energy do these suggest? • Are these lines thick or thin, light, or dark? What do these tell the reader?
Concepts	• What are the icons in this text? • What do they mean? (Holistically) • Are they archetypal or culturally specific? • Are they one off images, and if so, what do they represent? • Are they sliding metaphors? Is one image/concept recreated or reframed through related images? • Are the icons/metaphors created as a holistic concept, action, character trait, or as a series of related concepts?
Color	• How has color been used to convey emotion and induce reality concepts?
Angles	• How does height, use of angles, or size enable the reader to gain a sense of power, position, vulnerability, movement, direction, and emotion? • Are these consistent throughout, or do they vary? • What do these properties speak to the reader about power structures or gender differences?
Framing or Cropping	• How have the frames and flow of frames limited or revealed the amount of information available to the viewer? • Does the framing and cropping reveal information about social relationships, or signal a relationship with the reader? • How have the Long Shots revealed the subject(s)? • (subject in full figure and at a distance from the viewer gives the perception of a more public type of distance) • How have the Medium Shots revealed the subject(s)? framing the upper half of the body, shows a more social type of distance. • How have the Close Up Shots revealed the subject(s)? (usually head and shoulders and suggest a much more intimate and personal relationship to the viewer)

Gaze/Body/ Face as Demands and Offers	• How has eye contact with the viewer/character created a demand for the reader's attention? • How has the eyes/eye contact/diverted gaze become an offer or acquiescence? • Has the diverted gaze freed the viewer to look at a range of other elements first?
Space	• How has centrality or off-centeredness been used to code stability, or instability? • How has the "law of thirds" been applied? What does this imply?
Position	How has placement on the page been used? high on the page = ecstatic feeling, dream vision, power, status. and high self-esteem low on the page = depression/feeling low, low status centered on page = control left = place or position of insecurity, incompleteness right = place of risk, hope movement from left to right = adventure frequency = the more a character is shown, the more insecure they are, even if centered
Perspective	absent horizon = loss of self and place, less open minded, trapped focused horizon = the needed sense of self or security above the horizon = rising to find self/fulfilment, coded as male below the horizon = sinking into loss/trouble, coded as female
Vision	looking out of the frame = looking for the existential, a sense of place, a new temporality looking within the frame = accepting the status quo, place in the world

8

Picturing the State of Visual Literacy Initiatives Today

Dana Statton Thompson, Murray State University

Understanding the state of visual literacy in the twenty-first century

Previous chapters so far have worked to expand our thinking of the visual toward more diverse ways of "seeing and looking" and, thus, ultimately, knowing. This sense of knowing manifests with each investigation of the visual in our everyday life as we have the opportunity to contest, resist, and reappropriate the images we come into contact with. One common thread through these chapters has been this investigation of the visual; those who regularly practice this are, in some disciplines, known as "visually literate." Although visual literacy is not universally taught in K-12 or in higher education institutions, this multifaceted, interdisciplinary concept is evident in many previous and current education-related initiatives. This chapter, in particular, seeks to provide a current overview of the state of visual literacy and to serve as a resource of current visual literacy initiatives. But what does it mean to be visually literate in the twenty-first century, and why does it matter?

Visual literacy as a concept has been discussed in such different disciplines as art history, anatomy, architecture, astronomy, biology, business, civil engineering, chemistry, computer science, dentistry, economics, education, geography, geology, history, law, library science, linguistics, mathematics, medicine, occupational therapy, oceanography, philosophy, psychology, rhetoric, semiotics, sociology, and zoology (Avgerinou & Ericson, 1997; Bamford, 2003; Elkins, 2007; Schellenberg, 2015). As Hattwig, Bussert, Medaille, and Burgess note, visual literacy "has evolved into a multifaceted, interdisciplinary concept" and "its scope and definition are dynamic and have often been crafted to best fit particular contexts" (Hattwig, Bussert, Medaille, & Burgess, 2013, pp. 62–63). While it would appear that the exploration of visual literacy across many disciplines would

indicate inclusion into the curricula, these explorations lack a common language; each exploration stands on its own, in its own context, rather than as one part of a whole. Blummer (2015) even argues that the multitude of disciplines which explore visual literacy is the reason for a lack of systematic inclusion in education. Jordaan and Jordaan (2013) reinforce this idea: "Because the visual is so pervasive across disciplines, it has become the responsibility of everyone to teach it, and, therefore, nobody (formally) teaches it outside a few specialist disciplines" (pp. 89–90). Perhaps, instead, it would be more productive to view this multidisciplinary and interdisciplinarity as a boon; as Kędra (2018) argues, "the lack of coherence concerning a VL [sic] definition should be perceived as an outstanding feature of this multidisciplinary field" (p. 68). Even so, as of yet, scholars have yet to agree what it means to be visually literate (Avgerinou, 2003; Avgerinou & Pettersson, 2011; Brill, Kim, & Branch, 2007).

The importance of visual literacy in the twenty-first century

As Paivio, Rogers, and Smythe (1968) note, prior research has shown that images are easier to recall than words and, in comparison, "pictures are more effectively stored in or retrieved from" both long- and short-term memory (p. 138). Indeed, Hicks and Essinger (1991) state research in cognitive science suggests that users prefer visual displays of information to verbal descriptions (as cited in Metros, 2008, p. 105). This reflects Avgerinou and Ericson's (1997) summary of Patterson (1962), Rigg (1971), and Spencer (1991):

> The way we learn, and subsequently remember, bears a strong relationship to the way our senses operate. This means that we, as educators, cannot afford to ignore the fact that a very high proportion of all sensory learning is visual.
>
> (p. 287)

As this research has come to light, more and more educators in fields as diverse as astronomy to anatomy have called for curriculum to include visual learning in addition to verbal. Little, Felton, and Berry echo this increasingly common sentiment:

> At a young age, sighted individuals learn to "see" in ways that come to seem effortless and automatic. As teachers, we have a tendency to conflate this effortless seeing with visual literacy, assuming that students who possess the requisite baseline skills to "see" can, and therefore do, carefully observe and analyze each image before them. However, the often cursory attention students pay to the task of seeing a new image or reseeing a familiar image is not sufficient to produce a detailed observation

of what is there, let alone a sophisticated interpretation of what it might mean. We do not expect students to master a complex written text quickly, so why do we let them get by so easily with a visual one?

(2010, p. 46)

Students of all ages do not carefully observe and analyze each image before them (Brumberger, 2011; Bridges & Edmunson-Morton, 2011; Felten, 2008). Because they are not taught to do so, they are unprepared to critically understand the images they come into contact with on a daily basis, especially in an online environment.

In fact, numerous studies have shown that students are not "Digital Natives" as Marc Prensky so infamously opined; "Digital Natives" being those that "think and process information fundamentally differently from their predecessors" due to their interaction at an early age with technology (Prensky, 2001, p. 1). Some of the most well-known counterarguments include Bullen, Morgan, Belfer, and Qayyum (2008), Kennedy et al. (2007), and Kvavik (2005) whose arguments can be surmised as negating Prensky's central premise. More recent research into the "Digital Native" assumption has indeed provided evidence showing that "there is no such thing as a digital native who is information-skilled simply because (s)he has never known a world that was not digital" (Kirschner & Bruyckere, 2017, p. 135). This state of affairs has not improved, as Matusiak, Heinbach, Harper, and Bovee prove in their study published in 2019, writing: "Frequent interactions with images in online environments do not automatically translate into better visual literacy skills, and in some cases, may even lead to disregard of images as information resources" (p. 134). Cordell (2016) notes the danger this poses:

[O]ur students inhabit an information landscape in which visual data is a key component. In school, at work, and in everyday life, humans receive a steady stream of images: photographs, infographics, maps, illustrations, advertisements, etc., which must be processed, interpreted, validated, and incorporated into their personal knowledge base. In the modern world, visual fluency is a critical literacy skill.

(pp. 4–5)

It is this critical literacy skill that we examine in this chapter in particular. As Caraway and Kinnear presciently remind us in the Chapter 1, the predominance of the visual and the ways of seeing in contemporary media is up for debate—ignoring them is not.

This seemingly emergent understanding of *the visual as imperative* reiterates former calls for universal visual studies and visual literacy programs; unfortunately, these calls have largely been ignored in the past. In the twentieth century,

the call for visual literacy education frequently coincided with advances in technology; first, in the 1950s and 1960s with the growing popularity of television, and then in the late 1980s and early 1990s with rise of the global internet. With the rise of the smartphone in the 2010s, our interaction with images frequently happens in conjunction with social media apps such as Facebook, Instagram, or YouTube. And while it is true that "humans have always used their eyes to navigate the environment" (Fahmy, Bock, & Wanta, 2014, p. 84), as the twenty-first century marches on, it is clear that the way we currently encounter images differs from previous generations:

> [O]ur mediated environment increasingly presents visual messages to persuade, entertain, and possibly seduce us into believing that by seeing something we are learning something. We watch television for the news rather than read it in a newspaper, send memes to our friends instead of riddles, interpret the commercial world through logos.
>
> (Fahmy et al., 2014, p. 84)

As the ability to see coincides with the inability to decode images, our now constantly mediated environment provides the renewed impetus for integration of visual literacy skills and competencies into the curriculum. Our attempt to do so up until this point has been a failure.

Recommendations for visual literacy initiatives in the twenty-first century

Over the past 50 years and counting, visual literacy scholars have made several recommendations on how to integrate visual literacy into the curriculum. In 1973, Purvis predicted what many consider to be the foundation for instilling and installing visual literacy initiatives into the curriculum. He proposed education, materials, and programs for preservice and in-service teachers on visual learning and noted that

> [t]he concept of visual literacy is such that it enables program developers to operationalize it in many forms. It is not a program that is implemented at a specific grade level for a specific period of time. There is no closure to visual literacy. Visual literacy is that growing awareness on the part of teachers and pupils of greater alternative responses to a constantly changing visual world. It appears as if at every point in the curriculum where the teaching of verbal skills is justified, corresponding visual skills can also be justified.
>
> (Purvis, 1973, p. 715)

Important to our conversation are two points of consideration. The first is the idea that there is no specific grade level associated with learning visual literacy skills. This opens the door for K-12 teachers to engage with visual literacy in a more intentional manner and does not tie visual literacy education to a set of educational accreditation standards.[1] The second is the acknowledgment that those who train the preservice and in-service teachers must be taught about visuals for the twenty-first century. Too often, it is noted what should be taught without follow-through with the requisite educational resources or training. Given this pervasive cycle, how are educators to learn? This lack of completion in the education cycle of "teachers teaching teachers" has been one of the causes of the current state of affairs. In order to get past this impasse, educators must be educated in visual literacy skills and competencies. One potential way of doing this would be to modify the ACRL *Visual Literacy Standards*, which will be discussed in more depth later, for primary and secondary education and educators.

The second recommendation rests with higher education. If K-12 education in visual literacy can happen at any time and in any subject, it is important to consider what happens next. Noting this opportunity, Metros and Woolsey (2006) stated:

> Higher education has the opportunity to take a systemic institutional approach to defining core values that include visual acuity alongside the ability to read and write, formalizing curricula that teach skills and engage students, and initiating debate on issues related to how visual literacy benefits society.
>
> (p. 80)

This formalization in higher education is the next step needed as students become more educated in their disciplines and their subjects more niche. As previously noted, visual literacy education has the tendency to become discipline-specific at the tertiary level. By educating students about how visuals are contested, resisted, and reappropriated in their own discipline, it is possible for students to engage with visuals at a deeper level. The following questions proposed by Little, Felten, and Berry allow us to envision and formalize curricula in higher education by asking ourselves the following questions:

1. What kinds of student interpretations, projects, and understanding constitute appropriate levels of visual literacy in a disciplinary or general education course?
2. More broadly, what does visual literacy look like on a curricular level? How do we approach the development of visual literacy systematically and intentionally? Rigorously? Sequentially? Cumulatively?

3. How will we assess visual literacy in courses, programs, or across the curriculum?
4. What support do faculty, librarians, technologists, and administrators need to integrate visual literacy into the heart of liberal education?

(2010, p. 49)

These questions can be used by individual faculty, departments, colleges, and national organizations to determine how best to integrate visual literacy curricula into their areas of study.

In 2009, visual literacy scholar and oracle Maria D. Avgerinou spoke to the future nature of visual literacy education, writing:

> Some years ago, VL [sic] skills were considered as students' future needs. Today, that future is our present: The communication and information revolution has brought about a rather imperialist in nature, visual culture [...] Thus, educators have to face the demand for VL [sic] training more rigorously than in the past. They have to start taking systemic steps towards the direction of introducing the life-skill of VL [sic] to their teaching.
>
> (p. 32)

The future of visual literacy education stands at the threshold. As we practice and engage with our ways of seeing, it is imperative to ask ourselves "what comes next for visual futures?" Elkins (2007) provided us with one possible future in higher education, stating: "My hope is that in a few years, universities will take up the challenge of providing a visual 'core curriculum' for all students. Images are central to our lives, and it is time they because central in our universities" (p. 8).

Visual literacy initiatives in the twenty-first century

In an attempt to identify existing visual literacy initiatives, Zanin-Yost (2007) described 26 available articles, databases, online projects, and organizations. Almost concurrently, Felten (2008) published a resource review for visual literacy that included 25 publications and twelve websites. Blummer (2015), most recently, conducted a literature review of 94 published visual literacy initiatives in academic institutions from 1999 to 2014 (p. 22). Although each of these sheds light on previously existing initiatives or resources, no up-to-date resource exists to explain *current* initiatives—and much has changed in the intervening years as media, political messaging, and technology advances. Given this change in addition to the gap in a systematic approach to centralize visual literacy initiatives, I have used this chapter to seek answers to the following questions:

- What current visual literacy initiatives exist?
- Can these initiatives be easily modified to fit others' needs?

Best practices for visual literacy initiatives

The individual initiatives I identified are listed and described in the following pages; however, I first want to recognize best practices as discovered when identifying common threads between these visual literacy initiatives. The initiatives are organized according to four categories: frameworks and standards; higher education initiatives; museum and education partnerships; and national and international organizations. The best practices for each type of initiative are included under the heading for the initiative.

Visual literacy frameworks and standards

- provide a definition of visual literacy as it relates to the specific discipline or context; alternatively, use the definition provided by the ACRL *Visual Literacy Standards*;
- directly engage with visual learning and provide a series of steps, competencies, or skills that a person should achieve or move through in order to understand images;
- provide a scaffolded approach to visual literacy.

Visual literacy and related higher education initiatives

- have a clear mission;
- secure consistent funding;
- secure dedicated staff;
- provide up-to-date information on their website;
- provide teaching materials for free/in an open-access type format, if applicable;
- advocate for integrating visual literacy into the curriculum, if possible.

Visual literacy and related museum + education initiatives

- have a clear mission;
- secure consistent funding;
- secure dedicated staff;
- provide up-to-date information on their website;
- delineate responsibilities clearly across institutions;

- provide materials for free/in an open-access type format;
- publicize efforts widely.

Visual literacy and related organizations and task forces

- have a clear mission;
- connect, if possible, with the International Visual Literacy Association or the European Network for Visual Literacy as a partner organization;
- provide opportunities for cross-pollination during conferences and webinars;
- provide opportunities for special editions of journals featuring guest editors from other organizations.

These best practices are included so that others may understand the common threads connecting these initiatives within the particular categories I identified and use these best practices as a foundation for their own visual literacy initiatives.

Current visual literacy and visual literacy related initiatives

Turning to the initiatives themselves, it is important to note that I included only search results found in English. Because of this, it is inevitable that initiatives will be missing, especially when it comes to nonwestern and European countries. Even with this limitation in mind, by examining the existing initiatives included below, I believe it becomes possible for visual literacy scholars to better understand the current state of visual literacy, particularly within the United States.

Visual literacy frameworks and standards

Association of College and Research Libraries Visual Literacy Competency Standards for Higher Education (Visual Literacy Standards)

Published in 2011, the Association of College and Research Libraries (ACRL) *Visual Literacy Standards* provides a comprehensive definition of visual literacy for the twenty-first century, defining visual literacy as

> a set of abilities that enables an individual to effectively find, interpret, evaluate, use, and create images and visual media. Visual literacy skills equip a learner to understand and analyze the contextual, cultural, ethical, aesthetic, intellectual, and technical components involved in the production and use of visual materials.

A visually literate individual is both a critical consumer of visual media and a competent contributor to a body of shared knowledge and culture.

(para. 2)

This definition provides "what is perhaps the most extensive and tangible set of visual literacy abilities to date" (Brumberger, 2019, p. 12). There is evidence that this definition is also becoming a common thread in visual literacy research (Thompson & Beene, 2020). The document further explains the purpose of the standards, the goals of the standards, and how to use the standards:

The *Visual Literacy Competency Standards for Higher Education* establish an intellectual framework and structure to facilitate the development of skills and competencies required for students to engage with images in an academic environment, and critically use and produce visual media throughout their professional lives. The Standards articulate observable learning outcomes that can be taught and assessed, supporting efforts to develop measurable improvements in student visual literacy. In addition to providing tools for educators across disciplines, the Standards offer a common language for discussing student use of visual materials in academic work and beyond.

(ACRL, 2011, para. 6)

The document includes seven standards that students should meet to be considered visually literature:

- Standard 1: The visually literate student determines the nature and extent of the visual materials needed.
- Standard 2: The visually literate student finds and accesses needed images and visual media effectively and efficiently.
- Standard 3: The visually literate student interprets and analyzes the meaning of images and visual media.
- Standard 4: The visually literate student evaluates images and their sources.
- Standard 5: The visually literate student uses images and visual media effectively.
- Standard 6: The visually literate student designs and creates meaningful images and visual media.
- Standard 7: The visually literate student understands many of the ethical, legal, social, and economic issues surrounding the creation and use of images and visual media, and accesses and uses visual materials ethically (ACRL, 2011).

These standards are the first to develop and articulate learning outcomes and performance indicators for visual literacy in higher education.

Common European Framework of Reference for Visual Literacy

This framework was created from 2013 to 2016 by the European Network for Visual Literacy (ENViL) (see section titled "Visual literacy organizations and task forces" for more information) as part of the European Union funded project "Development of a Common European Framework of Reference for Visual Literacy" (CEFR-VL). The framework defines visual literacy as "a group of acquired competencies for the production and reception of images and objects as well as for the reflection on these processes" (Haanstra & Wagner, 2017, p. 1).

Presented at the 2016 International Society for Education through Art (InSEA) conference (see section titled "Related visual literacy organizations" for more information), the framework "describes the knowledge, skills and attitudes students have to obtain (and own) to be considered visually competent. The competencies are related to specific situations in daily life as well as domain-specific competencies" (Wagner & Laven, 2015, p. 1). The framework provides a structural competence model of what can be learned in art education by defining levels of competence with respective scales (International Society for Education through Art, n.d., para. 1). The framework, published in English, French, and German, is meant to "cover national, regional, and subject-specific traditions in the diverse European context" (Haanstra & Wagner, 2017, p. 2) and to "describe and reflect

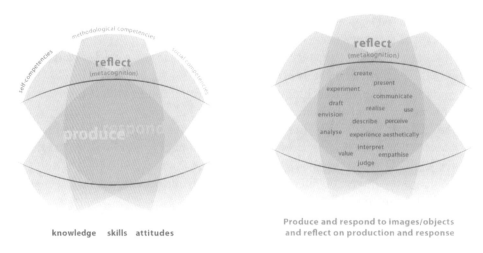

FIGURE 8.1: Basic dimensions of visual literacy (left) and differentiation of sub-competencies (right) of the CEFR–VL competency model.

art education practice in specific countries or situations" (International Society for Education through Art, n.d., para. 1).

Learning Framework: The Jacob Burns Film Center in Pleasantville, New York, USA

The Jacob Burns Film Center (JBFC) is a nonprofit cultural arts center "dedicated to teaching literacy for a visual culture" and created the Learning Framework "based on a decade of experience with over 100,000 students" which "provides a progression of vocabulary, concepts, critical and creative thinking skills to support fluency with visual and aural communication for learners at all stages of their development" (Jacob Burns Film Center [JBFC], 2014a, para. 2).

Each level explains the essential understanding or learning outcome. For example, the Level One "Essential Understanding" of "Viewing" states: "Visual texts use images and sounds to tell stories" and Level Six states: "Deep, critical understanding is formed by the synthesis of the visual text, the creators' point of view and the viewer's subjectivity" (JBFC, 2014b). According to the JBFC, the framework serves to provide "a benchmark for literacy in today's visual culture" (JBFC, 2014b). The JBFC provides resources for schools, teachers, and community

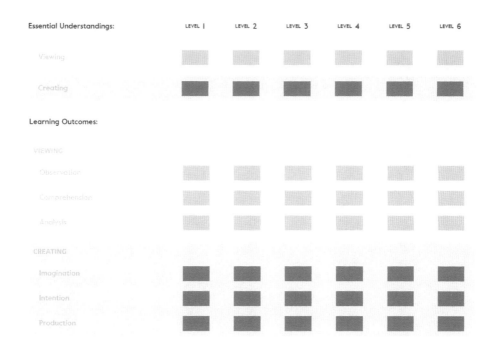

FIGURE 8.2: Jacob Burns Film Center Learning Framework.

organizations and has aligned their programs with the US Common Core Standards for English Language Arts and Literacy (JBFC, 2014c). The center has also developed the "Image, Sound, and Story" curriculum which "provides a scaffolded progression to support learners as they develop their visual and aural communication skills." There are ten "curricular strands": image, sound, story, character, setting, structure, mood, point of view, theme, and style. According to their website, "each curricular strand has ten projects designed to develop students' visual literacy through viewing and discussing curated media; completing short activities called 'View Now Do Nows'; capturing and editing images and video; and revising and reflecting on their work" (JBFC, 2014c).

The Art of Seeing Art™: Toledo Museum of Art in Toledo, Ohio, USA

The Art of Seeing Art™ is part of the visual literacy campaign developed by the Toledo Museum of Art (see the section titled "Visual literacy museum + education initiatives" for other initiatives developed by the Toledo Museum of Art).

Six steps comprise the process of viewing art and images found in everyday life: look, observe, see, describe, analyze, and interpret:

SIX STEPS TO UNDERSTANDING WHAT YOU SEE

LOOK
The first step in the Art of Seeing Art™ process, looking may seem pretty obvious. But it is so important that it is worth calling special attention to. Allow yourself to take the time to slow down and look carefully.

OBSERVE
Observation is where close looking comes into play. Observation is an active process, requiring both time and attention. It is here that the viewer begins to build up a mental catalogue of the image's visual elements.

SEE
Looking is a physical act; seeing is a mental process of perception. Seeing involves recognizing or connecting the information the eyes take in with your previous knowledge and experiences in order to create meaning. This requires time and attention.

DESCRIBE
Describing can help you to identify and organize your thoughts about what you have seen. It may be helpful to think of describing as taking a careful inventory. What figures, objects and setting do you recognize?

ANALYZE
Analysis uses the details you identified in your descriptions and applies reason to make meaning. Analysis is also an opportunity to consider how the figures, objects and settings you identified in your description fit together to tell a story.

INTERPRET
Interpretation, the final step in the Art of Seeing Art™ process, combines our descriptions and analysis with our previous knowledge and any information we have about the artist and the work. Interpretation allows us to draw conclusions about the image.

FIGURE 8.3: The Art of Seeing Art™.

- Look: The first step in The Art of Seeing Art™ process, looking may seem pretty obvious. But it is so important that it is worth calling special attention to. Allow yourself to take the time to slow down and look carefully.
- Observe: Observation is where close looking comes into play. Observation is an active process, requiring both time and attention. It is here that the viewer begins to build up a mental catalogue of the image's visual elements.
- See: Looking is a physical act; seeing is a mental process of perception. Seeing involves recognizing or connecting the information the eyes take in with your previous knowledge and experiences in order to create meaning. This requires time and attention.
- Describe: Describing can help you to identify and organize your thoughts about what you have seen. It may be helpful to think of describing as taking a careful inventory. What figures, objects, and setting do you recognize?
- Analyze: Analysis uses the details you identified in your descriptions and applies reason to make meaning. Analysis is also an opportunity to consider how the figures, objects and settings you identified in your description fit together to tell a story.
- Interpret: Interpretation, the final step in the Art of Seeing Art™ process, combines our descriptions and analysis with our previous knowledge and any information we have about the artist and the work. Interpretation allows us to draw conclusions about the image.

(Toledo Museum of Art, 2018)

The framework walks the participant through each step, outlining questions and considerations for each. Opportunities for exploring visual literacy at the museum include classes, workshops, tours, and gallery experiences.

Visual literacy initiatives in higher education

Center for Digital and Visual Literacy: Agnes Scott College in Decatur, Georgia, USA

Originally funded from 2015 to 2017 by the Andrew W. Mellon Foundation, the Center for Digital and Visual Literacy was created to support the establishment of a program for digital and visual literacy. In 2017, the center was awarded an additional grant to support initiatives to strengthen digital literacy efforts (Andrew W. Mellon Foundation, 2018) and the mission of the center has seemingly shifted to support digital literacy more so than visual literacy. According to their website,

> the Center for Digital and Visual Literacy is a resource for staff, students and faculty to cultivate digital literacy. The center employs staff and student tutors who help

facilitate the exploration of problem-solving options that advance digital and visual skills for academic, personal, and professional projects, ideas, and use.

(Agnes Scott College, n.d., para. 1)

The focus has shifted to helping students and faculty with the creation, curation, and maintenance of digital portfolios, online presence, and projects for academic and professional use.

Center for Visual Literacies: San Diego State University in San Diego, California, USA

The mission of the Center for Visual Literacies is to improve student learning through visually integrated teaching practices and explore the potential of visuals as data and for data analysis in qualitative inquiry (San Diego State University [SDSU], n.d.). According to their website, "The need for applying methodologies that deal with non-text/non-verbal data is high, particularly at a time when cultural mediation is dominated by image-based communication and in an area like San Diego with a high population of English learners" (SDSU, n.d.). The website contains resources such as a bibliography, list of online image banks, and teaching videos. The center is funded by the SDSU President's Leadership Fund and the SDSU College of Education.

Project Vis: Skidmore College in Saratoga Springs, New York, USA

The Project Vis initiative, funded from 2014 to 2017 by the Andrew W. Mellon Foundation, created "two central homes for visual studies on campus": the John B. Moore Documentary Studies Collaborative (MDOCS) and the Program for Media and Film Studies (Project Vis) (Skidmore College, 2018, para. 1). Project Vis is now part of the Center for Leadership, Teaching, and Learning (CLTL) at Skidmore College and will continue "to enhance the ability of faculty, staff, and students to create and understand visual media, and to increase visual literacy throughout the campus community" (Skidmore College, 2018, para. 2). According to their website, the initiative will do this by promoting

- a network for faculty teaching courses with visual content and otherwise engaged in visual studies.
- faculty and staff collaboration with external specialists to supplement our own expertise.
- partnerships with other institutions and organizations.

- faculty and staff development and student learning opportunities that build on existing strengths, to encourage and expand visual media and literacy.
- support for students as they transfer and apply their visual knowledge across courses and disciplines.
- the integration of visual literacy in the context of Skidmore's Goals for Student Learning and Development.
- the development of a mechanism for assessing visual literacy.

(Skidmore College, 2018)

In addition, the initiative created the Visual Literacy Forum which supports visual literacy across the college through workshops and programming.

Teach Visual: DePauw College in Greencastle, Indiana, USA; Oberlin College in Oberlin, Ohio, USA; and the College of Wooster in Wooster, Ohio, USA

Funded by the Great Lakes College Association Expanding Collaboration Initiative, a professional development program with major funding from the Andrew W. Mellon Foundation, Teach Visual is a centralized web repository and portal for visual literacy resources. It includes assessment tools, assignments, lesson plans, syllabi, and readings about object-based learning in a liberal arts context (Great Lakes Colleges Association Museums, 2016). Educators are also encouraged to submit their own materials for consideration and inclusion. Sample assignments include "Dissecting Works of Art," "Poetry and Painting in the 17th Century," and "Close Looking Activities."

Visual Literacy InFUSION Project: Lesley University in Boston, Massachusetts, USA

In 2015, Lesley University received a two-year grant from the Davis Educational Foundation to "integrate teaching visual and textual based teaching methods across all disciplines" and to enable undergraduate faculty in the College of Art and Design to collaborate with colleagues in the College of Liberal Arts and Sciences (Cambridge Chronicle and Tab, 2015, para. 1). Sixteen faculty, eight from each college, were tasked with designing innovative teaching methods and to "explore multiple literacies in model interdisciplinary teaching projects such as teaching history by analyzing photographs rather than text, or teaching art students to articulate what they see through more writing" (Cambridge Chronicle and Tab, 2015, para. 4). As a capstone to the project, Lesley University hosted the 49th Annual International Visual Literacy Association (IVLA) (see section titled "Visual literacy organizations and task forces" for more information) conference

in 2017 to showcase piloted projects and explain new pedagogical approaches for undergraduate teaching. According to their website, this professional development program will continue to use visual literacy to inform undergraduate learning experiences (Lesley University, 2018).

The Visual Literacy Toolbox: Learning to Read Images: University of Maryland College Park in College Park, Maryland, USA

Also known as Teaching Visual Literacy to Students with Technology, this initiative is funded by the Center for Teaching Excellence, the College of Arts and Humanities, the Department of History and the Visual Resources Center of the University of Maryland College Park. It includes learning outcomes, lesson plans, online activities, and a question bank. Examples of activity plans include "Literary Visualization," "Media Analysis," and "Visual Images: Seeing Everything in the Picture" (University of Maryland College Park, n.d.). Important to note, the site contains broken links. The date of the project is indeterminable, however, the project is listed in Alessia Zanin-Yost's 2007 article "Visual literacy resources on the web," and it is also widely cited on the web as a visual literacy resource. For that reason, it has been included here although it cannot be confirmed whether or not the resource is current.

Related visual literacy higher education initiatives

Alliance for the Arts in Research Universities: University of Michigan in partnership with over 40 other institutions

Officially founded in 2012, the Alliance for the Arts in Research Universities (a2ru) is "committed to transforming research universities to ensure the greatest possible institutional support for arts-integrative research, curricula, programs and creative practice between the arts, sciences, and other disciplines" (Alliance for the Arts in Research Universities [a2ru], 2018a, para. 1). The organization seeks to accomplish this by

- Researching best practices for arts-integrative research, curricula, and creative practice in research universities;
- Providing venues for presentation, leadership and faculty networking, and dissemination of research and creative scholarship;
- Advocating for and promoting arts and design practices as fundamental forms of knowledge production applicable to all disciplines.

(a2ru, 2018b)

Each partner institution has a profile which gives an overview of the relevant major, center, and/or college, and the projects which the institution has undertaken. Founding partner institutions include Arizona State University, Dartmouth College, James Madison University, Johns Hopkins University, Louisiana State University, Massachusetts Institute of Technology, Penn State, Tufts University, University of Alabama, University of Alabama at Birmingham, University of Colorado Boulder, University of Florida, University of Illinois at Urbana-Champaign, University of Iowa, University of Michigan, University of Nebraska-Lincoln, University of Virginia, Virginia Commonwealth University, and Virginia Tech (a2ru, 2018c).

How Do You Look?: Nasher Museum of Art at Duke University in Durham, North Carolina, USA

How Do You Look?, funded by the Andrew W. Mellon Foundation and sponsored by the Nasher Museum of Art at Duke University in cooperation with Duke Libraries, was created to promote visual literacy. It is possible to sort the homepage (dated 2013) by Frameworks, Medium, and Periods and Cultures. "Frameworks" includes looking, exhibitions, and collection, collectors, and collections. "Medium" includes paintings, prints, drawings, sculpture, photography, collage and mixed media, multimedia and new media, and installation art. "Periods and Cultures" includes classical art, medieval art, outsider and folk art, African art, art of the Americas, art of Asia, art of the Islamic world, and Russian art (Nasher Museum of Art, 2013). Each category gives background on the selected subject and a bibliography. The website also includes resources for researching, writing, and teaching with visual materials.

Project Zero: Harvard University in Cambridge, Massachusetts, USA

Established in 1967, Project Zero was founded to "study and improve education in the arts" (Harvard University, 2016a). Today, topics of interest include arts and aesthetics; assessment, evaluation, and documentation; civic engagement; cognition, thinking, and understanding; collaboration and group learning; digital life and learning; disciplinary and interdisciplinary studies; ethics at work; global and cultural understanding; humanities and liberal arts; leadership and organizational learning; learning environments; making and design; and science learning. Topics can be explored by level, such as early childhood, primary/elementary school, secondary/high school, higher education, and adult and lifelong learning. The organization also offers online courses for professional development which include "Creating Cultures of Thinking," "Making Learning Visible," "Multiple Intelligences," "Teaching for Understanding," "Thinking and Learning in the Maker-Centered

Classroom," and "Visible Thinking" (Harvard University, 2016b). With over 80 different projects and links to articles, books, tools, and videos, Project Zero has established itself as a valuable resource for exploring "the challenges facing education today and tomorrow" (Harvard University, 2016a).

Visual literacy museum + education initiatives

Advanced Placement classroom visual literacy video series: The Georgia Department of Education, the High Museum of Art, and Georgia Public Broadcasting in Atlanta, Georgia, USA

The Georgia Department of Education, the High Museum of Art, and Georgia Public Broadcasting jointly created a video series on visual literacy for the Advanced Placement classroom. The goal of the videos is to "provide teachers with instructional strategies and effective classroom activities for teaching visual literacy" and for teachers to "use these videos to help students interpret, analyze, and write about art and other non-text materials as it relates to their subject areas" (Georgia Department of Education, 2018). The series covers an overview of strategies for using visual literacy in the classroom as well as teaching visual literacy in art history, English language and composition, English literature and composition, human geography, world history, US history, and European history and within a museum setting. The videos are available to watch for free.

Recommended reads for visual literacy: visualliteracytoday.org

According to the website, "*Visual Literacy Today* is an ongoing conversation about visual literacy, a field of study and practice that explores how we see and interpret images, how we use visuals to convey meaning and what it means to be literate in a digital age" (Visual Literacy Today, 2019). The site was originally created to host the International Visual Literacy Association (IVLA) 2014–15 Selected Readings (see section titled "Visual literacy organizations and task forces" for more information). These ten articles stem from conference presentations at IVLA conferences during those years. The site now also hosts a bibliography of visual literacy, "Recommended Reads for Visual Literacy," which, full disclosure, I created with support of a 2019 Carnegie Whitney Grant from the American Library Association. The resource currently compiles a number of items focused on visual literacy within libraries and across disciplines, as well as research centered around the ACRL Visual Literacy Standards. In time, the resource will also feature seminal books about visual literacy as well as archival materials from the Joel and Irene Benedict Visual Literacy Collection which is housed as Arizona State University.

RETINA (RE-thinking Technical Interventions to Advance visual literacy of young people in art museums) Research Project—the University of Leuven (KU Leuven) in conjunction with the following museums: M Museum in Leuven, Belgium; Ludwig Forum in Aachen, Germany; Design Museum in Ghent, Belgium; Art and History Museum in Brussel, Belgium; and Van Abbemuseum in Eindhoven, Netherlands and the following research institutes at the University of Leuven: HIVA Research Institute for Work and Society and the Meaningful Interactions Lab. (Mintlab)

The RETINA research project's main goal is "to support art museums in defining digital strategies with regards to the topic of visual literacy" (KU Leuven, 2018). Specifically, the project wants to do this by

> support[ing] national and international art museums in defining digital strategies with regards to the topic of visual literacy that appeal to the audience of young people; and use[ing] digital technologies to encourage the transfer of visual literacy abilities beyond the museum walls.
>
> (Mintlab, 2018, para. 3)

The university has partnered with the aforementioned museums and research centers, taking a participatory design research approach to achieve these goals. As of this writing, the results have not been published.

Toledo Museum of Art and the University of Toledo in Toledo, Ohio, USA

The Toledo Museum of Art and the University of Toledo have partnered "to develop a campus-wide initiative in visual literacy that is available to all UT students across all majors" (University of Toledo, 2018a). The partnership includes the Toledo Museum of Art's Center of Visual Expertise (COVE) and the University of Toledo's Center for the Visual Arts in art education, Jesup Scott Honors College in interdisciplinary learning, and University Libraries. The initiative has created the following curriculum modules which can be integrated into existing courses: "Image Use, Search, and Appropriation;" "Infographic Interpretation and Creation;" "Visualizing Data; Translating Ideas through Images and Social Media: Second Law of Thermodynamics;" and "Principles of Design" (University of Toledo, 2018b) (see the section titled "Frameworks and standards" for more information on Toledo Museum of Art initiatives).

Seeing the Whole PICTURE™: Center for Visual Expertise

Developed by the Toledo Museum of Art, a partner of the Campbell Institute at the National Safety Council, and opened in 2018, the Center for Visual Expertise (COVE) teaches visual literacy within the occupational safety industry. According to their website, as part of the visual literacy training program, "COVE has developed a series of training modules to help integrate Visual Literacy into your health and safety programs—to mitigate risk and improve safety" (Center for Visual Expertise, 2018, para. 3). The Toledo Museum of Art and Campbell Institute have published two white papers which informed the creation of COVE: "Visual Literacy: How 'Learning to See' Benefits Occupational Safety" (Campbell Institute, 2017) and "A Second Look: Update on Visual Literacy" (Campbell Institute, 2018).

Visual Thinking Strategies (VTS)

Visual Thinking Strategies is a research-based education nonprofit that offers consulting, curriculum, online summer series, school programs, and workshops to museums, schools, and colleges and universities. VTS is known for the Visual Thinking Strategies Method, an inquiry-based teaching strategy for all grade levels (Visual Thinking Strategies, 2018). The method is used to develop critical thinking, communication, and visual literacy skills and primarily consists of three questions:

1. What's going on in this picture?
2. What do you see that makes you say that?
3. What more can you find?

Facilitators are responsible for asking the questions, paraphrasing the answers, and facilitating discussions. Students and participants discuss their observations, back up their ideas with evidence, and ultimately, discuss multiple interpretations of the object of study (Visual Thinking Strategies, 2018).

Visual literacy organizations and task forces

ACRL Visual Literacy Task Force

The original ACRL Visual Literacy Task Force, which was active from 2010 to 2015 (see https://acrlvislitstandards.wordpress.com/about/) created the *Visual Literacy Competency Standards for Higher Education* (see section

titled "Frameworks and standards" for more information) in 2011 and published their seminal article in 2013 (Hattwig et al. 2013). In 2018, ACRL in coordination with the Image Resources Interest Group (IRIG) reconvened the Visual Literacy Task Force, of which I am a member, with all new members (see https://acrlvisualliteracystandards2018.wordpress.com/about/). The charge from the IRIG was to update the 2011 ACRL *Visual Literacy Competency Standards* and align them with the 2016 ACRL *Framework for Information Literacy for Higher Education*. In their efforts to update the standards, the current iteration of the group has created an online bibliography of 400 sources (ACRL Visual Literacy Task Force, 2019), created a working draft, and has undergone a qualitative research study, the results of which have not yet been published.

European Network for Visual Literacy

The European Network for Visual Literacy (ENViL) was established in 2010 and is funded by the European Commission. From 2013 to 2016, the organization was responsible for developing the European Framework of Reference for Visual Literacy (see section titled "Frameworks and standards" for more information), a project supported by the European Union under the Lifelong Learning Programme in 2014 and 2015. The organization is composed of art teachers, curriculum developers, specialists of didactics, and teacher trainers from 25 countries in Europe. Specific working groups include topics such as assessment/visual rubrics, competence levels, early childhood education, museum education, the theory of artistic thinking, and the visual language of adolescents (European Network for Visual [ENViL] Literacy, 2018).

International Visual Literacy Association

The International Visual Literacy Association (IVLA) was established in 1968 and is a nonprofit association of artists, designers, educators, media specialists, and researchers who are "dedicated to the principles of visual literacy" (International Visual Literacy Association [IVLA], 2019, para. 1). Members come from diverse backgrounds, including but not limited to the arts, business, communication, computer applications, education, health, instructional technology, photography, and videography. According to their website,

> IVLA was formed for the purpose of providing a forum for the exchange of information related to visual literacy. We are also concerned with issues dealing with education, instruction, and training in modes of visual communication and their

application through the concept of visual literacy to individuals, groups, organizations, and to the public in general.

(IVLA, 2019, para. 2)

The association produces the *Journal of Visual Literacy*, which from 1981 to 1988 was known as the *Journal of Visual Verbal Languaging*.

Related visual literacy organizations

Association for Education Communications and Technology

Established in 1923 as the National Education Association's Department of Visual Instruction, the Association for Education Communications and Technology (AECT) is primarily concerned with "promoting scholarship and best practices in the creation, use, and management of technologies for effective teaching and learning" (Association for Education Communications and Technology [AECT], 2018a, para. 4). The organization is composed of eleven projects/committees: Culture, Learning, and Technology; Design and Development; Distance Learning; Emerging Learning Technologies; Graduate Student Assembly; International; Organizational Training and Performance; Research and Theory; School Media and Technology; Systems Thinking and Change; and Teacher Education. Members are from such varied backgrounds as the armed forces, colleges and universities, hospitals, libraries, and museums (AECT, 2018b, para. 1). The association produces two print bimonthly journals, *Educational Technology Research and Development* and *TechTrends*, and three electronic journals, *Journal of Formative Design in Learning*, the *Journal of Applied Instructional Design*, and the *International Journal of Designs for Learning*.

Association for Education in Journalism and Mass Communication: Visual Communication Division

The Visual Communication division of the Association for Education in Journalism and Mass Communication (AEJMC VisCom) represents a variety of application, research, and teaching methodologies relating to advertising, broadcast, digital imaging, film, graphic design, multimedia, web design, app design, computational journalism, photojournalism, propaganda images, human-centered design, visual images and culture, visual literacy, and visual aspects of political campaigns (Association for Education in Journalism and Mass Communication [AEJMC], 2018). AEJMC VisCom also hosts several competitions during the annual AEJMC conference: the annual Best of the Web competition with the Communication Technology

Division, the AEJMC logo competition, the Creative Projects competition, and student and faculty research paper competitions. Since 1994, the division has published the journal *Visual Communication Quarterly*.

Association for Visual Pedagogies

In 2016, the *Video Journal of Education and Pedagogy* (VJEP) was established. The Association for Visual Pedagogies (AVP) was subsequently created to support the VJEP and promote the emerging field of visual pedagogies. The VJEP is the first video journal in the field of education, and is open-access and peer-reviewed. Subjects include educational practices, teacher education, classroom teacher and child observation, and structured interviews with educators involved in studying visuality in education and society. According to their website,

> [i]t aims also to provide a research forum for the production of video articles to facilitate video data collection, production and analysis. The journal aims to develop integrated visual approaches to educational research and practitioner knowledge in order to encourage innovation and to establish new research frontiers in education.
> (Association for Visual Pedagogies, n.d., para. 2)

Founded in New Zealand, the association includes institutional members from Croatia, Denmark, New Zealand, Norway, Taiwan, and the United States.

College Art Association

Established in 1911, the College Art Association (CAA) "promotes these [visual] arts and their understanding through advocacy, intellectual engagement, and a commitment to the diversity of practices and practitioners" (College Art Association [CAA], 2018, para. 1). The organization publishes professional practices guidelines, intellectual property guidelines, and diversity practices guidelines as well as two academic journals, *The Art Bulletin* and *Art Journal*, and two online publications, *caa.reviews* and *Art Journal Open*. The CAA also publishes an online directory of affiliated societies with over 70 organizations included. Several professional development opportunities exist such as the annual conference, awards, graduate student fellowships, publishing grants, and travel grants.

EDUCAUSE

According to their website, "EDUCAUSE is a nonprofit association whose mission is to advance higher education through the use of information technology" and

membership is open to institutions of higher education, corporations serving the higher education information technology market, and other related associations and organizations (EDUCAUSE, 2018a, para. 1). Currently, members include 99,000 professionals from over 2,300 organizations in 45 countries (EDUCAUSE, 2018b). EDUCAUSE has five main focus areas: enterprise and infrastructure, policy and security, teaching and learning, the EDUCAUSE Center for Analysis and Research (ECAR), and the EDUCAUSE Learning Initiative (ELI). ECAR publishes research on technology trends and practices in higher education while ELI provides professional development and online resources. The association also produces the *EDUCAUSE Review*, an open-access digital and bimonthly print publication. In 2018, EDUCAUSE acquired the New Media Consortium (NMC), which was best known for its Horizon Report on the future of education technology (McKenzie, 2018).

Graphic Communications Education Association

According to their website, the Graphic Communications Education Association (GCEA) is "an association of educators in partnership with industry, dedicated to sharing theories, principles, techniques and processes relating to graphic communications and imaging technology" (Graphic Communications Education Association [GCEA], 2018, para. 1). Established in 1922, the organization has published the *Visual Communications Journal* since 1997. The organization also hosts an annual conference which serves to connect educators from high schools, community colleges, and universities with business representatives for workshops, demonstrations, and seminars in emerging areas of the graphic communications industry (Specialty Print Communications, 2017).

International Association for Visual Culture

Established in 2009, the International Association for Visual Culture (IAVC) is an international association of artists, curators, educators, museum professionals, and scholars who are "dedicated to the advancement of Visual Culture Studies in a transnational and contemporary framework" and who are "engaged in critical analyses of and interventions in visual culture" (International Association for Visual Culture [IVAC], 2018, para. 1). The association hosts biennial conferences; conference topics have included "Visual Pedagogies in London" (2018), "The Social in Boston" (2016), "Visual Activism in San Francisco" (2014), "Now! Visual Culture in New York" (2012), and the inaugural meeting in London (2010). The conferences are "designed to be points of gathering organized around politically expedient themes related to the contemporary moment and the host city" (IVAC, 2018, para 5).

International Communication Association: Visual Communication Studies Division

In 1993, the "Visual Communication Interest Group"—the precursor to the Visual Communication Studies Division—was founded at the annual International Communication Association conference; the current moniker was adopted in 2009 (Visual Communication Studies, 2015a). According to their mission statement, the division "seeks to enhance the understanding of the visual in all its forms—moving and still images, displays in television, video and film, art and design, and print and digital media" (Visual Communication Studies, 2015b, para. 1). Research topics include but are not limited to "investigating the interaction of the visual with public policy and law, mass communication processes, corporate image and organization, technology and human interaction, elite and popular culture, philosophy of communication, education and the social sphere" (Visual Communication Studies, 2015b, para. 2).

International Society for Education through Art

Established in 1954 and officially becoming a nonprofit organization in 2009, the International Society for Education through Art (InSEA) is an official partner of the United Nations Educational, Scientific, and Cultural Organization (UNESCO). According to their website, the organization includes

> 1,000 professional and organizational members in 74 countries from the following fields of interest: advocacy, art education, arts, education, cultural diversity, cultural education, cultural mediation, culture, curriculum development, environmental education, inclusive education, interdisciplinary, museum education, peace education, peace education, environmental education, and teacher training.
> (International Society for Education through Art [InSEA], 2018a, para. 4)

The association publishes two peer-reviewed journals. The first journal, *International Journal of Education through Art* (IJETA), is a scholarly journal publishing on topics such as art, craft, and design education; formal and informal education contexts; and visual communication and culture. The second journal, *IMAG*, is a visual journal featuring articles and visual essays that "provide an alternative, experimental and artistic mode of presenting research and praxis" (InSEA, 2018b, para. 1).

National Art Education Association

According to their website, the National Art Education Association (NAEA) is "the leading professional membership organization exclusively for visual arts educators" (National Art Education Association [NAEA], 2018, para. 1). Members include elementary, middle, and high school visual arts educators; college and university professors; university students preparing to become art educators; researchers and scholars; teaching artists; administrators and supervisors; and art museum educators (NAEA, 2018, para. 2). The organization, established in 1947, produces and circulates its national goals and checklists for quality art education to its stakeholders and provides expertise, training, and tools such as workshops, publications, and supporting resources. NAEA officials also regularly meet to discuss issues in arts education with the US Department of Education, National School Boards Association, National Endowment for the Arts, National Assembly of State Arts Agencies, American Council for the Arts, Arts Education Partnership, Alliance for Arts Education, National Association of Secondary School Principals, and other education organizations who are actively concerned with the quality of art education in the schools (NAEA, n.d.).

International Visual Sociology Association

The International Visual Sociology Association (IVSA) is a "nonprofit, democratic, and academically-oriented professional organization devoted to the visual study of society, culture, and social relationships" with members from the following disciplines: sociology, anthropology, education, visual communication, photography, filmmaking, art, and journalism (International Visual Sociology Association [IVSA], n.d., para. 1). The association was established in 1981 and encourages

- documentary studies of everyday life in contemporary communities;
- the interpretive analysis of art and popular visual representations of society;
- studies about the social impact of advertising and the commercial use of images;
- the analysis of archival images as sources of data on society and culture;
- the study of the purpose and the meaning of image-making practices like recreational and family photography.

(IVSA, n.d.)

The association publishes the journal *Visual Studies*, which was known as *Visual Sociology* from 1986 to 2002.

Society for Photographic Education

The Society for Photographic Education (SPE) held its first annual conference in 1963 and the organization was officially incorporated the following year. According to their website, "SPE is the leading forum for fostering understanding of photography in all its forms and related media" (Society for Photographic Education [SPE], 2018a, para. 1) and was originally organized to address the emerging academic field of photographic education which, in the 1960s, was moving from journalism departments to art departments. Members include artists, critics, curators, educators, fine art photographers, historians, and students (SPE, 2018a). The organization's journal, *Exposure*, has been published since 1970 and is "devoted to the analysis and understanding of photography through scholarly insight, historical perspectives, critical dialogue, educational issues, and reviews of contemporary photographic publications" (SPE, 2018b, para. 1).

Visual Resources Association

Established in 1982 after "almost a decade of informal gatherings," the Visual Resources Association is "a multi-disciplinary organization dedicated to furthering research and education in the field of image and media management within the educational, cultural heritage, and commercial environments" (Visual Resources Association, 2018a, para. 1). Members include academic technologists; architectural firms; art historians; art, architecture, film, video, metadata, and digital librarians; artists; digital image specialists; galleries; information specialists; museum professionals; photographers; publishers; rights and reproductions officials; scientists; slide, photograph, microfilm, and digital archivists; and vendors (Visual Resources Association, 2018a). Topics of interest to the organization include

- preservation of and access to media documenting visual culture;
- cataloging and classification standards and practices;
- integration of technology-based instruction and research;
- digital humanities;
- intellectual property policy;
- visual literacy and other topics of interest to the field.

(Visual Resources Association, 2018b)

The VRA offers data standards, metadata standards, resources on intellectual property rights and copyright, and other resources for members including a list of affiliated and related organizations on their website.

In this chapter, I have attempted to outline current visual literacy and visual literacy related initiatives in order to shed light on what current visual literacy initiatives exist and how these initiatives could be modified to fit others' needs. This attempt has been made to encourage others to create and implement their own visual literacy initiatives in an effort to bring awareness of visual literacy and its importance to the education of our students to the forefront of twenty-first-century educational practices. It is time to recognize the visual as imperative and start taking action.

NOTE

1. Because K-12 education is so diverse and country-dependent for accreditation standards and national organizations, it has not been examined in any depth in this chapter. For the most part, visual education has been folded into arts education; however, it is fair to say that most of these programs do not deal with visual or media literacy specifically. The one notable exception to this is the national F-10 curriculum of Australia.

REFERENCES

Agnes Scott College. (n.d.). Center for Digital and Visual Literacy. Retrieved from https://cdvl.agnesscott.org/about-2/.

Alliance for the Arts in Research Universities. (2018a). History. Retrieved from https://www.a2ru.org/about/history/.

Alliance for the Arts in Research Universities. (2018b). United effort. Retrieved from https://www.a2ru.org/.

Alliance for the Arts in Research Universities. (2018c). Partners. Retrieved from https://www.a2ru.org/partner-profiles/.

Andrew W. Mellon Foundation. (2018). Center for Digital and Visual Literacy. Retrieved from https://mellon.org/grants/grants-database/grants/agnes-scott-college/21500618/.

Association for Education Communications and Technology. (2018a). About us. Retrieved from https://www.aect.org/about_us.php.

Association for Education Communications and Technology. (2018b). Home. Retrieved from https://www.aect.org/.

Association for Education in Journalism and Mass Communication. (2018). About the VisCom division. Retrieved from http://aejmcviscom.org/about-the-viscom-division/.

Association for Visual Pedagogies. (n.d.). About the journal. Retrieved from https://visualpedagogies.com/.

Association of College & Research Libraries (ACRL). (2011). Visual literacy competency standards for higher education. Retrieved from http://www.ala.org/acrl/standards/visualliteracy.

Association of College & Research Libraries (ACRL) Visual Literacy Task Force. (2019). *ACRL Visual Literacy Taskforce* [Bibliography]. Retrieved from: https://www.zotero.org/groups/2264485/acrl_visual_literacy_taskforce.

Avgerinou, M. D. (2003). *A mad-tea party no more: Revisiting the visual literacy definition problem* [Paper presentation]. International Visual Literacy Association Annual Conference, Newport, Rhode Island, USA.

Avgerinou, M. D. (2009). Re-viewing visual literacy in the "bain d' images" era. *TechTrends*, *53*(2), 28–34.

Avgerinou, M. D., & Ericson, J. (1997). A review of the concept of visual literacy. *British Journal of Education Technology*, *28*(4), 280–291.

Avgerinou, M. D., & Pettersson, R. (2011). Toward a cohesive theory of visual literacy. *Journal of Visual Literacy*, *30*(2), 1–19.

Bamford, A. (2003). The visual literacy white paper [White paper]. Retrieved https://www.aperture.org/wp-content/uploads/2013/05/visual-literacy-wp.pdf.

Blummer, B. (2015). Some visual literacy initiatives in academic institutions: A literature review from 1999 to the present. *Journal of Visual Literacy*, *34*(1), 1–34.

Bridges, L. M., & Edmunson-Morton, T. (2011). Image-seeking preferences among undergraduate novice researchers. *Evidence Based Library and Information Practice*, *6*(1), 24–40.

Brill, J. M., Kim, D., & Branch, R. M. (2007). Visual literacy defined: The results of a Delphi study: Can IVLA (operationally) define visual literacy? *Journal of Visual Literacy*, *27*(1), 47–60.

Brumberger, E. (2011). Visual literacy and the digital native: An examination of the millennial learner. *Journal of Visual Literacy*, *30*(1), 19–46.

Brumberger, E. (2019). Past, present, and future: Mapping the research in visual literacy. *Journal of Visual Literacy, 38*(3), 165–180.

Bullen, M., Morgan, T., Belfer, K., & Qayyum, A. (2008, October). *The digital learner at BCIT and implications for an e-strategy* [Paper presentation]. The 2008 Research Workshop of the European Distance Education Network (EDEN), Researching and promoting access to education and training: The role of distance education and e-learning in technology-enhanced environments. Retrieved from https://app.box.com/shared/fxqyutottt.

Cambridge Chronicle and Tab. (2015). Creativity Commons at Lesley received $175K grant. Retrieved from http://cambridge.wickedlocal.com/article/20150712/news/150706799.

Campbell Institute. (2017). Visual literacy: How "learning to see" benefits occupational safety [White paper]. Retrieved from https://www.thecampbellinstitute.org/visual-literacy/.

Campbell Institute. (2018). A second look: Update on visual literacy [White paper]. Retrieved from https://www.thecampbellinstitute.org/visual-literacy/.

Center for Visual Expertise. (2018). Programs. Retrieved from https://covectr.com/programs/.

College Art Association. (2018). About. Retrieved from http://www.collegeart.org/about/mission.

Cordell, D. M. (2016). *Using images to teach critical thinking skills: Visual literacy and digital photography*. Santa Barbara, CA: ABC-CLIO.

EDUCAUSE. (2018a). Mission and organization. Retrieved from https://www.educause.edu/about/mission-and-organization.

EDUCAUSE. (2018b). About EDUCAUSE. Retrieved from https://www.educause.edu/about.

Elkins, J. (Ed.). (2007). *Visual literacy*. New York, NY: Routledge.

European Network for Visual Literacy. (2018). Visual literacy. Retrieved from http://envil.eu/.

Fahmy, S., Bock, M. A., & Wanta, W. (2014). *Visual communication theory and research: A mass communications perspective*. New York, NY: Palgrave Macmillan.

Felten, P. (2008). Visual literacy. *Change, 40*(6), 60–63.

Georgia Department of Education. (2018). Introduction to AP visual literacy video series. Retrieved from http://www.gadoe.org/Curriculum-Instruction-and-Assessment/Curriculum-and-Instruction/Pages/Introduction-to-AP-Visual-Literacy-Video-Series.aspx.

Graphic Communications Education Association. (2018). About. Retrieved from http://gceaonline.org/about/.

Great Lakes Colleges Associations Museums. (2016). Teach visual. Retrieved from http://teachvisual.glca.org/about/.

Haanstra, F., & Wagner, E. (2017). Common European Framework of Reference for Visual Literacy (CEFR-VL)—Introduction. Retrieved from http://envil.eu/wpcontent/uploads/2017/09/CEFR_VL-Introduction.pdf.

Harvard University. (2016a). History. Retrieved from http://www.pz.harvard.edu/who-we-are/history.

Harvard University. (2016b). Online courses. Retrieved from http://www.pz.harvard.edu/professional-development/online-courses.

Hattwig, D., Bussert, K., Medaille, A., & Burgess, J. (2013). Visual literacy standards in higher education: New opportunities for librarians and student learning. *Libraries and the Academy, 13*(1), 61–89.

International Association for Visual Culture. (2018). About. Retrieved from https://www.iavc.info/about/.

International Society for Education through Art. (2018a). About InSEA. Retrieved from http://www.insea.org/insea/about-insea.

International Society for Education through Art. (2018b). IMAG. Retrieved from http://insea.org/publications/imag.

International Society for Education through Art. (n.d.). European Network for Visual Literacy. Retrieved from http://www.insea.org/ENVIL.

International Visual Literacy Association. (2019). About us. Retrieved from https://ivla.org/about-us/.

International Visual Sociology Association. (n.d.). About us. Retrieved from https://visualsociology.org/?page_id=235.

Jacob Barnes Film Center. (2014a). Learning framework—For schools. Retrieved from https://education.burnsfilmcenter.org/education/for-schools#spy-framework.

Jacob Barnes Film Center. (2014b). Learning framework. Retrieved from https://education.burnsfilmcenter.org/education/framework.

Jacob Barnes Film Center. (2014c). Learning framework—For schools and teachers. Retrieved from https://education.burnsfilmcenter.org/education/for-schools.

Jordaan, C., & Jordaan, D. (2013). The case for formal visual literacy teaching in higher education. *South African Journal of Higher Education*, 27(1), 76–92.

Kędra, J. (2018). What does it mean to be visually literate? Examination of visual literacy definitions in the context of higher education. *Journal of Visual Literacy*, 37(2), 67–84.

Kennedy, G., Dalgarno, B., Gray, K., Judd, T., Waycott, J., Bennett, S., & Churchward, A. (2007). The net generation are not big users of Web 2.0 technologies: Preliminary findings. In R. J. Atkinson, C. McBeath, S. K. A. Soong, & C. Cheers (Eds.), *ICT: Providing choices for learners and learning. Proceedings of ASCILITE 2007 conference*. Singapore: Centre for Educational Development, Nanyang Technological University.

Kirschner, P., & Bruyckere, P. (2017). The myths of the digital native and the multitasker. *Teaching and Teacher Education*, 67, 135–142.

KU Leuven. (2018). RETINA. Retrieved from https://www.kuleuven.be/samenwerking/retina/project.

Kvavik, R. (2005). Convenience, communications, and control: How students use technology. In D. Oblinger & J. Oblinger (Eds.), *Educating the Net Generation* (chapter 7) [E-book]. Retrieved from http://www.educause.edu/educatingthenetgen/5989.

Lesley University. (2018). Visual literacy at Lesley. Retrieved from https://research.lesley.edu/c.php?g=658321&p=4622473.

Little, D., Felten, P., & Berry, C. (2010). Liberal education in a visual world. *Liberal Education*, 96(2), 44–49.

Matusiak, K. M., Heinbach, C., Harper, A., & Bovee, M. (2019). Visual literacy in practice: Use of images in students' academic work. *College and Research Libraries*, 80(1), 123–139.

McKenzie. (2018). Educause purchases New Media Consortium. Retrieved from https://www.insidehighered.com/quicktakes/2018/02/16/educause-purchases-new-media-consortium.

Metros, S. E. (2008). The educator's role in preparing visually literate learners. *Theory into Practice*, 47(2), 102–109.

Metros, S. E., & Woolsey, K. (2006). Visual literacy: An institutional imperative. *EDUCAUSE Review*, 41(3), 80–81.

Mintlab. (2018). RETINA. Retrieved from https://soc.kuleuven.be/mintlab/blog/project/retina/.

Nasher Museum of Art at Duke University. (2013). How do you look. Retrieved from https://sites.nasher.duke.edu/hdyl/.

National Art Education Association. (2018). About us. Retrieved from https://www.arteducators.org/about.

National Art Education Association. (n.d.). *Education, communication, and empowerment statement*. Arlington, VA: National Art Education Association.

Paivio, A., Rogers, T. B., & Smythe, P. C. (1968). Why are pictures easier to recall words? *Psychonomic Science, 11*(4), 137–138.

Prensky, M. (2001). Digital natives, digital immigrants, part 1. *On the Horizon, 9*(5), 1–6.

Purvis, J. R. (1973). Visual literacy: An emerging concept. *Educational Leadership, 30*(8), 714–716.

San Diego State University. (n.d.). Center for Visual Literacies. Retrieved from http://go.sdsu.edu/education/visual-literacies/Default.aspx.

Schellenberg, J. (2015). *Visual literacy practices in higher education* (Master's thesis). Retrieved from https://oda.hioa.no/nb/visual-literacy-practices-in-higher-education/asset/dspace:10544/Schellenberg.pdf.

Skidmore College. (2018). Project Vis. Retrieved from https://www.skidmore.edu/cltl/project-vis.php.

Society for Photographic Education. (2018a). History. Retrieved from https://www.spenational.org/about/history.

Society for Photographic Education. (2018b). About *Exposure* journal. Retrieved from https://www.spenational.org/exposure/about-exposure-journal.

Specialty Print Communications. (2017). An overview of the 2017 GCEA Annual Conference. Retrieved from https://www.specialtyprintcomm.com/blog/overview-2017-gcea-annual-conference/.

Thompson, D. S., & Beene, S. (2020). Uniting the field: Using the ACRL Visual Competency Standards to move beyond the definition problem of visual literacy. *Journal of Visual Literacy, 39*(2), 73–89.

Toledo Museum of Art. (2018). The art of seeing art. Retrieved from https://www.toledomuseum.org/education/visual-literacy/art-seeing-art.

University of Maryland College Park. (n.d.). Visual literacy toolbox. Retrieved from http://vislit.arhu.umd.edu/index.php.

University of Toledo. (2018a). Visual literacy. Retrieved from http://www.utoledo.edu/honors/visual-literacy/.

University of Toledo. (2018b). Modules. Retrieved from http://www.utoledo.edu/honors/visual-literacy/modules.html.

Visual Communication Studies. (2015a). Division history. Retrieved from https://www.visualcommunicationstudies.net/division-history/.

Visual Communication Studies. (2015b). Mission statement. Retrieved from https://www.visualcommunicationstudies.net/mission-statement/.

Visual Literacy Today. (2019). Recommended reads. Retrieved from https://visualliteracytoday.org/recommended-reads/.

Visual Resources Association. (2018a). About. Retrieved from http://vraweb.org/about/.

Visual Resources Association. (2018b). Membership. Retrieved from http://vraweb.org/about/http://vraweb.org/membership/.

Visual Thinking Strategies. (2018). Visual thinking strategies. Retrieved from https://vtshome.org/.

Wagner, E., & Laven, R. (2015). Visual literacy: A universal concept? In R. Mateus-Berr & M. Gotsch (Eds.), *Perspectives on art education*. Symposium, May 28–30, 2015. D'Art—Austrian Center for Didactics of Art, Textile & Design. University of Applied Arts, Vienna, Austria.

Zanin-Yost, A. (2007). Visual literacy resources on the web: A look at what is available. *College and Research Libraries News*, 68(8), 508–510.

Afterword:
To Visualize the Future Is Political Work

Danielle Taschereau Mamers, McMaster University

When the initial call for papers for the 2018 Visual Futures conference appeared in my inbox, I was particularly struck by a key question posed by the conveners: how do we visualize the future? Visuality, futurity, and practices of visualizing the future (or futures) are, to me, Inherently political undertakings. Images, visual practices, and visuality make possible particular ways of seeing, thinking, and imagining our worlds. Describing the political nature of images, Roland Bleiker (2018) writes, "they delineate what we, as collectives, see and what we don't and thus, by extension, how politics is perceived, sensed, framed, articulated, carried out, and legitimized" (p. 4). The stakes of visuality are high. Whether or how an individual, a community, an issue, or an event is depicted can have powerful effects on how histories are narrated, how precarity might be attended to, or how categories of knowledge are reproduced or disrupted. The future is also a concept with significant political stakes. The future is not a given or determined system of relations. Our perspectives on history, hegemonic structures and institutions as well as narratives of the possible all shape the multiple futures that might be brought into being or foreclosed. The work of rethinking and reimagining possible worlds requires a host of practices, which include the work of seeing, of image-making, and other visual methods. To visualize the future is political work.

Taking a political approach to the task of visualizing the future involves, among other things, developing analyses that are sensitive to power relations. Reading images and futures through power also requires attentiveness to historical, colonial, cultural, and geographic contexts in relation to how images are framed, circulated, and interpreted. Similarly, a political approach examines both visualities and futurities in relation to normative and hegemonic orders, asking to what extent such orders are maintained and reproduced or disrupted and redistributed by visual praxis. In seeking a political approach to visualizing the future,

AFTERWORD

I am primarily interested in attentiveness to the conditions of possibility that images and visual practices generate. This is very different from seeking to identify a causal relationship between a given image and a specific political event. Politically oriented research about visualities creates possibilities for emergence and foreclosure; for the disruption and maintenance of hegemonic structures and stories; and for the redistribution of seeing, thinking, and imagining. From this perspective, the visual is neither inherently good nor necessarily violent. Rather, visual practices are frequently indeterminate, generating different possibilities in the encounters of production, circulation, and interpretation.

Research in this vein explores of what images depict and how they are produced and circulated, but also extends into the critical question of what images actually do. It is now routine to note that over the past few decades, images have circulated with ever-increasing speeds and velocities, while image-making technologies have become more accessible. But the challenge of articulating with precision what all of these images are doing remains. To invoke W. J. T. Mitchell (2005), what do images, visual artefacts, and visual practices want? Or, as this volume is framed, what ways of seeing, knowing, and imagining futures do they make possible? Responding to Mark Reinhardt's (2012) call to examine how "visual practices shape political life" (p. 51), the wager of this Afterword is that taking a political approach to images and visual practices can help us attend to the material issues of power, inheritances, and justice at stake in how we visualize our futures.

The visual and the future are expansive spheres, as the chapters in this volume reflect. The authors of the preceding chapters and participants in the 2018 Visual Futures conference in Toronto employ a wide range of methodologies and research sites in order to ask how visualities and visual practices work, how these practices intersect with other modes of knowledge and exchange, and how visualities connect to—and help us think about—other complex phenomena, such as environmental change, social justice, gender and sexuality, and scientific knowledge. My reflections on the work of the Visual Futures conference and book take the form of four overarching questions, which respond to the chapters in this volume while looking ahead to the next convening of this group of thinkers. My orientation toward the political lives of images is rooted in my training in both media studies and political theory, as well as my ongoing research in decolonial aesthetics and contemporary Indigenous art and media. While the conference and book project were not explicitly grounded in political or decolonial projects, it is my hope that these questions might offer fertile ground for research-to-come in the vital task of visualizing futures.

What is the role of visuality and visual praxis in the work of world-building?

What do images do? This question, as vexing as it is simple, strikes me as crucial to our work as visual scholars, educators, and practitioners. The chapters collected in this volume demonstrate a variety of ways in which images and visual praxis are invested in projects of world-making. From photography, graffiti, and drawings to scientific illustrations and architectural designs, images and the visual practices that generate them can help us imagine otherwise. They are powerful tools for visualizing new and future worlds.

Creating media that reflects viewpoints extending beyond hegemonic narratives has long been a tactic of world-making. For counterpublics, as Michael Warner (2002) argues, creating and circulating media that responds to alternative political, social, and cultural desires is a critical activity for nourishing communities and creating spaces where people can find their lives and worlds reflected back to them in affirming ways. In addition to critique of structural violence, visual practices can be sources of affirmation and joy. Visual practices—and perhaps visual art especially—can challenge us, prompt us, and give us opportunities to see the world anew. As Bleiker (2018) describes, visual work has the potential "to make us see a different reality than the one we are used to and the one that is commonly accepted" (p. 28).

In addition to the freeing qualities of aesthetic projects based in speculative futures, visual practices are vital tools for identifying and representing categories, power hierarchies, and other hegemonic structures. Making visible and representing the scopic systems that shape identities and frequently constrain agency, images can be a staging ground for the critiques of those systems. As Elizabeth Peden's contribution to this volume articulates, visual media such as film intersects with structures of social ordering in powerful ways, confirming existing categories, such as race. However, as Peden is careful to note, film can also be a practice for disturbing and transgressing such categories. Oppositional readings that look for contingencies, such as the decoding techniques advocated by Stuart Hall (1980), can be strategies for resisting the racial, capitalist, or heteronormative gazes. Such critique can reappropriate images and recruit them into projects of imagining otherwise.

As sites of both oppositional readings and speculative creation, visual practices can map, nurture, and activate prefigurative politics that envision new relationships, narratives, and modes of identification. In her account of developing a virtual forest world, Kylie Caraway's citation of Donna Haraway is an apt description

of the potential for affirmation and possibility that visual practices can bring to world-building: "perhaps it is precisely in the realm of play, outside the dictates of teleology, settled categories, and function, that serious worldliness and recuperation become possible" (p. xx, Chapter 6, this volume). By denaturalizing the categories at work in hegemonic scopic regimes, images, artwork, and other visual practices provide material spaces for imagining new relations, shift power structures, and enact new ways of seeing. This volume is rich with diverse examples of visual praxis bringing worlds into being. Charudatta Navare's chapter on scientific imagery demonstrates the world-making capacity of visuality through the labor of images in making a world appear as real and creating possibilities for "knowing" or accessing the unseeable. Drawing on the striking example of different illustrations of egg fertilization, Navare prompts us to consider how our senses of the world might change if we are given different images. In their analysis of culturally relevant architecture, Matthew Dudzik and Marilyn Whitney describe the design process of "envisioning" as a practice of working from what is known into unknown. Here a combination of imagination, empathy, and visual rendering combines to bring images—and eventually buildings—into being in ways that create worlds that will meet the needs of the communities inhabiting them. In each of these examples, as well as other contributions to this volume, images and visual practice provide ways of moving outside of settled orders of knowledge and engaging the kinds of play through which new worlds can be imagined and brought into being.

How do material matters of access and justice shape possibilities for visualizing the future?

In the media and cultural studies classrooms, journals, and conferences where I have been working, it is common to remark on the democratization of access to the means of producing and circulating images at relatively high speeds. At times this characterization bemoans the glut of images circulating through our screens, crowding modern minds, and assaulting our capacities for reflection or attention. Other times, these reflections take on a celebratory character, marveling at the new possibilities for citizen journalism, cultivating a plurality of perspectives, and opportunities for creative collisions between visual practices. However, the ability to create, circulate, and respond to images in these ways hinges on material issues of access: cameras and other imaging technologies to create visual texts, as well as networked phones, computers, and relatively high-speed internet or cellular networks to circulate and respond to images.

Access to the means of image-making and circulating is more fragile than concerns about or celebrations of the flood of images might let on. For example,

many communities in rural and northern Canada continue to have limited access to high-speed, reliable internet, and cellular networks. Changes to internet policy in the United States, such as attacks on net neutrality, risk the further commoditization of communications networks put at further risk equitable access to the means of publishing, circulating, and responding to visual texts. Protests and citizen uprisings are often taken up as an example of the power of images and their circulation to connect people and to have clear political effects. And yet, the capacity for photographs and other images to galvanize public sentiment requires access to the means of circulation. In the first half of 2019, internet access was suspended and cellular networks were jammed in attempts by state powers to curtail protests in Kashmir, Moscow, Sudan, and Zimbabwe. These disruptions of access were motivated desires to shut down the communications networks essential to protest organizations, but they have also limited or slowed down the circulation of protest documentation (such as visual records of protest size or instances of police or military brutality).

Each of these examples points to the broader question of who has access to the images, visual practices, and imaging technologies used to visualize futures. Access to the means of image production and circulation is not just a matter of which perspectives are absent or underrepresented. Rather, material matters of access and justice also engage the ways that visual cultures and perspectives become stratified, distorted, or disrupted resources that are unavailable to particular groups or in different places. Tracy Bowen's chapter in this volume demonstrates the power of accessible image-making tools, where paint and public walls are leveraged by members of San Francisco's Mission neighborhood and San Diego's Chicano Park to record community histories. The perspectives made visible in these graffiti projects, Bowen observes, are acts of public pedagogy, memory work, and resistance. Embedded in graffiti work are indictments of a neoliberal vision for the future of these areas, as well as countervisions for futures that preserve and invest in communities. The street-level sites of inscription that Bowen observes reflect the importance of public spaces, but also the work of documentation in archiving the layered, in-flux work of graffiti artists and possibilities for moving the histories and visual futures in these works from the street to policy and planning spheres.

If images and visual artefacts frame the conditions of possibility for politics and for our political imaginations, then the kinds of images available and that we attend to are key concerns. In conducting research that considers how a plurality of visual perspectives might flourish, it is critical to attend to these questions of material access and justice. To generate the range of images and visual practices vital to visualizing the future in inclusive, decolonial, antiracist, queer, and multispecies ways requires tools of image-making and circulation that are available to a wide range of communities and creators.

AFTERWORD

How do our visual inheritances foreclose possibilities for visualizing the future? Can we see in ways that do not reproduce violent epistemic and ontological structures embedded in associations between vision and rationality?

As the plurality of critical approaches collected in this volume makes clear, analyses of seeing, visual creation, and visualities are complex undertakings. Many of this volume's contributors correctly point out that visual practices are rarely projects that represent the world in mimetic or indexical ways, but instead are structured by interests, power, and other aspects that locate our perspectives. The many ways we create and interpret images emerge from how we have learned to look, to see, and to envision. As Susan Sontag, Jonathon Crary, Martin Jay, and many others have observed, the privileging of vision and its suturing to rationality in euro-western systems of knowledge continues to have a profound effect on how many of us have learned to see and, crucially, to unsee or to look differently. Associations between vision and power can structure our sensibilities about evidence, display, transparency, truth, observation, and control in explicit and subtle ways. Identifying and engaging with visual inheritances requires sensitivity to the orientations that are privileged, solidified, undermined, or refused by visual media, methods, and literacies.

Surveillance and biometric practices, phenotypical frames through which race is made to appear, hegemonic expectations of gender performance, and the maps and charts of statecraft are just a few ways in which power operates through visual techniques. Such techniques explicitly and implicitly serve the reproduction of regulative institutions and ideas of citizenship, belonging, racial hierarchies, heteropatriarchy, and colonial sovereignties. Images of bodies, of relations, and of territories have long been critical to reproduction of certain lives and experiences as seeable, and thus knowable, while leaving a wide range of experiences outside the world of the sensible. Vision and power have long been linked under different modalities of state power, which Foucault (1977) has charted from exhibitions of the sovereign power to kill to the surveilling visualities of disciplinary and biopolitical power. Nicholas Mirzeoff (2011, p. 4) also demonstrates that the convergence of visuality and sovereignty naturalizes those who have the authority to see—those agents invested with enacting the state's gaze—and diminish the power of the overseen. The precise relationship between visuality and power varies by political context. For example, in colonial and settler colonial contexts, colonial agents have used a variety of methods to make lands visible as colonized territories and lives differentially visible as "other" (ranging from objects of exoticized consumption to targets of assimilationist policy to outright erasure). As Priya Dixit (2014) observes, these kinds of visual practices are "a production of colonial power relations" (p. 339).

While visualities and visual praxis have played important roles in the maintenance of hegemonic institutions, systems of knowledge, and power relations, they can also be avenues for reckoning with euro-western inheritances. Jacques Rancière (2010)—and many after him—has characterized the political capacity of aesthetics as the "re-distribution of the sensible," which creates "breaks with sensory self-evidence of the 'natural' order" (p. 139). In our analyses of images and visual practices and our efforts to visualize the future, we have the opportunity to reflect upon and redress some of the damage done by our visual inheritances. In some cases, this might mean engaging reversals or refusals of heteronormative or colonial gazes. In other cases, learning new visual habits may entail practices of multisited looking or collectively creating images. How might we use images, visual artefacts, and visual literacy to disrupt the legibilities demanded and reproduced by oppressive regimes, institutions, and knowledge structures? How can our efforts to visualize the future uphold multiple ways of seeing in ways that ensure those emergent futures do not reproduce the violent inheritances of euro-western gazes and do not reproduce violent epistemic and ontological structures embedded in associations between vision and rationality? Put another way, what are the ways that visual media and visual research can create noise in the signals of colonialism, heteropatriarchy, capitalism, and state sovereignty?

Critical future work in response to these questions can involve developing methods for visual futures that intercede in observational practices that demand everything be seen. Opacity is one visual strategy that artists and scholars have experimented with to create spaces of refuge from colonial gazes and other nonreciprocal scopic regimes. The settler colonial gaze at work in visualizing settler futures is part of a strategy that renders Indigenous peoples visible as objects of knowledge. The settler colonial gaze refuses to see Indigenous peoples as sovereign nations and refuses to recognize Indigenous legal orders and kinship relations. And yet, colonial gazes also refuse to let Indigenous peoples go unseen. Cree theorist and poet Billy-Ray Belcourt (2018) diagnoses this visual scene as "against opacity, as against the right to be unseen and unseeable" (n.p.). This denial of opacity, he argues, is "a structural and structuring articulation of Indigenous life so as to refuse it the promise of freedom, to refuse us a world-making kinship that was in opposition to the world-engulfing effects of racial capitalism" (n.p.). The visual techniques of settler colonial ways of seeing seek to foreclose Indigenous world-making practices and possibilities for visualizing Indigenous futures. Insistence on opacity, then, as Cree and Dene Suline media scholar Jarrett Martineau argues, "is not passive acquiescence to colonial erasure, but one that instead seeks to make ontological hierarchies established and produced by colonialism visible and brought into contention" (p. 70). Secwépemc artist Tania Willard's "Only Available Light," a 2016 video installation, makes use of opacity

(https://www.taniawillard.ca/gallery/only-available-light-callresponse). To create the work, Willard projected footage from "The Shuswap Indians of British Columbia," a 1928 educational film made of her community through selenite crystals found in Secwépemc territory. Using the crystals create a distorted prismatic image, Willard's installation denies the extractive and appropriative gaze of the original film while also repatriating images of elders to her community. As an aesthetic strategy, opacity creates pockets of refuge where the creative praxis of visualizing Indigenous futures and decolonial ways of seeing can be nurtured, while also denaturalizing the visual techniques through which colonialism operates and regenerates.

How can we learn other ways of seeing and visualizing?

My final question is prompted by the Visual Futures group's roots in visual literacy scholarship. It strikes me that the preceding questions of world-creation, material access, and visual inheritances all pass through the space of learning. Whether in formal classrooms or in individual experiments with methodologies, attempts to see differently and to visualize expansive futures requires experimentation. How do we enact a visual literacy program that is sensitive to the histories of looking and potentially violent visual practices? How can we as scholars learn new ways of seeing? How can we as educators bring experiments in visualization into our classrooms? Several chapters in this volume make clear the importance of visual techniques in places of learning. As Charudatta Navare's research on biology instruction, Matthew Dudzik and Marilyn Whitney's exploration of architectural design processes, and Dana Statton Thompson's survey of visual literacy curricula each demonstrate, the images and visual techniques featured in our classrooms have powerful effects on how students understand relationships between themselves, knowledge, and potential avenues for engaging in the world. Similarly, the "heart mapping" activity described in Phil Fitzsimmons and Edie Lanphar's chapter engages the capacity for visual literacy and visual expression activities to help students cultivate connections between their personal experiences and their broader worlds. These and other chapters underscore the value of the pedagogy to developing new approaches to analyzing images, to cultivating critical orientations to visualities, and to investigating how the visual intersects with regimes of knowledge and power.

I do not have a program for visual pedagogies, nor is asserting one my interest in this chapter. Instead, I offer a brief reflection on my own experiences with visual artefacts in the classroom. As a settler scholar and media studies instructor, two places I have found valuable guidance is in Angela Haas's (Eastern Cherokee) work

on decolonizing visual pedagogies and Jolene Rickard's (Tuscarora) theorization of visual sovereignty. The challenge of reckoning with visual inheritances means both assessing the presences and absences or visibilities and erasures within hegemonic scopic regimes. For the decolonial project Haas (2015) outlines, this means examining the historical and ongoing effects of colonialism on our institutions, relations, knowledge practices, senses of selves and of others. In a visual context, this reflection on colonizing gazes might ask how Indigenous experiences are erased, appropriated, or caricatured in settler colonial images and visual practices. From this attention to absences and erasure, Haas recommends shifting focus to an analysis that seeks Indigenous presences as well as to privilege the visual practices and self-representation of Indigenous artists, creators, and communities. The interplay of critical reflection and asserting Indigenous presence can help students engage in disrupting and dismantling the reproduction, transmission, and diffusion of hegemonic colonial visual practices. Attention to critique and holding space for Indigenous presence is at the heart of this approach. While critique of colonial practices is necessary, to stop there risks recentering violent visual practices and their erasures. Emphasizing Indigenous presences creates space for encountering different ways of seeing and understanding the imbrication of visualities and power.

Visual sovereignty is a key concept that I use with my students to grapple with the entwinement of colonial visualities and governance, as well as the critical contribution of aesthetic and visual strategies to Indigenous survival, resistance, and resurgence. Visual sovereignty describes Indigenous creative practices that combine contemporary media practices and with traditional knowledge to disrupt settler knowledge regimes and insist on expansive concepts of "self-defined renewal and resistance" (Rickard, 2011, p. 467). For Rickard, the concept of visual sovereignty articulates the relationship between art and ideals of nationhood, self-representation, and reimagining philosophies. "Art and making culture," she writes, "is integral if not central to the affirmation of these ideals" (Rickard, 2017, p. 84). Indigenous artists and activists have played an important role in generating representational and political strategies to activate alternative ways of seeing that preserve and enhance Indigenous lifeworlds, lived identities, and sovereign relations. Expressions of visual sovereignty are not limited to anticolonial critique or the disruption of settler colonial gazes. Such visual praxis contributes to building decolonial futures by activating imaginations.

By bringing visual sovereignty and decolonial pedagogies into my classroom, students engage with art and aesthetic practices in ways that open, disrupt, recontextualize, and denaturalize hegemonic narratives and political claims. From Kent Monkman's paintings that are insertions of an Indigenous gaze into the eurowestern canon of landscape and history painting (http://www.kentmonkman.com/) to Skawennati's time-travelling avatars that enact futurist virtual worlds beyond

colonial regimes (http://www.skawennati.com), I invite students to engage with both the critical and generative dimensions of decolonial visualities that Haas, Rickard, and others describe. Here, centering Indigenous creativity, scholarship, and resurgence while prompting reflexivity and critical understanding of the histories of power relations that effect present and future politics in Canada create a staging ground for visualizing more equitable futures.

Images and visual praxis are incredibly powerful tools for bringing experiences and knowledges into being. The labor of visualizing the future, as I have suggested throughout this chapter, is a political practice with the potential to generate queer, decolonial, antiracist, and more just worlds. In an essay on Black photography and the relationship between vision and justice, Sarah Elizabeth Lewis (2016) argues that artwork can establish opening to new forms of political relations and "create a clear line forward, and an alternate route to choose" (p. 14). The aesthetic force of images and other visual artefacts rests in these clear lines forward, and away from the colonial, heteronormative, and extractive gazes of those that are visualizing futures in this late-capitalist present. The work to come for Visual Futures can perhaps be oriented toward attending to the kinds of images that create lines forward and to developing and sustaining the practices that will lead us toward the alternative futures we have been imagining.

REFERENCES

Belcourt, B.- R. (2018, July 19). Fatal naming rituals. *Hazlitt*. Retrieved from https://hazlitt.net/feature/fatal-naming-rituals.

Bleiker, R. (2018). Mapping visual global politics. In R. Bleiker (Ed.), *Visual Global Politics* (p. 4). London, United Kingdom: Routledge.

Dixit, P. (2014). Decolonizing visuality in security studies: Reflections on the death of Osama Bin Laden. *Critical Studies on Security*, 2(3), 339.

Foucault, M. (1977). *Discipline and punish: The birth of the prison*. (Trans. A. Sheridan). New York, NY: Vintage.

Haas, A. (2015). Toward a decolonial digital and visual American Indian rhetorics pedagogy. In L. King, R. Gubele, & J. R. Anderson (Eds.), *Survivance, sovereignty, and story: Teaching American Indian rhetorics* (pp. 188–208). Boulder, CO: University Press of Colorado.

Hall, S. (1980). Encoding/decoding. In S. Hall, D. Hobson, A. Love, & P. Willis (Eds.), *Culture, media, language* (pp. 128–138). London, United Kingdom: Hutchinson.

Lewis, S. E. (2016). Vision and justice. *Aperture*, 223, 14.

Martineau, J. (2015). *Creative combat: Indigenous art, resurgence, and decolonization* (Unpublished Doctoral dissertation). University of Victoria, Melbourne, Australia.

Mirzeoff, N. (2011). *The right to look: A counterhistory of visuality*. Durham, NC: Duke University Press.

Mitchell, W. J. T (2005). *What do pictures want?: The lives and loves of images*. Chicago, IL: University of Chicago Press.

Ranciere, J. (2010). *Dissensus: On politics and aesthetics*. (Trans. S. Corcoran). London, United Kingdom: Bloomsbury.

Reinhardt, M. (2012). Painful photographs: From the ethics of spectatorship to visual politics. In A. Grønstad & H. Gustafsson (Eds.), *Ethics and images of pain* (p. 51). London, United Kingdom: Routledge.

Rickard, J. (2011). Visualizing sovereignty in the time of biometric sensors. *South Atlantic Quarterly, 110*(2), 467.

Rickard, J. (2017). Diversifying sovereignty and the reception of indigenous art. *Art Journal 76*(2), 84.

Warner, M. (2002). Publics and counterpublics (abbreviated version). *Quarterly Journal of Speech, 88*(4), 413–425.

Notes on Contributors

Tracey Bowen has a PhD from the University of Toronto, Ontario. Her research is situated at the intersection of contemporary hieroglyphics, social justice, and visual communications. She teaches in the areas of visual rhetoric as well as experiential education. Her research has been published in *Visual Communications*, *Studies in Art Education*, *Metaphor and Symbol*, *Studies in Higher Education*, and *Higher Education Research and Development*.

Brett R. Caraway obtained his PhD from the University of Texas at Austin before coming to the University of Toronto where he teaches and researches economics, Marxian theory, and sustainability. His research has been published in *Environmental Communication*, *Communication Theory*, *Information, Communication & Society*, *Media, Culture & Society*, and the *International Journal of Communication*.

Kylie Caraway is a creative technologist and filmmaker from Toronto, Ontario. She received her master of fine arts in digital futures from OCAD University. Her research and creative practice focus on the interplay between environmental communications, information visualization, and digital technologies.

Marilyn Corson Whitney is an independent scholar whose research focuses on the professionalization of interior design, specifically examining the intersection of research-based exploration and the iterative design process in studio environments.

Matthew Dudzik is professor and the international architect in residence in Department of Civil and Natural Resources Engineering at the University of Canterbury in Christchurch, New Zealand. He is also the creative director of the architect and interior design firm DUDZIK Studios. His research focuses on issues of socio-spatial justice and how architecture can create inclusive environments for indigenous populations.

Phil Fitzsimmons is education-head of school at Alphacrucis College, Sydney, Australia. Prior to this position, he was an independent researcher and educational consultant, assistant dean of research (Faculty of Education, Business and Science - Avondale University College, Australia) and director of research (San Roque Research Institute, California). His research interests include all things gothic and monstrous in film and literature, literacy in all its forms, and adolescent spirituality.

Penny Kinnear completed her PhD in second language education and comparative and international development education in 2004 at the Ontario Institute for Studies in Education. Her doctoral research used narrative as a data collection method allowing her to develop a deeper understanding of the narrative impulses and practices we all share. She is the co-author of *Sociocultural Theory in Second Language Education: An Introduction through Narratives*. Since 2009 she has taught in the the engineering communication program with a focus on multilingual students and professional language development. In 2014 she collaborated with Annie Simpson and ILead to design and teach the course, *The Power of Story: Discovering Your Leadership Narrative*. Her current research interests include how students make meaning in team contexts, professional identity development and the impact of multilingualism and translingualism on the ecology of university classrooms.

Edie Lanphar is director of curriculum and instruction at the Knox School for Gifted Students, Santa Barbara, California. Lanphar has had an extensive education-related career, which includes teaching PK to 12th grade; holding the posts of curriculum director of a progressive/project-based learning PK-12th grade school and university lecturer in Australia; and is also an author and researcher. Her current research is grounded in adolescent development and school- based professional development.

Charudatta Navare is a graduate student at the Homi Bhabha Centre for Science Education, Tata Institute of Fundamental Research (TIFR), Mumbai, India. His research focuses on the ideologies embedded in scientific representations, and particularly on the visual rhetoric of biology.

Elizabeth Peden is a PhD Candidate at the Ontario Institute for Studies in Education at the University of Toronto. Her research focuses on visual culture and media representations.

NOTES ON CONTRIBUTORS

Danielle Taschereau Mamers is an SSHRC Postdoctoral Fellow (2020–22) at McMaster University. She is a theorist of visual politics working in the fields of settler colonial studies, critical animal studies, and media theory. Her research investigates how media sustain ways of seeing and how we might engage these visual and political worlds in disobedient ways.

Dana Statton Thompson is assistant professor and research and instruction librarian at Murray State University, Kentucky. Her research and teaching interests focus on the intersection of visual literacy and news literacy, the integration of visual literacy instruction into higher education, and the scholarship of teaching and learning.